INCANDESCENCE

TEXT BY **FRÉDÉRIC PROT**
AFTERWORD BY **PATTI SMITH**

YVES KLEIN

INCANDESCENCE

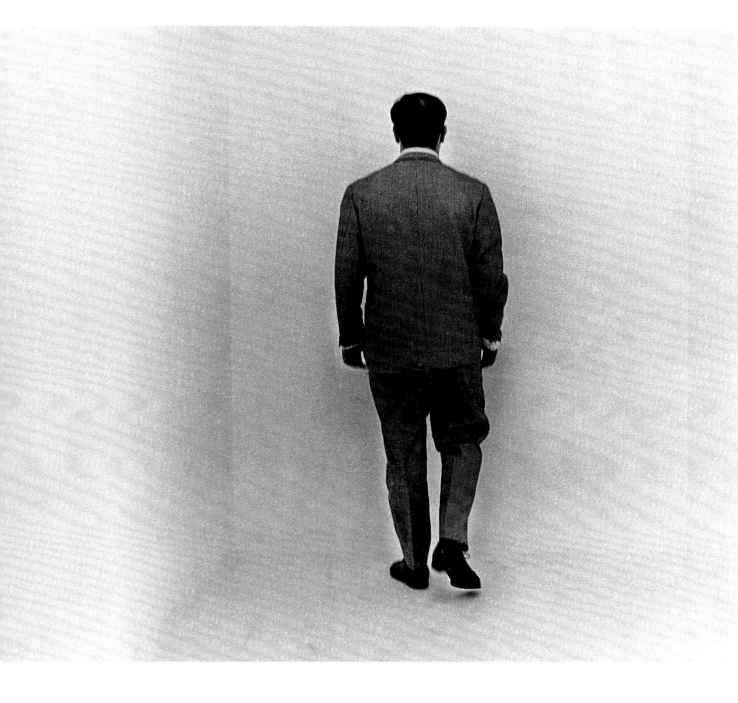

And following page: Yves Klein in the "empty" room devoted to "immaterial pictorial sensibility," 1961

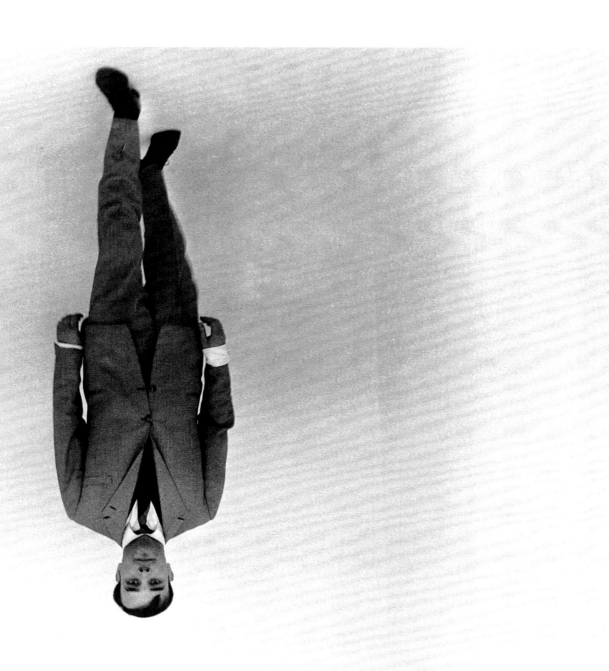

CHAPTER I

THE INVISIBLE CITY

And at dawn, armed with glowing patience,
we will enter the cities of glory.[1]

Rimbaud

As he approaches the city, the traveler is unable to perceive it. Nor will he fare better beneath its very gates, as the city is made almost entirely of air. When only a few steps away his face starts to feel its cool breath, feeling like a welcome echoing through the air. Being invisible, this is how it reveals itself, through contact. All the nerve endings of the skin are suddenly alert to its presence, clearer and clearer as each step brings him closer. If he is not to lose his way in the red desert, the traveler has but one way to find it: he needs to keep his wits about him and wear light fabric, or even, if it comes to it, strip to the waist. A map of the area and good skin are all he needs otherwise. Tired after the long trudge, his body yearns for this air as if it were a shelter.

Since it was founded, when Eden was still young, the city has been ageless and without history to those looking upon it. Indeed, neither time nor men have the power to change this constant and unvarying air. The past has left no trace of erosion; nor has society made its mark on the buildings or open spaces. All is transparent and as it was on the first day. The names of the successive architects have become jumbled in memory. Thus does the air convey to the city and its inhabitants the lesson of time's deletion, instant joy, with no memories of the future. "All foundations are ruins."[2]

If the eye is powerless to distinguish one city of air from another, it is not true that each is a copy of its neighbor. On the contrary, they all vie with one another with tactile surprises,

aimed at the traveler walking their streets, between their houses and across their squares. One day, science managed to control this air, which had been unstable until then. Thanks to an astonishing network of jets, vents, and underground piping, it succeeded in somehow shaping it and the air was able to build itself, as if by magic. Walls, floors, roofs: to the eye everything was immaterial, while the hand could feel its smooth texture.

Air simplified architecture. Windows, for example, lost all purpose. At the apex of its power, science has emulated poetry by creating a skin-apprehended architecture. Air has jettisoned the age-old separation between outdoor and indoor functions in the city like an invisible skin, influencing its climate, while receiving the input of the atmosphere.

Everything vibrates beneath the huge dome of blown air protecting the city. In the middle of the desert, it is a haven for the traveler, a colony of coolness ready to spread throughout. Wasn't the ultimate aim of its founders to cool the region by means of a screen of colored air to alleviate the suffocating temperatures?

While the air organizes and safeguards the city, water and fire maintain its good spirits and climate. Basins are scattered here and there, enabling the inhabitants to plunge their legs into reflections of the blue sky. Fountains of fire spout burning heat, making the air shimmer and licking at the surface of the water,

where it cools and flees. The lunging blue flames crackling dully above the mirror are an extraordinary sight. Like air, with its sense of rising and falling, water and fire permeate the traveler's mind and provide him with the basis of health and an explanation of the world: the image of an elementary, inexorable clash.

The city fulfils the deep instinct for lightness that has always led man to dream of being at home in the air, endowed with a secret power of flight, and is filled with wonder when suddenly it comes true. The elasticity of forced air thus creates a sensation of weightlessness. Everywhere in the city large disks piercing the transparent ground and powered by a strong bellows blow out a cushion of air that invigorates the body from ankle to shoulder: one jump and you're in it, suddenly feather light. In this air which supports you even in mid-air time itself is suspended, where happiness overcomes the fear of falling, nipped in the bud. The feeling is that of delightful buoyancy.

You can wander all over town with your eyes shut for its transparency makes sight redundant. Your route unfolds in a fingertip caress, moving over the elastic surface of the panels of air. So you walk along a wall until a sharp angle tells you have reached a corner. When this continuum comes to a halt, it's because a street or a square opens right in front of you. Architecture has become a tactile sculpture whose general structure and volume you mentally reconstruct. The retinal image of the world is no longer the basis of your perception.

Getting one's bearings means feeling things on your own skin, recording tangible space and sharpening your sensitivity right down to your soul. This is how the layout of the invisible city becomes engraved in your memory.

In short, the whole city fashions its inhabitants and travelers. It transmits itself. The impalpable softness of the air, its flowing mobility and cheerfulness leach out man's sad worries that elsewhere would weigh down on him and cause him anxiety. The city of air draws you into itself and unburdens you. Man discovers an affinity with this insubstantial element to the point of adopting its qualities. There is now no place for intimacy, for instance. The pervasive transparency has dissolved the very meaning of the word. Freedom has been attained just like that, by necessity. Air's sweet benefits soon required complete nakedness, so that the body could fully partake of Eden's delights. What the city has discontinued is the individual and not the person. Each of us comes to acknowledge he is part of a single, all-inclusive whole.

Clarity unconfined! And just as your gaze reaches the most distant point, so can your mind grasp other men's most rarefied thoughts. By osmosis, you "dream in others' dreams," just as you steal ideas from the air.[3] Prominent among these is "*the poet* who, beyond the dream itself, experiences the enlightened trance of contact with the emotional heart of all things and *joy* in its primordial material state, which, lofty and profound . . . lies at the origin of life itself."[4]

The immaterial city exits at your fingertips and in your imagination. It echoes deep inside you in an infinite range of possible images. It is inhabited through sensibility, it impregnates you by becoming one with "life itself, which is this space."[5] And when you fall asleep, as you dream of the city, so you rebuild it.

"But what enhanced for Kublai every event or piece of news reported by his inarticulate informer was the space that remained around it, a void not filled with words. The descriptions of cities Marco Polo visited had this virtue: you could wander through them in thought, become lost, stop and enjoy the cool air, or run off . . . With cities, it is as with dreams: everything imaginable can be dreamed, but even the most unexpected dream is a rebus that conceals a desire or, its reverse, a fear."[6]

1. A. Rimbaud, *Une saison en enfer* (1873), in *Poésies*. Paris: Gallimard (coll. NRF Poésie), 1999, p. 204. All quotations from Rimbaud have been taken from this edition and are our translation.

2. Y. Klein, "Des bases (fausses), principes, etc. et condamnation de l'évolution," in M-A. Sichère and D. Semin (eds.), *Le Dépassement de la problématique de l'art et autres écrits*. Paris: École Nationale Supérieure des Beaux-Arts, 2003, p. 19. All quotations from Yves Klein are our translation.

3. Y. Klein, "Les Voleurs d'idées," *Dimanche*, p. 108.

4. Ibid., p. 108.

5. Y. Klein, *L'Évolution de l'art vers l'immatériel*, p. 123.

6. I. Calvino, *Invisible Cities*. London: Picador, 1979 (1972). Trans. William Weaver.

L'Eau et le Feu (Fontaine de feu) [*Water and Fire* (Fountain of Fire)], ca 1959

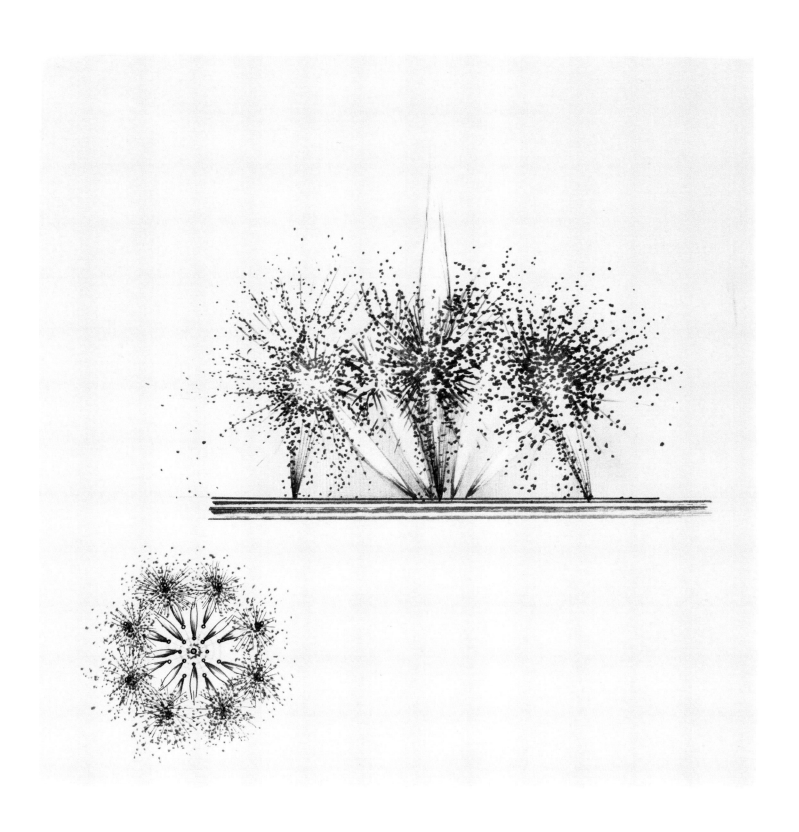

Jets d'eau et de feu [*Jets of Water and Fire*], ca 1959

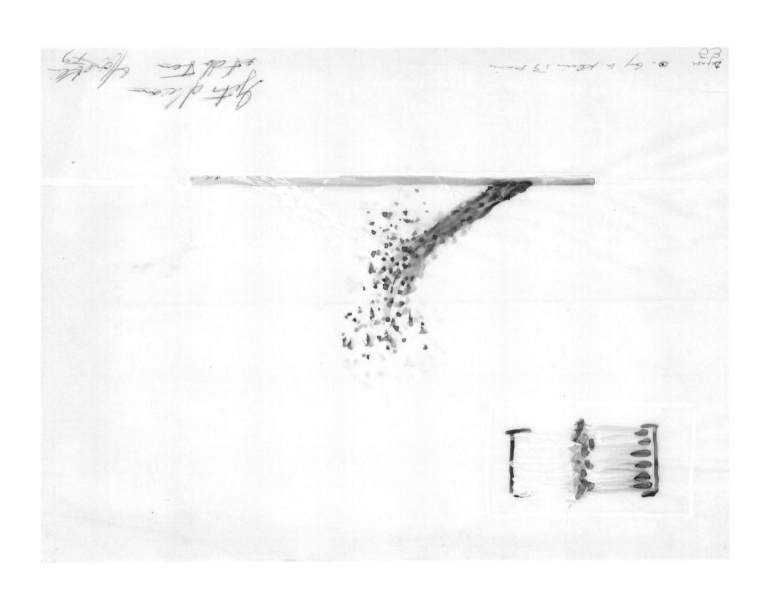

Jets d'eau et de feu [Jets of Water and Fire], 1959

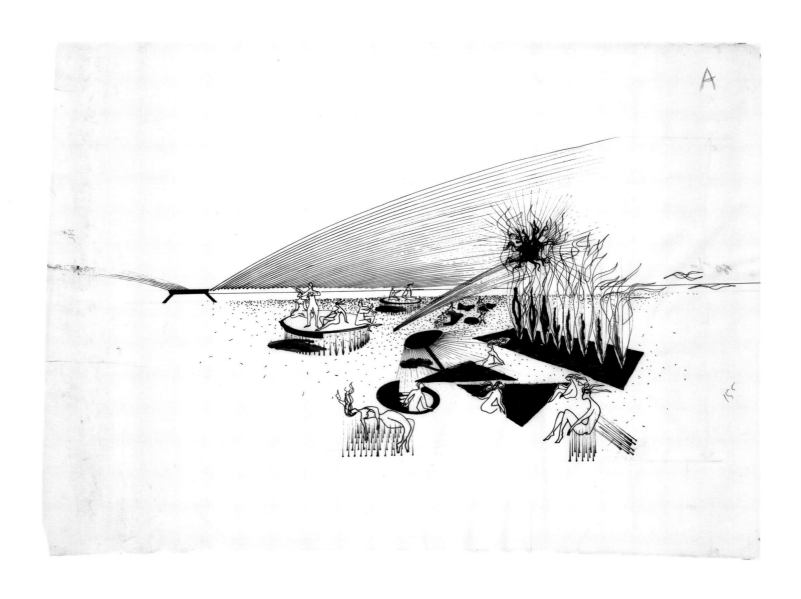

Cité climatisée (toit d'air, murs de feu, lit d'air) [*Climatized City* (Air Roof, Walls of Fire, Bed of Air)], 1961

Fontaines d'eau et de feu [*Fountains of Water and Fire*], ca 1959

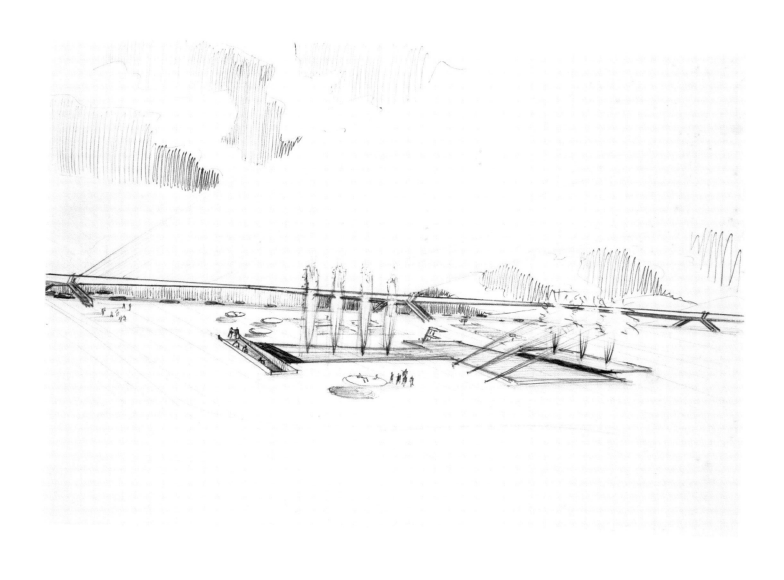

Cité climatisée – Accès à l'Éden technique [*Climatized City – Access to Technical Eden*], 1961

Yves Klein and the *Globe terrestre bleu* [*Blue Globe*], ca 1960

Place publique : murs d'eau et de feu [Public Square: Walls of Water and Fire], ca 1960

The inventions of the unknown
require new forms
Rimbaud

Why Not?

Devil take the fake bases, which are just so many wrecks! The great seam, the huge realm of life does not lie there. *Oh, future Strength!*[7] An elsewhere that may be imagined! Where to find it, where to touch it? How to set it off so that it opens up before us? "The inventions of the unknown require new forms."[8] The immaterial shall have its architecture: it will be made of air and space out in the open, adorned with flames and jets of water. A city of the future for a life without precedent. *Destruction + construction = Creation*,[9] writes Yves Klein.

Oneiric but possible, immaterial but discernible, air architecture is the emblem of the entire work. Or better: the incriminating evidence. "Unrestrained imagination is achievable. It is feasible."[10]

The immaterial city, with walls[11] and roofs of blown air, enables man to lead a new kind of life: a future freed from the material of the past and from the deposits of old worlds. Nothing accumulating. Nothing inherited. A city with no layers is a challenge for an architecture used to rebuilding over ruins or old foundations. "A thankless, tiresome job, often sprinkled with cruel doubts."[12] Fortified by this "daring of sensibility,"[13] Yves Klein would always respond to his critics by saying: *And why not?* "That's what's behind everything in a man's life . . . it's the sign that the archetype of a new state of things is ready."[14] Boldness brings adventure to science. *Why not?* And suddenly research expands, in which sanity is gambled, scorning ready-made answers and authority. "Every true discovery determines a new method; it has to scrap the prior method. In other words, in the realm of thought recklessness is a method."[15] Any sniggering can be dealt with by appealing to a passion for "all-powerful indifference."[16]

For notes from 7 on see pp. 216–21.

Detail of one of the two blue monochromes at the Gelsenkirchen opera house, 1959

Marvelous Realism

Since "the greatest of poetic realities is oneiric reality,"[17] Yves Klein does his best to extract it from the virtual realm of the imagination. Art realizes the world's potential by "[giving] existence to the things that in their natural state have remained mere intentions"(Goethe)[18]. It's up to man to follow the *path of wonder*,[19] that instantaneous daydream.

Air architecture would be nothing more than a pipe dream if Yves Klein were not raring to act and invent the world with no holds barred. As Albert Camus wrote: "A man's work is nothing but this slow trek to discover through the detours of art the two or three simple, great images which first caused his heart to open."[20] Yves Klein loved to tell how one day he was put on the path to his own mythology. *Hapax*, a single instant taken up and extended for a whole life. "I spent all my childhood and adolescence painting my first big monochrome fresco on the beaches of the South of France . . . I stretched out on the pebble beach and I suddenly saw my work. I was nineteen. The first painting truly mine and by me . . . would be the beautiful blue sky, clear and cloudless, huge, much huger than infinity! This is how I became Monochrome."[21]

I witness the blooming of my thought: I watch it,
I listen to it; I draw the bow over the strings; the
symphony grumbles in the depths, or leaps onto
the stage in a single bound
Rimbaud

Enhanced reality is the climate engendered in *marvelous realism*,[22] where the gaze shreds the natural order of things and scrambles all that seemed familiar. Desire revives the world's strangeness. It opens its folds and it is astonishing to sense this wonderful power within us to bring it to life and be renewed by it. "I witness the blooming of my thought: I watch it, I listen to it; I draw the bow over the strings; the symphony grumbles in the depths, or leaps onto the stage in a single bound."[23] A new world emerges *in the fullness of the great dream*,[24] not a supernatural world but simply thrust up under its own strength. "Imagining is heightening the real by a tone."[25]

Air architecture designs cities yet unseen, made of tough, fluid skin. The air is molded by the genius of technology; an oneiric reality, where dynamic properties prevail over the virtues of form.

Mur de feu [*Wall of Fire*], ca 1959

Ah ! Quick, quickly; over there, beyond the night, these future, eternal rewards . . . will we escape them? . . . What can I do? I know what it is to work; and science is too slow

Rimbaud

A Mythology

Science no longer fulfils its role of technical usefulness when, with its own ends firmly in sight, it makes common cause with *pure art*.[26] It is then that both appear to respect "a course made necessary and laid down by higher laws."[27] In this mutual illumination, the whole human condition is changed. "Ah ! Quick, quickly; over there, beyond the night, these future, eternal rewards . . . will we escape them? . . . What can I do? I know what it is to work; and science is too slow."[28] And Yves Klein goes on to complain that painting and music are still at the stage of *representing* the world. "We're so behind science and religion," he exclaims; while it is life itself in the raw which *presents itself* just as it is, with no "flights of fancy."[29]

Air architecture posits a city blending two great and seemingly contradictory Western myths: the myth of the Golden Age and the myth of Prometheus. "The absolute, a catch-all term, is always blocked with the branches of progress, however anemic its magic climate" (Char)[30]. On the one hand the sweetness of an idyllic, timeless society, and on the other, technological culture and the boom to come. The Eden-like art of living and liberating science. By the flames of the fountains within the immaterial city of air, man "can at last lead life as a constant *wonderment*."[31] "[Yves Klein] always said that hyper-technology lay at the root of creating an emancipated world,"[32] recalls his friend the architect Claude Parent.

> "Life, that very life which is absolute art itself"[33] within the "marvelous realism of art-science."[34]

Mastering the elements is the job of the *demiourgos*, the builder-architect who knows how to break matter down, combine the elements, and fashion an order of intelligible beauty. Yves Klein is attracted to this mythology and its enchantment.[35]

Demiurgic acts characterize his work, beginning during his adolescence when he turned the sky into a huge monochrome. "I want space."[36] Of all Promethean technology, the power to control fire is held to be the most secret. Through the action of flames, Yves Klein was to provide an image of the

Detail of one of the two great sponge-reliefs at the Gelsenkirchen opera house, 1959

body's immaterial flesh on which the imagination could work. In the end, through the ritual transfers of the *Zones of Immaterial Pictorial Sensibility*, he was to lead to a new world. Set against the gold tossed into the river, a single act would reveal a region of space, and apprehending this corner of the world vouchsafed us would be like returning to the first morning.[37] "Being / The first to come" (Char)[38]. One could even draw a demiurgic analogy with Yves Klein's very death, for his creative ambition led him to inhale repeatedly the fumes of his IKB mixture (*International Klein Blue*), thus contributing directly to his end. He installed huge ultramarine panels in the Gelsenkirchen opera house foyer and one could hear the silent ripples rumbling through the eyes and the ocean floors splashing the wall with hundreds of blue sponges.

A demiurgic act is proud faith in man's creative forces, which are capable of this "shock, at once violent and gentle, which is . . . the proud spirit, sure of itself and of the future,"[39] writes Yves Klein.

"The longer one lives in the immaterial, the more one loves matter"[40]

"Architecture is the will of an era translated into space (Mies van der Rohe)."[41] It unveils its hidden meaning. Yves Klein believes in the existence of the *Zeitgeist*, "the spirit of the time," the work of men and not of some external fate . . .

His air architecture is not just a possible environment. Through it, he provides his contemporaries with a metaphor for the present and a fresh future.[42] Air gathers the characteristics of a time that is beginning: a time of fluidity and dynamic networks, of potential realities and virtual spaces, of analogical sensibility and numeric immaterialization. Yves Klein's art doesn't abolish matter[43]: it thoroughly and fundamentally reveals that which is immaterial in the world and in life. The city of air and fountains is a space acting as a conductor for this invisible realm.

In order to be immaterial, architecture creates new materials. Air, fire, and water are joined by sounds, odors, magnetic forces, electricity, electronics, etc.[44] All this has to be marshaled in order to organize a sensorial space, made of impalpable, inconsistent matter, waves, vibrations, and jets. In the city of the future, the service rooms (kitchens, sheds, bathrooms, and toilets) as well as home automation systems and immaterializing equipment will be located below the living quarters. While the basement hosts the service areas, the residential area can be laid out in the open.[45]

Open Spaces

The immaterialization of buildings is part of a long history of remodeling space. After removing screen walls, glass, and Plexiglas, air can at last do away

33

Sous-sol d'une cité climatisée (Climatisation de l'espace) [*The Underground Climatized City (Climatization of Space)*]. ca 1959

Création d'un toit d'air soufflé [*Creation of a Roof of Forced Air*], 1959

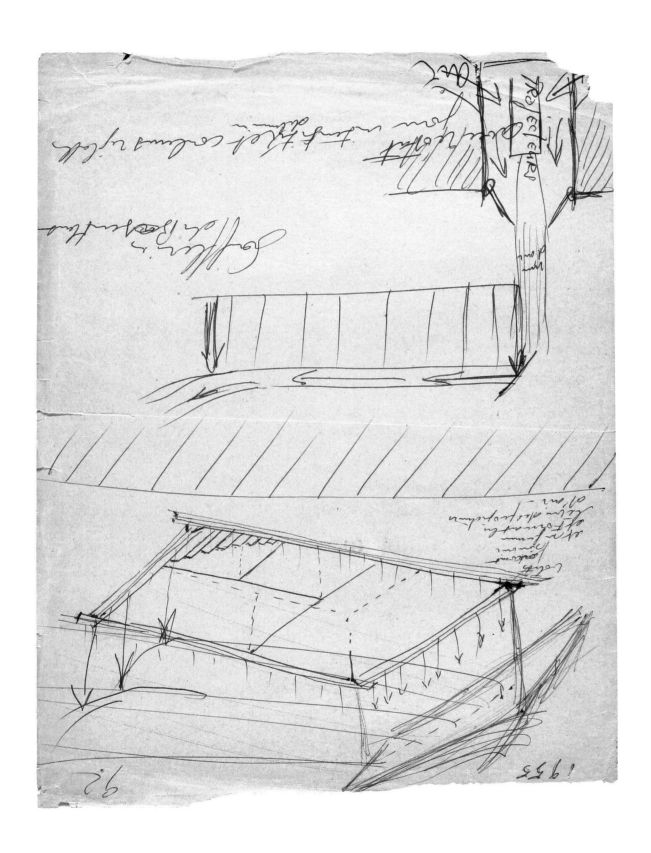

with all barriers. It provides a building with a membrane that lends it structure without divorcing it from its environment. The living area is no longer separated from its surroundings: the ambiguity of its outlines becomes its aim and its merit.[46]

By "inhabiting it through sensibility,"[47] we become the interpreters and *livers*[48] of this new architecture. As an *open work*, it expands through the effects of thought and dreaming. It blossoms by not fulfilling its possibilities. Any attempt to confine its site would contradict its nature.

Living in air architecture molds a new awareness of oneself and of the world. "The poetics of an open work express the positive potential of a man open to the constant renewal of his life patterns and understanding, engaged in gradually discovering his faculties and horizons," writes Umberto Eco.[49] Yves Klein's immaterial city is a life-affirming and invigorating architecture; a focal point where life finds models in the imagination. Although open as far as the eye can see, it redirects man in his quest. There is no pause. "As a matter of fact, I aim to go beyond art itself and to work individually on returning to real life, where the thinking man is no longer at the center of the universe but the universe is at the center of man. We will then know what 'prestige' is in relation to the 'vertigo' of the past."[50] The volatilization of intranquillity. Air architecture is freedom through sensibility.

The world will vibrate like a huge lyre
Rimbaud

Although it was thanks to glass and steel that Mies van der Rohe opened his buildings out onto a space that was as free as possible, he nonetheless found himself "caught out by the last obstacle [he] had not been able to overcome yet: the roof, the screen that separates us from the sky, from the blue of the sky,"[51] claimed Yves Klein in 1959. A membrane of compressed air was to be the solution: "one single air roof with a row of tubes blowing air out and one for sucking and recycling it at the end."[52] The atrium of a Roman villa had already turned a section of roof into open sky, just as the teenage Yves Klein changed sky blue into Monochrome.

And beneath this huge veil, "units of air perpendicular to the ground"[53] acting as walls. "The world will vibrate like a huge lyre."[54]

Of Skin and Flesh

Yves Klein's city has almost done away with its skeleton. If Mies van der Rohe already distinguished between bones (load-bearing elements) and skin (non

Interior view of the "empty" room devoted to the "immaterial pictorial sensibility," 1961, Museum Haus Lange, Krefeld

load-bearing elements), Klein envisions flesh as space. Only one type of pillar, whose job is to bear the imagination and the mind, stands under the great pumped-up skin: fountains of water and flames. Dreams are projected and life is led.

"I have created every feast, every triumph, every drama. I have tried to invent new flowers, new stars, new flesh, new languages."[55]

With the gesture of a painter, Yves Klein rebuilds Mies van der Rohe's architecture in January 1961. Created between 1928 and 1930, the Krefeld Museum Haus Lange (Rhineland), which hosted his great retrospective, is one of the buildings designed by the German architect. After the war an enclosed room was added at the heart of the building without his authorization, infringing the principle of universal space. That's why Yves Klein chose that precise place to immaterialize architecture. He paints the whole room white[56] and a photograph completes the work. The shimmering light dissolves the corners and edges. Within a halo, the background blends into deep space. Yves Klein enters as if he were weightless. In this place where the virginity of the void can be sensed, painting becomes architecture, which in turn becomes "radiance."[57]

I have created every feast, every triumph, every drama. I have tried to invent new flowers, new stars, new flesh, new languages

Rimbaud

"Life's own colors darken, dance, and drift around the Vision in the making."[58] (Rimbaud)

Space, invisible, behind color. And only its deep dimension.

In Gelsenkirchen, near Düsseldorf, Yves Klein's blue for the first time adds space to space. "In the presence of a great expanse of blue . . . architecture will be enhanced by the notion of unprecedented grandeur."[59]

In September 1954, the town council had given the Werner Ruhnau studio[60] the task of designing a transparent opera house, which was to be the pride of the town, where a number of leading firms in the glass industry were based and which was still blighted by the 1943–1945 bombings. The building was inaugurated on December 15, 1959, three years after the foundation stone was laid (June 1956). From its forecourt at night Yves Klein's ultramarine worlds emerge from behind the huge glass façade. Waves of dark blue, slow and immobile in the air.

Yves Klein met Ruhnau in March 1957, at the Paris gallery of his dealer Iris Clert.[61] Klein's vision of open-space color and magical realism immediately

Top: *Monochrome bleu* [*Blue Monochrome*], Gelsenkirchen opera house, 1959
Bottom: *Monochrome bleu* [*Blue Monochrome*] and *Relief éponge bleu* [*Blue Sponge-Relief*], 1959

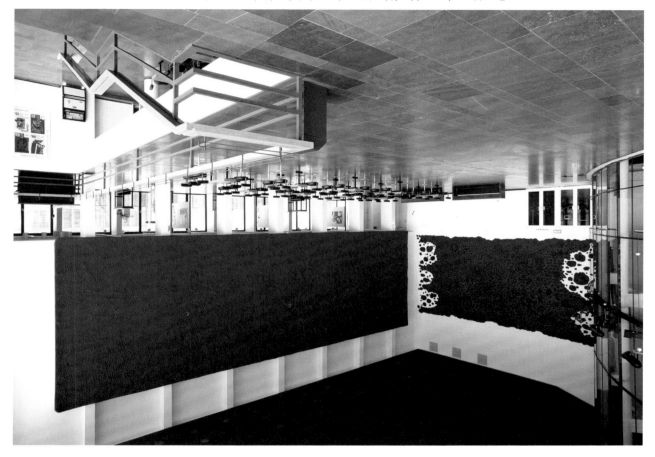

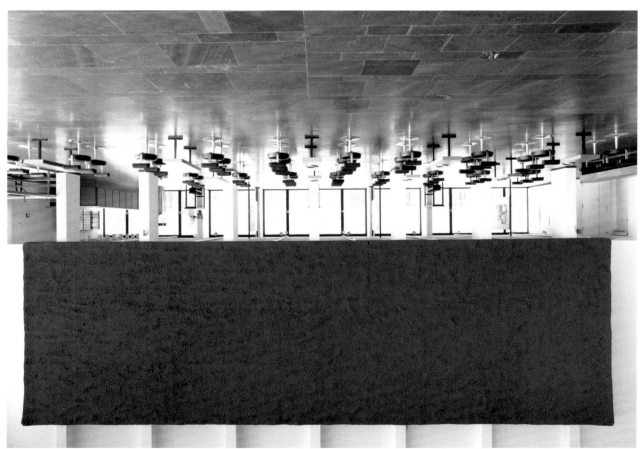

intrigued the architect, who convinced him to take part in the project.[62] On seeing the size of the foyer's side walls he was to work on in June, Yves Klein could not hold back his enthusiasm. "A high-pressure Blue! It has always been my spiritual ideal to achieve such a spatial unity, I hope I can do it at last."[63] Before designing the work, the space had to be studied. So, together with the architect Bernadette Allain, Yves Klein made a mass of sketches, created IKB-colored plaster models,[64] outlining a thick wave, softly swelling and folding in balance.

The international team he joined was reminiscent of medieval cathedral building sites. The artist was also a laborer, and each discipline played its part in fashioning the finished work. The creative atmosphere attracted many visitors, such as the two young composers Mauricio Kagel and Sylvano Bussotti, whom Klein later appointed to two of the chairs of music in his "École de la Sensibilité" (School of Sensibility). The Gelsenkirchen and Bauhaus spirit echoes throughout this 1959 project: "Immaterial architecture will be the face of this school. It will be flooded with light. Twenty teachers and three hundred pupils will work there, with neither syllabus nor board of examiners . . . In order to imbue this school with the spirit of sensibility and immaterialization, the teachers have to help build it. The entire student body represents an exercise in collaboration in the erection of this ceaselessly reborn building."[65]

Besides Yves Klein, the studio included four sculptors: Robert Adams (for a long, sharp-angled relief in white concrete on the front façade); Paul Dierkes (for the white molded rotunda of the foyer); Norbert Kricke (for a large sculpture made of metal pipes in clusters)[66]; and finally Jean Tinguely (for two kinetic reliefs for the foyer of the little theatre). By recommending him to the Gelsenkirchen committee, Yves Klein reinforced their bonds of close collaboration, as testified by their joint exhibition *Vitesse pure et stabilité monochrome* (Galerie Iris Clert, November 1958).

Yves Klein had to argue for months in favor of his pure IKB monochromy against a cautious blue and white combination.[67] In January 1959 he finally got the approval of the committee and opened the huge sponge-attaching site to construct a monumental set of four 10-metre long reliefs,[68] combined with two 7 x 20 m monochromes. The sponges had to be heated to remove any dampness, plunged into a bath of catalyzed resin, and squeezed in order for polymerization to occur.[69] The reinforced plaster framework where they were arranged in their hundreds was painted with the IKB mix (pigment-binder-alcohol-acetone), applied with a spray gun. A toxic, indeed fatal, chemical cocktail.

"Summer's ardor was confided
to silent birds and due indolence
to a priceless mourning boat
through gulfs of dead loves
and fallen perfumes."[70]

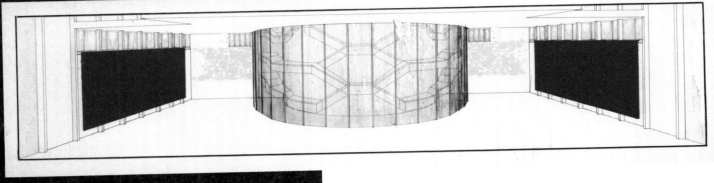

Right: Yves Klein at work in the Gelsenkirchen opera house, 1959

Bottom: perspective drawing for the Gelsenkirchen opera house, 1958

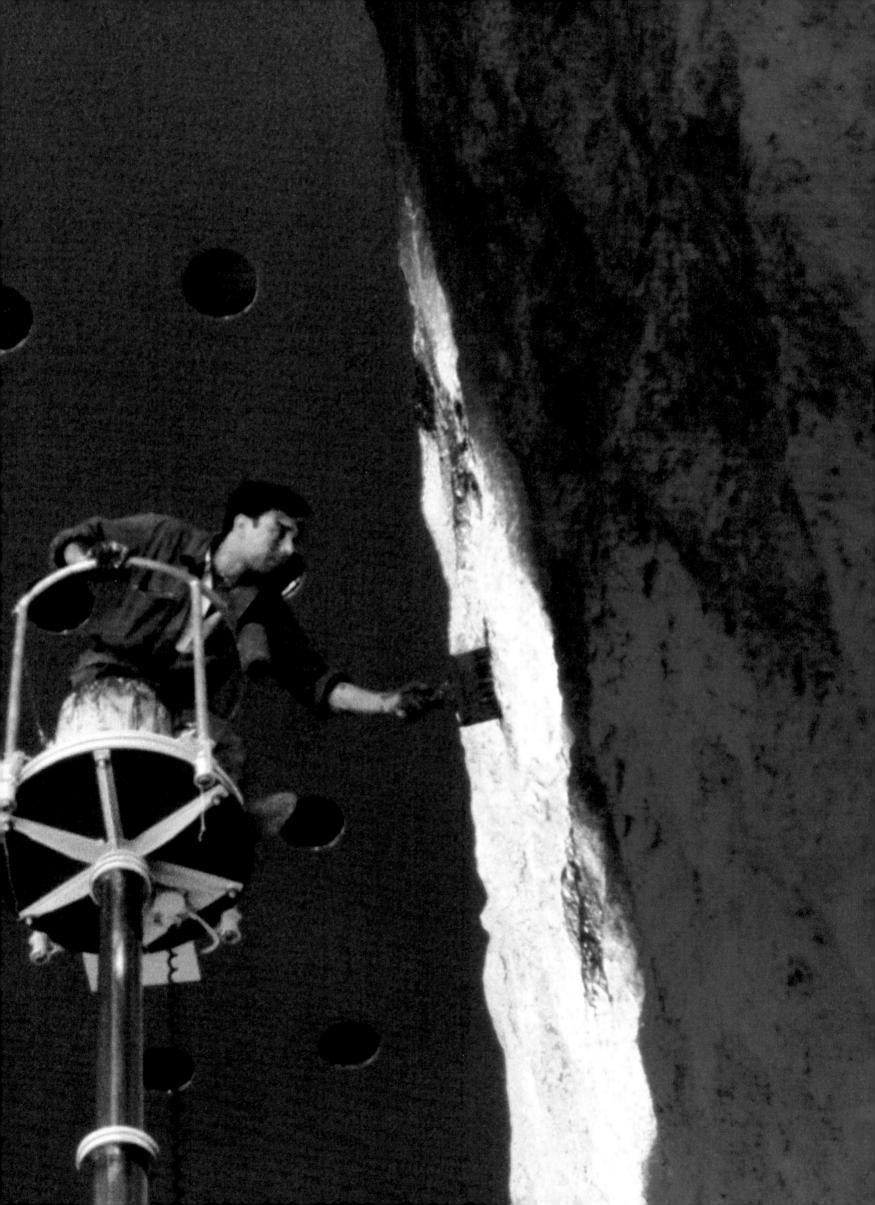

Yves Klein at work in the Gelsenkirchen opera house, 1959

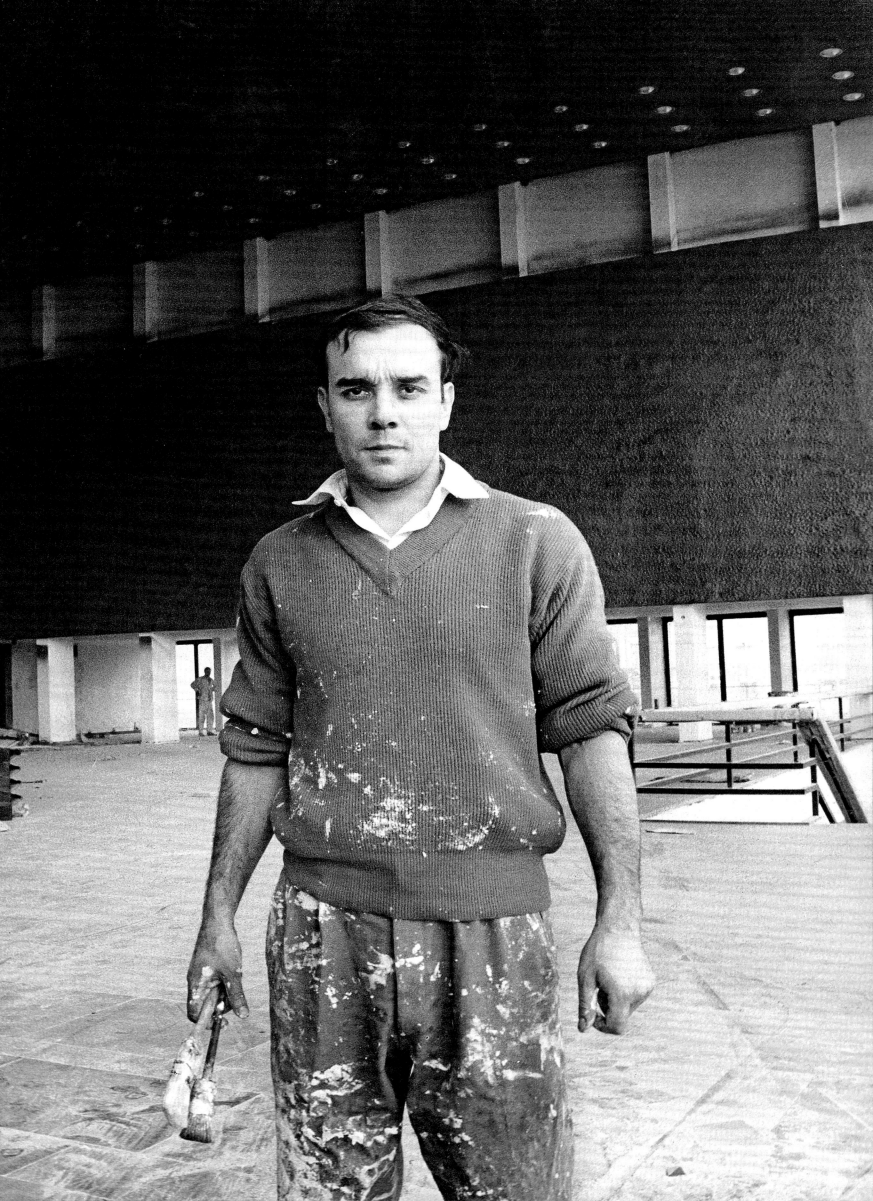

View of the Gelsenkirchen opera house, Germany, 1959

Although the IKB monochrome already opened immaterial space through its strange and indefinable blue depth in the heart of the foyer, Yves Klein wanted to go beyond. Towards an "architecture on the way to becoming a non-architecture."[71] Molding air and fire was the way to achieve it. "That's why I'm now dragging out this old project which has never been done anywhere in the world, and I'm actually astonished because fire has many architectural properties."[72] In 1959 he performed several experiments in the Küppersbusch factory regarding the plasticity of flames and air.

In Norbert Kricke, Yves Klein found a fellow believer in the power of the imagination. "We shared out the realms and kingdoms of the elements as it suited our creative will, as follows: KRICKE, *water and light*; KLEIN, *air* (plus *wind:* anger of sensibility) and *fire.*"[73] In 1956, the German sculptor had actually exhibited the new forms of a "water architecture."[74] The following year, he was conceiving[75] four columns made of transparent Plexiglas, 3 to 6 m high and 1 to 2 m wide, on the vast forecourt of Gelsenkirchen's opera house: streaming down from the top, water would form a liquid veil, creating the illusion it was standing there, upright and vibrating.[76] This division of elements between Klein and Kricke can be seen in a drawing of a fountain with columns of water, surrounded by thrusting flames.

Yves Klein also designed a large café laid out on the theatre's esplanade, under a roof made of air. Fire columns in an ornamental pond and a wall of fire[77] would spread heat throughout and come up against the streaming water of Kricke's[78] fountains. Two scale models were presented to the Gelsenkirchen[79] committee. The deafening blast of the pipes spitting fire and the extra energy expenses for the air roof meant it was turned down.[80] But Yves Klein did not admit defeat, and in December 1960 he still wanted to convince the boss at Küppersbusch to pay tribute to Gelsenkirchen—already nicknamed "the city of a thousand fires" owing to its tall furnaces glowing red—by helping him create a 30-m burning wall and a fire fountain flickering up to 4 or 5 m.[81] The first prototypes were shown to the public in the Krefeld Haus Lange museum in January 1961. For the great retrospective of his work, Klein had the site connected to the town's gas supply. A 3-m flame burned in the center of the park. "There are gardens / where burns a single jet of water" (Caubère).[82] On its sides was set a grid holding fifty burners, "throwing the eight petals of their flowers." "At night, this created the illusion of fantastic glass windows where light truly throbbed, for fire is constantly in movement."[83]

Tapping a Fountain's Flames

"Fountains of fire are part of my mythology,"[84] Yves Klein wrote one day. It was in Spain that his imagination first forged them. A blade of fire cutting with a burning flash, the flare searing through the air till it reaches the flesh, "pliable and soft / beyond colors" (Char).[85]

47

Yves Klein: *Monochrome und Feuer* exhibition. *Fontaine de feu* [*Fountain of Fire*] in the garden of the Museum Haus Lange, Krefeld, January 14, 1961

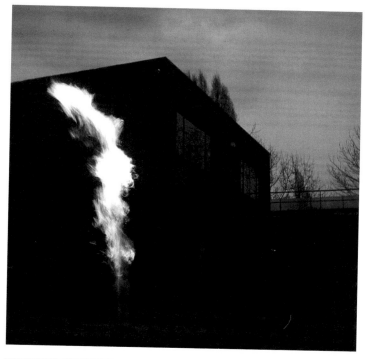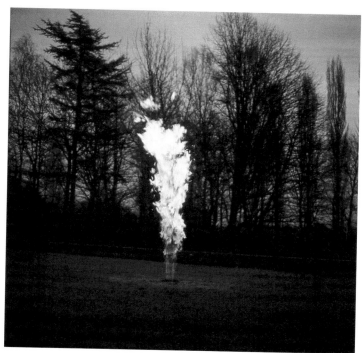
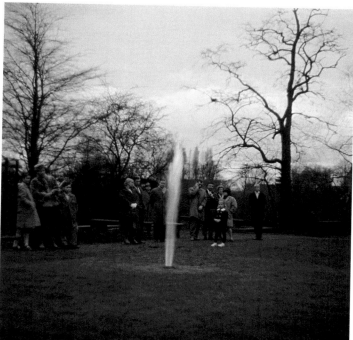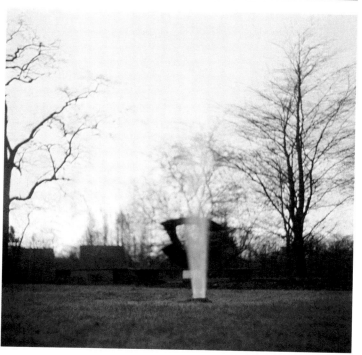

Top: *Mur de feu* [*Wall of Fire*], 1961 | Right: Yves Klein during a test for *Mur de feu* [*Wall of Fire*] in the Küppersbusch laboratories. Gelsenkirchen, 1959

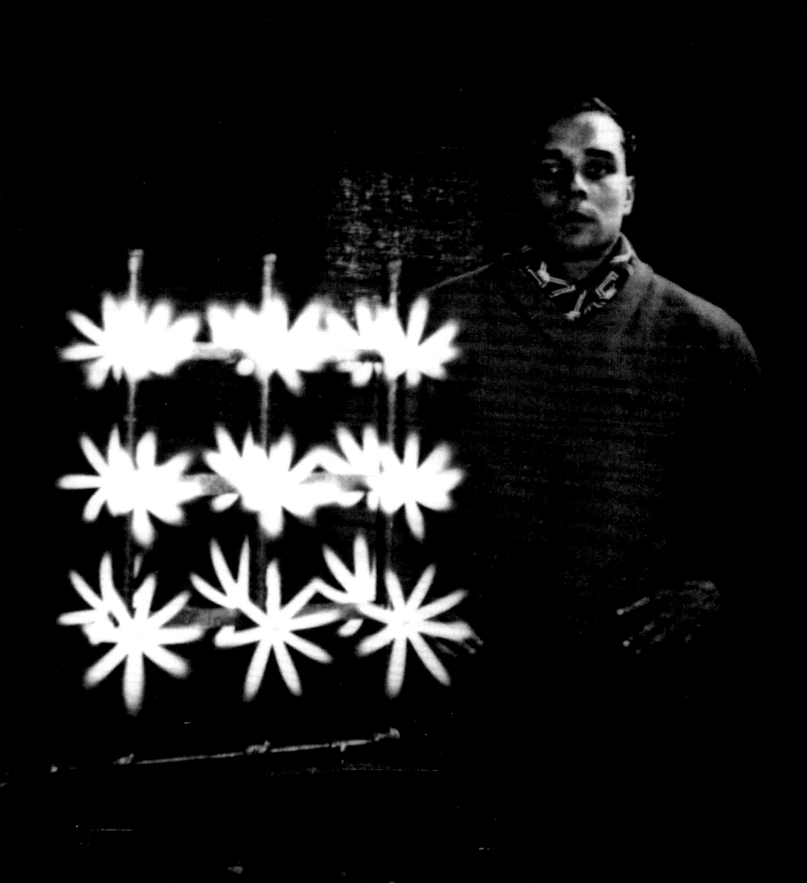

Top: *Mur d'eau traversé de flammes* [*Wall of Water Traversed by Flames*], ca 1959
Bottom: *Mur d'eau traversé de flammes sur une pièce d'eau* [*Wall of Water Traversed by Flames on a Sheet of Water*], ca 1959

The gardens of the Royal Palace of La Granja, which Yves Klein first saw in 1951, are punctuated by ornamental ponds on the Versailles model. The air is permeated by this coolness throughout. Why not imagine "shining jets of fire" which would "dance" on a grand square? *Why not ?*,[86] he thought to himself. "I can . . . heat an entire public square with forests of immense flames, swept by a wind that makes these flames wave gently, while at the same time spreading the heat everywhere, even to adjacent and neighboring streets, especially in Nordic countries."[87] Intimate buttressing of the elements. Klein dreamed of scattering his fountains in Paris, New York, Caracas, to the four corners of the earth.[88]

In the face of these alliances, where water and fire compare their forces end to end and merge with bitter rage one into the other, or agree to make an impossible peace, the mind sees far. It draws on the first principles of existence. Flames and water *will always be too huge to devote themselves to strength and beauty.*[89] These fountains from another age are *mythical elements* beyond themselves. Recalling the archaic order of the elements, they show man what he cannot manage—or no longer manages—to grasp in his own history and which is primeval. Through them can be perceived the latent eternity of beginnings in a historical and social time-scale. "Fire, for me, is the future without forgetting the past. It is the memory of nature."[90]

Their lesson, their enchantment? Creation springs from antagonistic forces which coalesce and never cancel each other out. "From difference is born the fairest harmony; all arises out of discord" (Heraclitus).[91] Paradox is but a momentary helplessness of the mind.

The architecture of air, fire, and water places men in a new climate of vitality fashioned by Yves Klein.[92] Each fountain makes a unique impression on the soul and psyche.

Yves Klein creates image poems and subliminal wisdom. For instance, what lies in these "fire effects on a spatial, aquatic mirror stand, which thus forms an insurmountable and invisible barrier"[93]? Could this water, without a ripple while the flame on top is burning, be the image of impassiveness? Could it be the image of a dormant power suddenly turning to action? A dark realm from which a being suddenly springs? "Every flame is engendered by water" (Novalis).[94]

Or is beauty a proud secret laid over the world like fire perched on water? It is up to each of us to let this image act on his mind; a recollection, a sensation, or a thought will make it grow.

In collaboration with the architect Claude Parent,[95] Yves Klein created fountains which stimulate the imagination and the soul.

Water falls like a curtain into a pond, and as it plunges it is pierced on both sides by fine, long flames. They whisk the air in front of them for two or three meters and stretch out without catching anything. An image capturing effort? The same effect is performed symmetrically directly opposite: the flames end

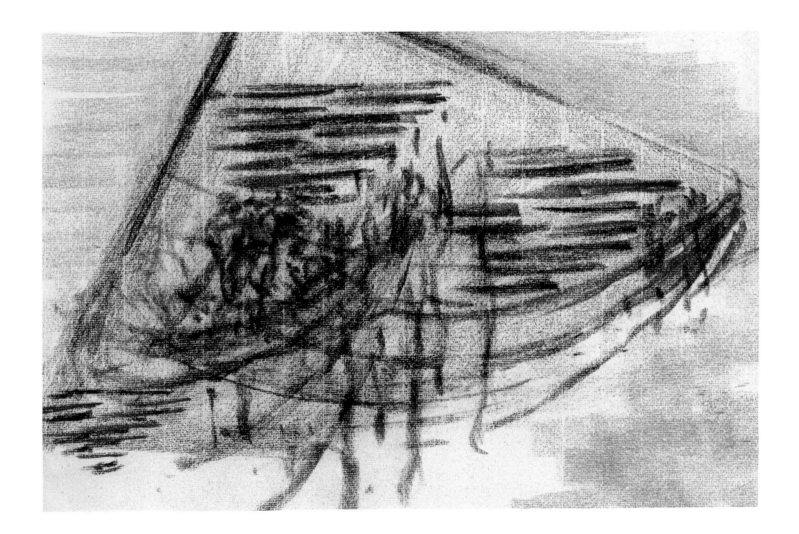

Murs d'eau et de feu (Fontaine d'eau et de feu (Walls of Water and Fire (Fountain of Water and Fire)], ca 1960

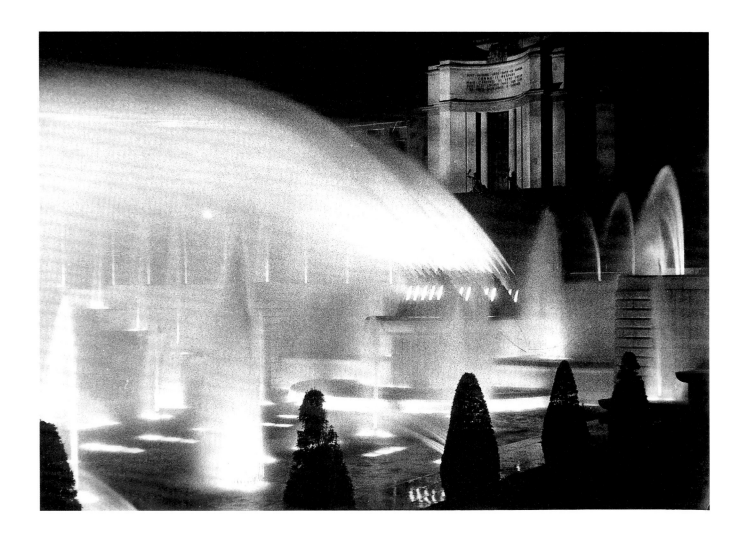

Fontaines de Varsovie [*Warsaw Fountains*], Palais de Chaillot. Paris, France

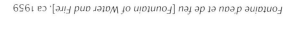

Fontaine d'eau et de feu [Fountain of Water and Fire], ca 1959

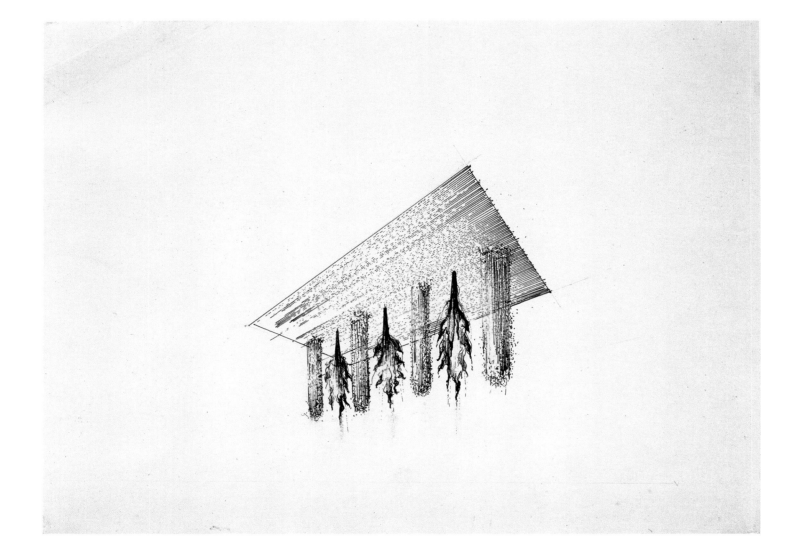

L'EAU ET FEU ④

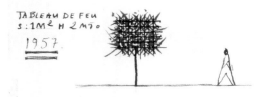

TABLEAU DE FEU
S : 1 M² H 2 M70
1957.

TABLEAU ET MUR DE FEU :

TABLEAU : 1 M² MATÉRIEL·INSTAL⁼ 750 $

CONS⁼⁼⁼ PAR HEURE : 18 M³ GAZ.

HONORAIRES : PAR M² -- 600 $

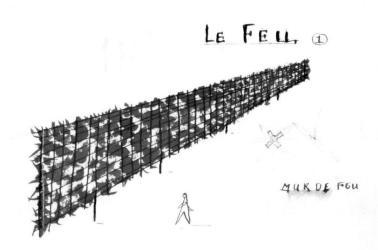

LE FEU. ①

MUR DE FEU

Top: *L'Eau et le Feu...* [*Water and Fire . . .*], ca 1959 | Bottom: *Le Feu* [*Fire*], ca 1959

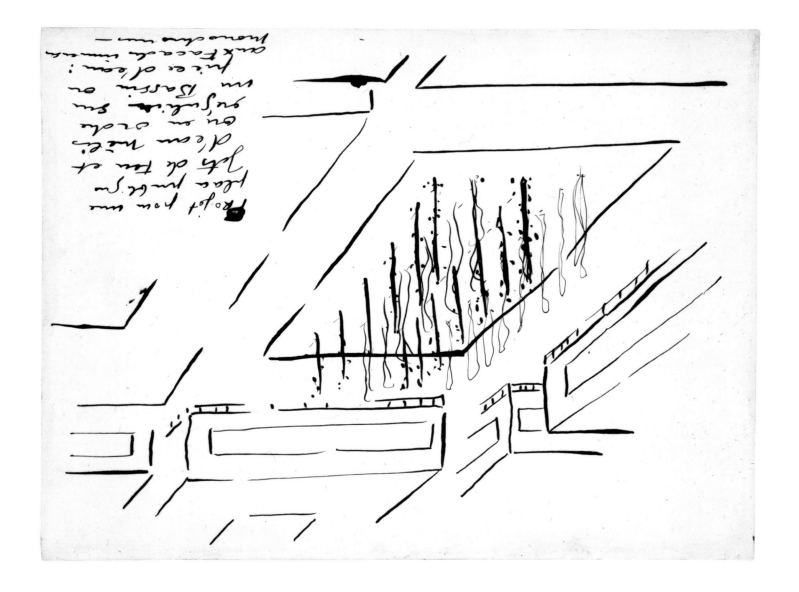

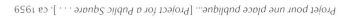

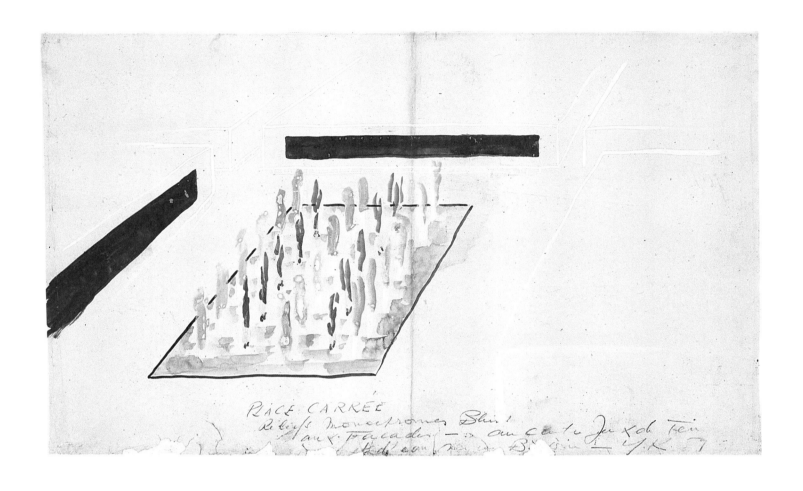

Place carrée, Reliefs monochromes bleus [Square, Blue Monochrome Reliefs], 1959

FONTAINES DE VARSOVIE
AUGMENTEES D'UNE
PROPOSITION DE FONTAINES DE FEU
D'YVES KLEIN
S'OPPOSANT AUX FONTAINES
EXISTANTES

nuages de vapeurs d'eau
resultants du choc feu
et eau eclairés a 20 metres
au dessus du bassin par
des projecteurs bleus
echelle
yves KLEIN avec la
collaboration de cl.parent
14 rue campagne premiere
PARIS 1961

PLAN

A B

COUPE
AB

ELEVATION

Top: drawing for the *Fontaines de Varsovie* [*Warsaw Fountains*], 1961 | Bottom: project for the *Fontaines de Varsovie* [*Warsaw Fountains*], 1961

in a vertical sheet of water. There is also this fountain with rows of flames and tapered jets of water, from the highest and strongest in the background of the pond, to the smallest at the front.

In striking the tips of the huge flames, the water is vaporized and turns into a fine mist in the air. Three jets collide in a great crash where the flashing flames compete with sparkling water around a dazzling core. The image of splintering discord, or of fusion? "Annihilating the principle of contradiction is perhaps the prime task of higher logic" (Novalis).[96]

Flame and water meet as they reach their apex and intensify them: *radiance*. Brilliance and translucency. One flashes as high as it can, while the other rises to its utmost. The essence of fire is the fierce desire to strain upwards, to the last ounce of strength; that of water to gush up and drop back when it is spent. Yves Klein invents effects by swapping these natures. So flames become liquid and water burns. "[The soul] takes great pleasure in seeing its fire's impetuousness soothed by this water which fuels it all the more" (Teresa of Ávila).[97] Yves Klein provides a stunning example of this false paradox in his design for the *Fontaines de Varsovie* (1961), on the esplanade at the foot of the Palais de Chaillot in Paris.

Extraordinary jets of water gush out of cannons and crash against the base of four gigantic flames dozens of meters away, whose one aim is to quench them. But the ultra-powerful fire is equal in force to the smothering water. It turns the equation upside down and the water actually serves to strengthen it. A loud crackling sound issues from the clouds of steam and spattering spray. Water is at work in its forge. Is this a paradox coming true? No, quite the opposite: it's the pulverization of its alleged impossibility.

Two diagonals made up of six huge flames complete the setting. They meet at their tips and become a single vertical fire. Their size increases or diminishes according to how they are seen. Or else the single flame splits into two angles towards one another, followed by a row of more powerful ones; and so on up to the four monumental flames, enraged by the water falling at their feet. Or again, these four flames shrink in stages, turning into sets of two, each smaller than the previous one, until the last is a single flame standing alone. "What burns well burns high. The destiny of both consciousness and flames is verticality."[98]

Fontaines de Varsovie grips the imagination. The "fountains" provide images of forces grappling with each other and of governed chaos. The blue flames rise, turn pink, and narrow to a golden plume: the trilogy emblematic of Yves Klein's work, where the immaterial is the point of synthesis, just as fire dissolves into the air at its tip. The spectacle generates a mythology of life, whose two poles are solitary stillness and power ruling over the surrounding din. Existence oscillates between these two points.

"L'acclimatisation de l'atmosphère à la surface de notre globe"

... la conclusion technique et scientifique de notre civilisation

est enfouie dans les
entrailles de la terre et assure
le confort par le contrôle absolu du
Climat à la surface de tous
les continents, devenus vastes
salles de séjour communes.

:..... C'est une sorte de retour à l'eden
de la légende. (1951.)

.. Avènement d'une société nouvelle, destinée à
subir des métamorphoses profondes dans sa
condition même. Disparition de l'intimité
personnelle et familiale. Développement
d'une ontologie impersonnelle.
 La volonté de l'Homme peut enfin
 régler la vie au niveau d'un
 "merveilleux" constant.

L'Homme libre,
l'est à tel point, qu'il
peut même léviter !
Occupation : Les loisirs.
.. Les obstacles autrefois subis dans
l'architecture traditionnelle sont
éliminés.

Soins du corps par des méthodes
nouvelles, telles le lit d'air.

Architecture de l'air [*Air Architecture*] (ANT 102), 1961

I know it's You, who, in this place,
Blend your almost Saharan blue!
Rimbaud

A Quiver of Calm

The architecture of the elements (air, water, and fire) triggers stimulating sensations in man. On October 2, 1959 Yves Klein submitted a particularly striking design for a work to the secretary of the XII Milan Triennale: "Jets of colored water will fall vertically onto a horizontal layer of air and be thrust violently outwards at right angles, which will be quite an amazing sight—waterspouts stopped in mid-flight just above visitors' heads as they climb the entrance staircase."[99] What is the purpose of this colored cascade crashing against an invisible barrier? The delicious lightheadedness of being always slightly off-balance. "Didn't you know joy is actually fright from one end to the other, and that is precisely what joy is. A fright whose origin is all we do not know. A fright we trust" (Rilke).

At Yves Klein's request, the designer Roger Tallon built a model of a similar device for the *Antagonismes 2* exhibition, held at the Musée des Arts Décoratifs in March 1962. The diorama featured a number of small naked figures. They are shown walking through a simulated shower. As the drops of water fall, so they are blown sideways by a powerful jet of air, turning them to mist.

"I know it's You, who, in this place,
Blend your almost Saharan blue!" (Rimbaud)[100]

Air architecture is not just a question of a structure being totally wide open under a great canopy of blown air. It also aims to "reclimatize" certain parts of the world and create new ecosystems. In this regard Klein would like his immaterial city *preferably* to be set in the red desert of the Sahara.[101] Air roof technology should one day enable not only single houses, stadiums, or cities to be covered, but also entire regions and even continents, becoming "communal living rooms."[102] Protection from the assaults of the climate will ensure man governs a *well-tempered environment.*[103]

The nakedness of the immaterial city's inhabitants, which can be seen in Yves Klein's and Claude Parent's drawings, means there are no longer any demands made on the body's heat regulation mechanisms. The body blossoms, without expenditure, in the *hot breeze of the day*[104] which prolongs its temperature. The ideal disintegration of the shell. A thermal continuum between body and space. What's so astonishing about Yves the monochrome translating into

Projet d'une ville... [Project for a City . . .], ca 1960

color a man who has turned into pure radiation and pure space? "For me, colors are living beings, highly evolved individuals who blend with us as they do with everything. Colors are the true inhabitants of space."[105] To be as one with space: that's one of the meanings of this Eden-like nakedness, already present in the bare color of monochrome.

Before the resplendent expanse where we feel
The mightily flourishing city blow
Rimbaud

Air architecture calls upon all the resources of color. It is endowed with filtering powers and for instance can take the form of a cloud sprayed over the air roof in order to dim the brightness of the sun.[106] Part of Yves Klein's concept is the idea of heat being pushed back by a powerful colored draught, which would be blown "through the valley, above masses of cool air."[107] Monochromy comes before air architecture. Climate control through colored clouds or winds is an oneiric image. "The highly material sensibility of color has to be reduced to a more pneumatic immaterial sensibility."[108] Color plays its part in the immaterial.[109]

"True science is pure art."[110] And indeed, the poetic instinct probably does compete with scientific intuition. An example? "I blow gales of cooled air that strike the water from all sides and in one direction at a given moment, constantly shaping it as if it were living, glittering matter and producing a proper cooling effect in the area involved."[111] Trusting in the poetry of forces and elements, without knowing it, Yves Klein reinvents the *badgir* "windcatcher" principle first introduced in Ancient Persia. Hot air is captured at the top and funneled down to the room below, where water from a pool cools it by evaporation and disperses it.

"Before the resplendent expanse where we feel
The mightily flourishing city blow." (Rimbaud)[112]

Life is transparent and public in the immaterial city. "A new atmosphere of human intimacy prevails . . . The primitive patriarchal family structure no longer exists. The community is perfect, free, individualistic, impersonal."[113]

Man eludes the humdrum existence lying in wait for him in a wilting life through leisure and artistic creativeness. Play is a condition for him and his whole condition.[114] The city is "hyper-architecture of desire,"[115] providing a life matrix for multiple *situations*.

65

Untitled anthropometry (ANT 4), ca 1961

All harmonic and architectural possibilities will swirl about your seat. Perfect, unexpected beings will present themselves to be explored by you. Around you will flow the dreamy curiosity of ancient crowds and slothful luxury. Your memory and your senses will be no more than food for your creative impulse

Rimbaud

Yves Klein believes in life as *lived poetry*. In this rapture, which is not the bliss of Heaven, as its realm is the here and now, man keeps relentlessly inventing radiant possibilities. Far more than a normal inhabitant, he creates his city and nurtures the empathy he feels with what both instructs and mirrors him. He is a nomad within it and his mobility shifts the space opening before him commensurate with his steps. Continuous *sphere of influence*. The huge city's air roof builds and evolves according to need: "The air roof has its machinery, and grows or comes to a halt, throughout its extent, all along its working parts," explains Claude Parent. ". . . In a way, it's as if you were living next to a river, you live along a route that blows out air in order to create air roofs as required, just when you need one."[116]

The immaterial city achieves the "Blue Revolution."[117] Poetry is a policy option.

> "All harmonic and architectural possibilities will swirl about your seat. Perfect, unexpected beings will present themselves to be explored by you. Around you will flow the dreamy curiosity of ancient crowds and slothful luxury. Your memory and your senses will be no more than food for your creative impulse."[118]

Technology would be no more than a tour de force[119] if it didn't find its raison d'être in a revolution of minds. Living in an immaterial city means being *actively involved* in it. You change it and let yourself be changed by it in an unceasing loop, in the same way as Yves Klein also thinks in terms of *living* his monochrome: "For me it's no longer a matter of dashing off a painting but rather of creating . . . a NEO-FIGURATIVE canvas which is both the most real and at the same time the most immaterial work of all, thus, through pure conduct, providing a spectacle for the readers, or better "LIVERS," of such pictorial events or climates."[120] These *pictorial climates* are *situations* designed to prompt a revolution in life. Impregnation is *rudderless*

Untitled anthropometry (ANT 127), 1960

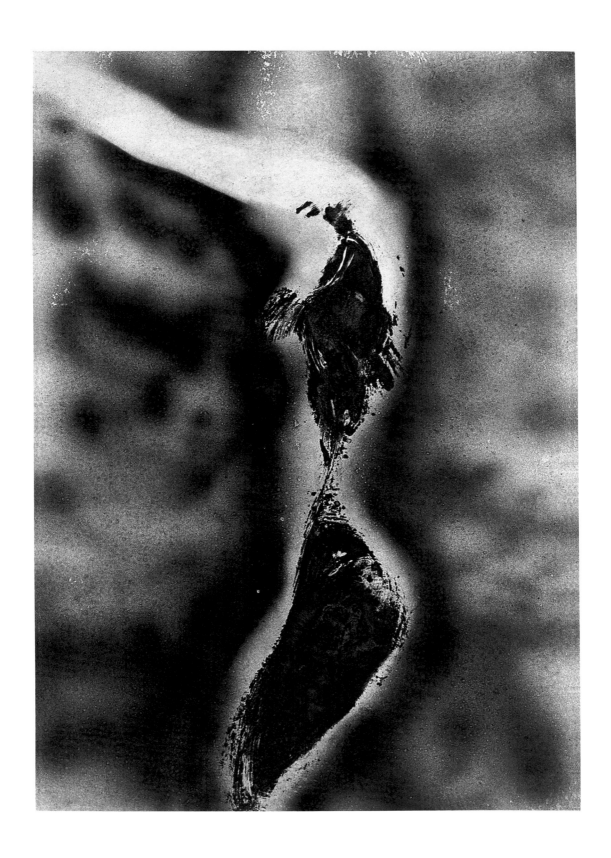

Hiroshima (ANT 72), 1960

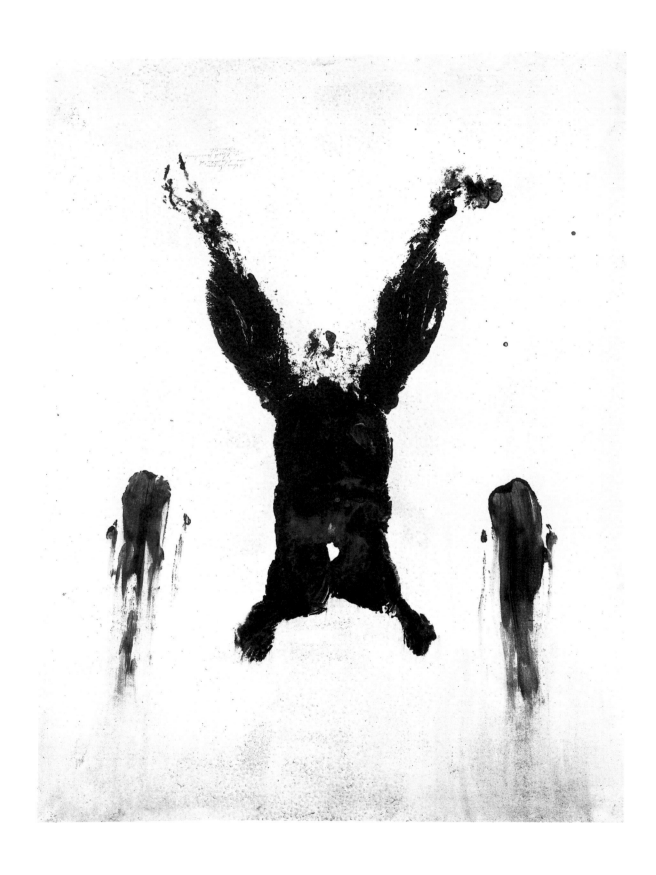

art, described by Guy Debord in 1956 as a form of drifting where one is primed for encounters.[121]

"The Eden of Legend"[122]

The immaterial city casts us in its image. We go through it in our minds until we finally become familiar with the place. Its poetry is the sort that can never be exhausted. As Yves Klein wrote: "For over ten years I have dreamed in the most wakeful manner possible of a kind of return to Eden! I've rebuilt a spiritualized image of this Garden of Eden ceaselessly in an infinite and probably unknowable number of dimensions. It wasn't just a vision of the imagination, not at all. I have lived in a state of constant fusion with this Eden; I have strolled about in it and existed in it just as truly as I move about and exist in our world of the five senses, physical, tangible, and problematic as it is!"[123]

For Yves Klein, the virtual world already has the qualities of the real world it will soon become. As Bachelard wrote: "A conviction stemming from the astonishingly homogenous subconscious life of dreams seeks confirmation in the full light of day. For some, souls drunk with dream fantasies, days are made to explain nights."[124]

Air architecture achieves its aim when it goes beyond itself[125]: pure space, pared down to its core. Another paradox . . . wrong. The city's immateriality plus life's translucency is the new equation. "The idea of secrecy, ever current in our world, has vanished in this city, bathed as it is in light and completely open to the outside."[126]

The city is a return to the "Eden of legend,"[127] before sin and the primitive hut in which Adam and Eve sheltered from the inclement weather.[128] Ambivalence of divine punishment: the cause of catastrophes and source of architecture as a sublimation of the first shelter.[129] The return to Eden—"the biblical myth, more than a myth"[130]—is a deed showing mankind returning to its bosom.

"The first displacement," writes Benoit Goetz, "is the expulsion from Paradise. Not only as it occurs in Genesis, where the first humans are ejected from a unique and perfect Place, but because they have entered a space ruled by the binary opposition inside/outside . . . In Paradise there is no need to move from one place to the other, in the sense that you always move around in a unique, unsegregated place. It's a place with no otherness and no negativity, an environment with no border and no limits."[131]

The expulsion from Paradise marked an existential *displacement* and a dispersion into multiple spaces. In Christian mythology, the human condition arises from a double loss: a loss of unity of place and a loss of unity of being. Klein wants to break out of this destiny. So, for his *Void* exhibition (April 28–May 12, 1958)[132], he transforms Iris Clert's gallery into a *creation* studio. He sets up the "void" so that the visitor suddenly finds himself in pure space

Senseless and infinite rush
towards invisible splendors
Rimbaud

in this white hall, as occurs through the IKB monochrome. And indeed the displacement vanishes in an instant.

Yves Klein is a man with one central idea. There is no other world rivaling our own, but it has a latent depth which is its true dimension and its whole space. Nostalgia for a lost unity is warded off by art, whose mission is to restore Eden.

Harmony lies in plain monochrome. For Yves Klein the line which might segment monochrome, streaking it and dividing up its space, is a metaphor for the anguish that assails a man driven out of the garden of delights: "Pure color, the universal soul in which the soul of man bathed at the time of the earthly paradise, is imprisoned, compartmentalized, hacked about and reduced to slavery."[133] "In the Garden of Eden the snake, evil, was the embodiment of line, drawing, outline, form . . . "[134] In his fall from grace man lost his "interior color vision."[135] A powerlessness to recover "impregnation" in Being. A powerlessness that wears man down and exhausts him. Psychology is this superabundance of self before the world, which on the contrary requires man to be unburdened.[136] Art itself lost its way on the paths of realism and abstraction.[137] Returning to Eden means recovering man's place in the world: "In the Eden of the Bible man certainly found himself in a static trance, as if in a dream. In his oneness with total space, in his participation in the life of the universe, the man of the future . . . will live in a state of absolute harmony with invisible nature."[138]

The course of human history takes the form of a spiral through the reinstatement of Eden: in the second loop, future time is superimposed over the initial point of the expulsion from Paradise. Yves Klein's marvelous realism represents space and time regained. Mankind is being given a second chance and has to take care not to repeat the mistake which led to the fall . . . "It will no longer be possible to keep anything hidden in this kind of air architecture . . . We shall therefore be in Eden, in the state Adam and Eve were in the beginning, and this time we shall have to be careful not to eat the fruit of the tree of knowledge but of life."[139] Man will reach this bliss by becoming sensitive to the point of being invisible.[140]

Yves Klein fancies he can discern a "real chance of achieving *total freedom*."[141] And art is its instrument and its end: "For me the artists who truly deserve to be called such are those who through some mysterious power still have access to Eden and go there on the sly to eat the fruit of the tree of life."[142]

Illuminations

Immaterial! Man introduced to life's inexhaustible resources. "Senseless and infinite rush towards invisible splendors."[143] *Anima!* In the immaterial city's

Untitled fire painting (F 80), ca 1961

clear expanse, in the pure open space emanating from blue monochrome, or in the virtual harmonics of a symphony uncoupled in the silence,[144] *something happens.*[145] Art is pared to its essential core. Reaching this point it acts on man, creating shapes, images, and sounds. *Enhanced reality* is the world enhanced within us through its reverberation. A new *dimension.* Art *changes life*[146] by making its depth manifest. Eden is here, in a state of emergence. "Through absolute art, that is to say through the living illumination which I become by . . . immersing myself in the limitless eternal sensibility of space, I return to Eden . . . Of course, along my way I shall reach my subject, which is space, pure spirit, although it actually shares the same nature as the countryside or the wonderful seaside which our true painters of the past loved so much."[147]

"Who will restore this immensity, this density, around us, truly made for us as it is, and which (not divinely) flows over us from all sides?"[148] asks René Char. The poet, answers Yves Klein. Art takes man back to his origin, where everything can start over again at last. "This is the painter's act—this gravitation towards his sources, diverting images from their purpose as and when they appear. They draw closer, as if caught in the draught of the movement carrying them away. And in the simplification they undergo, which is the richness of the utopia of the return to origins and borne thus to the furthermost point, they are taken in hand by a force, the innermost force, the force of cohesion."[149] Displacement has been vanquished.

"Adopted by the open, pared down to invisibility, we were a victory which would know no ending" (Char).[150]

78

Untitled colored fire painting (FC 1), 1962

Following page: creating an anthropometric sequence: Elena Palumbo and Yves Klein, 1960

Right: portrait of Yves Klein

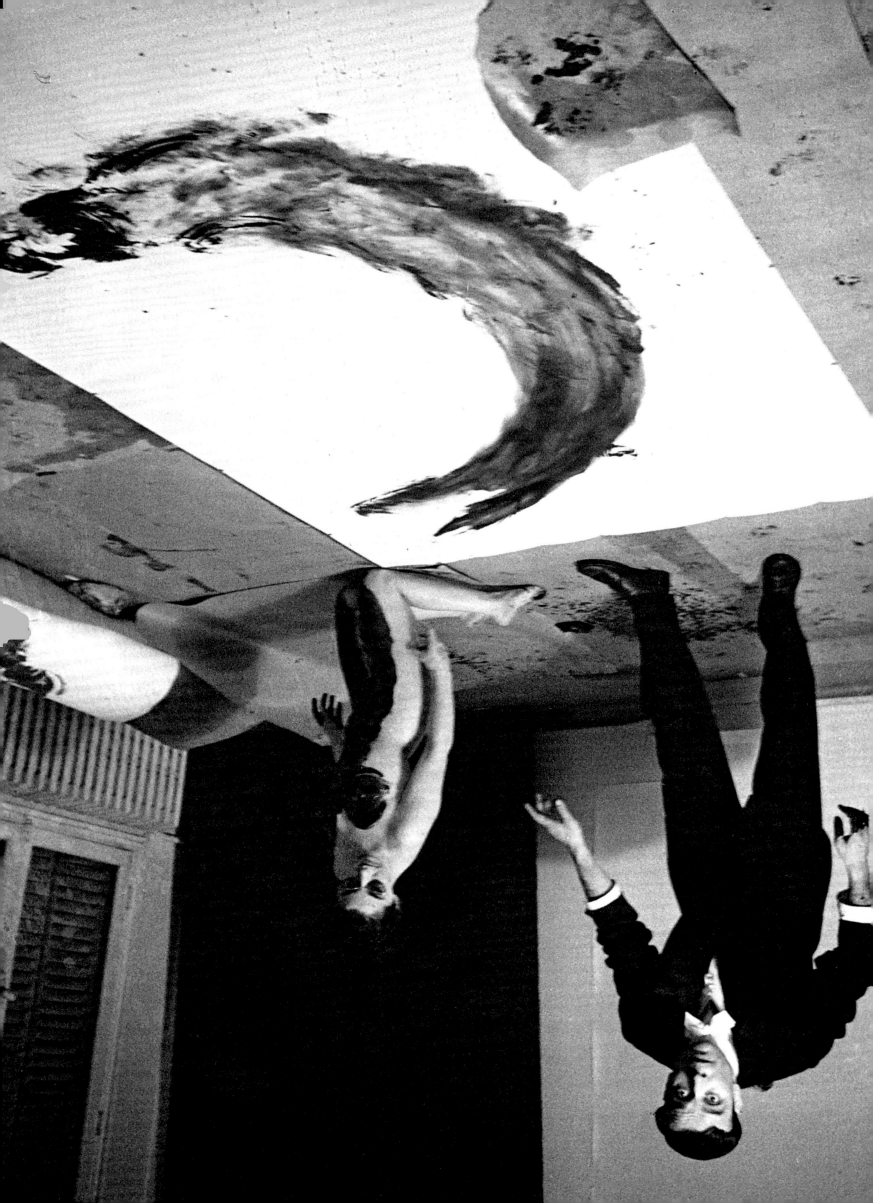

THE FLESH OF THE WORLD

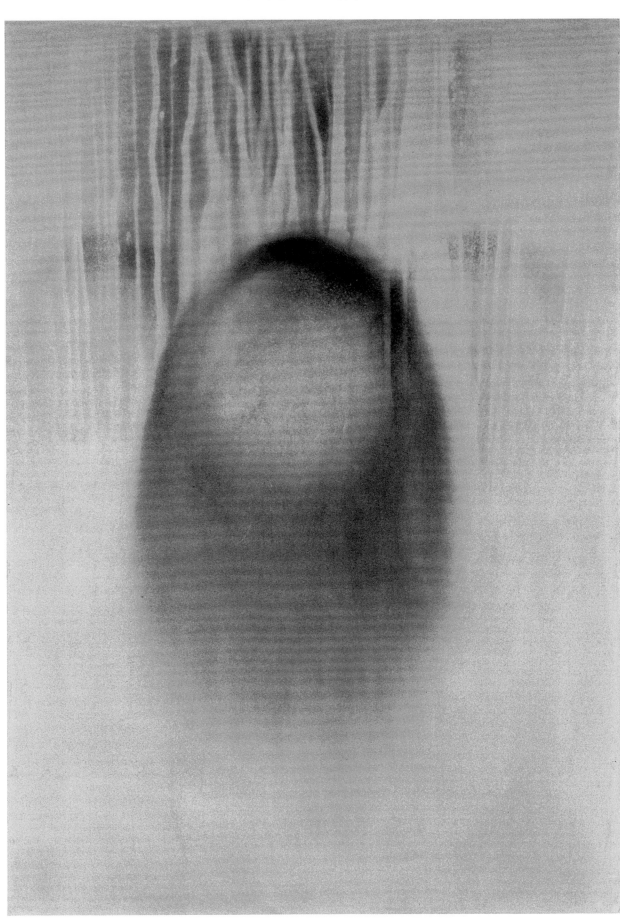

Untitled fire painting (F 2), 1962

**. . . nourished by a soul, a bright intelligence,
whose flame glows in each member of the frame
and stirs the mighty whole**[151]
Virgil

March 1961. Centre d'Essai de Gaz de France, Saint-Denis.

Cupped in the hands, the *torchère* blows a white, liquid fire. The frantic, eager flames flow into the air. They jump, tear apart, overflow in a spray of light. And there they are, point-blank, melting on the cardboard. All along, the fire catches and spreads. It hunts in the void, parched. It seizes the air and surfaces. When it is done, there it is in front of one.

The flame has gouged deep under the skin. An amber-colored zone is embedded. And in this immobility, float halo-like objects. Something, with no ending and no beginning, as if it had crossed the invisible. Within, the atmosphere is thick. A sense of a golden limbo, suspended in a powder air. Space bathes, bottomless. Vague, unstable shapes can be made out in the distance. They might be plume of smoke, coils, black clouds and not coals, columns of sand, sprinkled light, outpourings of lava, moving with a slowness almost without motion. But no, all this is off the mark. A vague resemblance, at the most. The images the fire has imprinted surpass the world. They lie before it, through the cardboard.

Because the flames have breathed flesh into the invisible. And the imagination takes wing in the embrasure. It sinks in, up to the neck, in this insentient limbo.

The Image of Matter

Oneiric reality. Of course, but what else? A parallel world one might visit in dreams? No. Some phantasmagoria, maybe? A weird replica of the world? No. So, what exactly? What the world keeps hidden in its innermost recesses and which supports life. The great dimension, that's what it is. The depth of the world, inseparably connected to it and absolutely invisible. Nature likes to hide.

Exploring oneiric reality, and in a word imagining it, is not escapism; it's sensing the power of Being beyond all images designed to fix it. Fire is a flame of matter, but more than that: a symbol of that imagination. Behind these halos, it conjures up fleeting visions that lead far. Fire paintings are a *glimpse* of the world of dreams. A *fundamental* image. What our senses perceive is nothing compared to what we imagine.[152]

Yves Klein translated his by means of air and fire. Ungraspable and searing. Translucent and radiant. Such character, such life, such work. "For me, painting is not associated with the eye; it is associated with the one thing of ours that does not belong to us: our LIFE." [153]

85

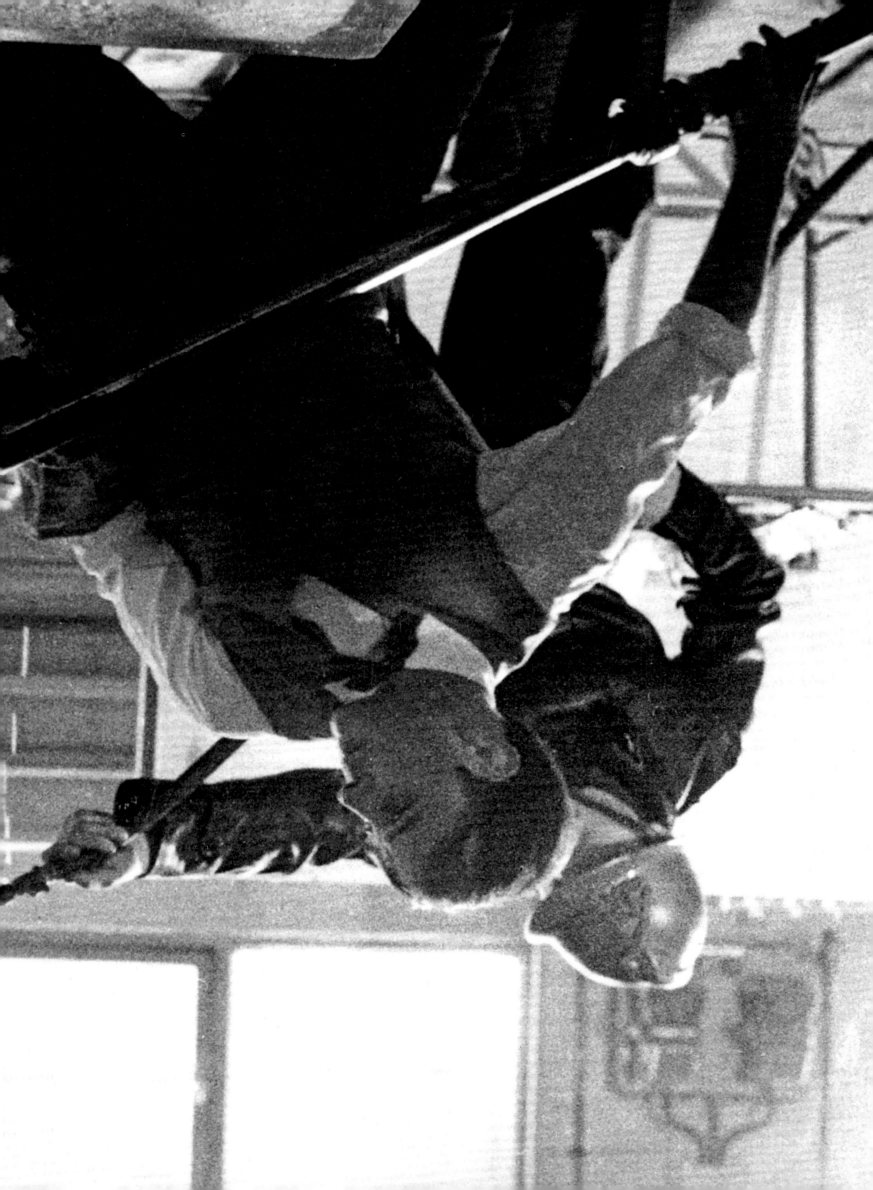

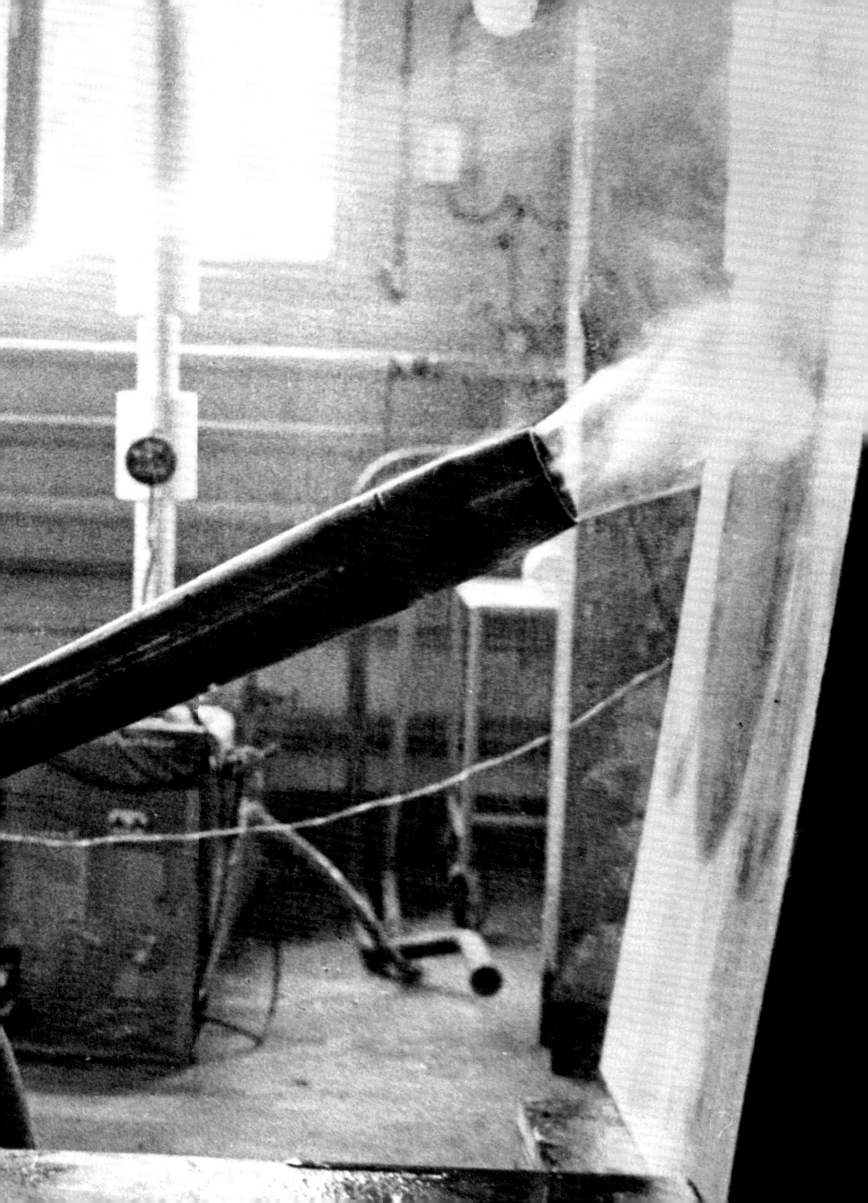

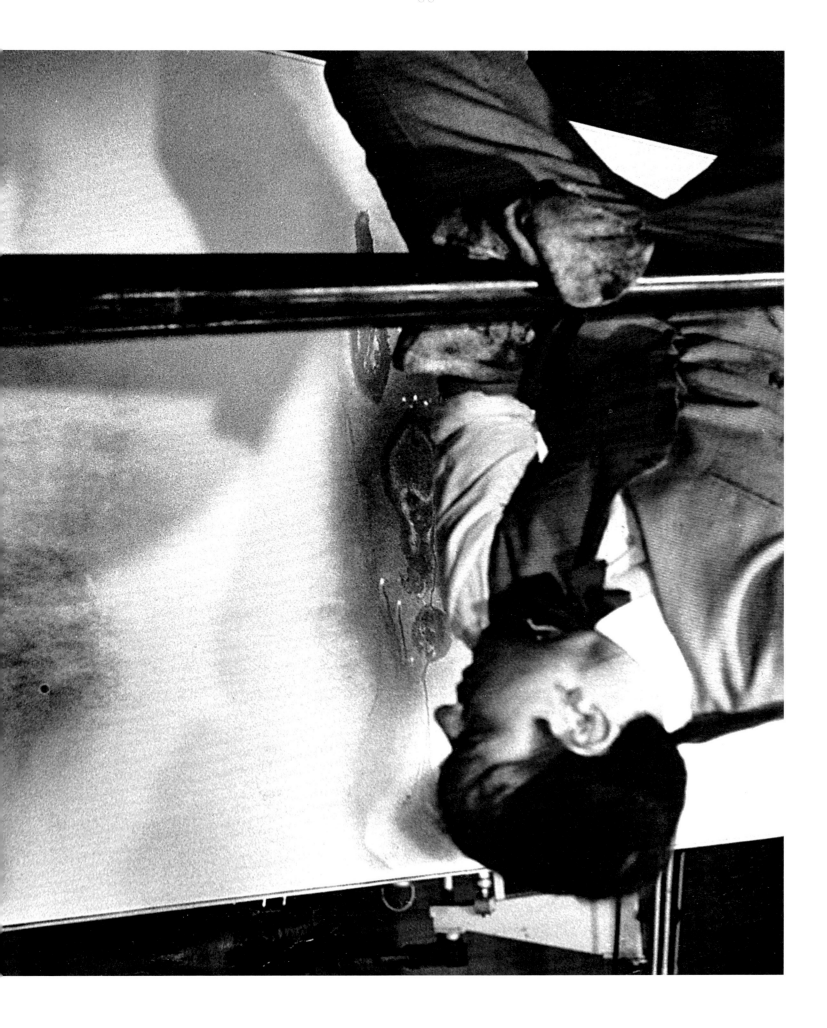

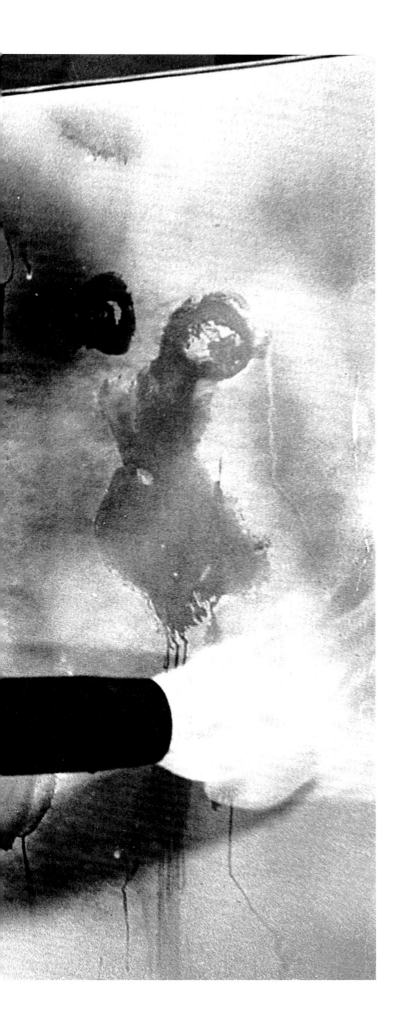

Previous page: Yves Klein creating a fire painting (F 2), 1962

Left: Yves Klein creating a fire painting (F 88), 1962

Yves Klein creating a fire painting (FC 30), 1962

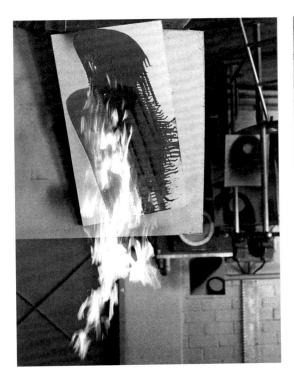
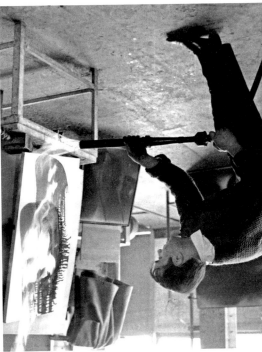

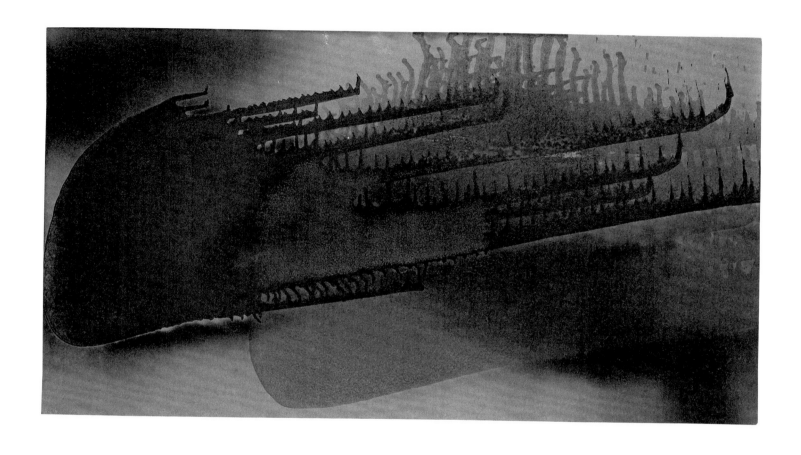

Feu de l'enfer [*The Fire of Hell*] (FC 30), 1962

Those dear ancestors
around their fires

Rimbaud

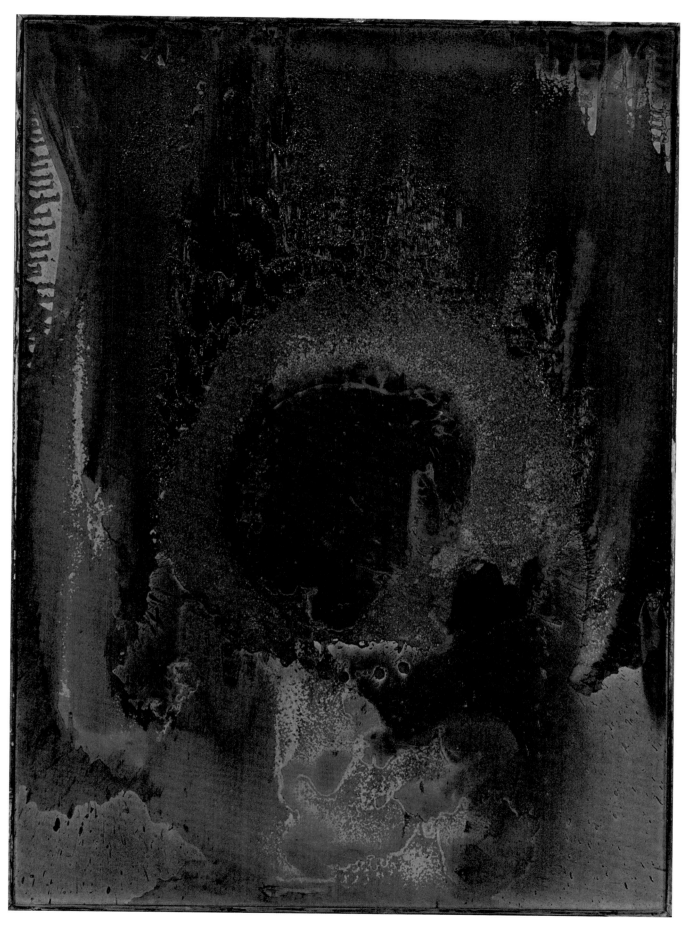

Untitled colored fire painting (FC 19), 1962

Untitled fire painting (F 27 I), ca 1961

Enough. Shut up! These are errors whispered in my ear, magic spells, alchemy, mystic notions, feigned perfumes, callow music

Rimbaud

"What causes me to search for the marks of fire?" wonders Yves Klein. "Why should I search for the Trail itself?"[154] Because of an overwhelming sensation that he is capable of capturing the *naked* image of matter. Not its representation, but its very presence scorched on film. The cardboard seared by the flames captures the movement *instantaneously* as well as some of the fire's grace and matter. A *supernatural image*. "A painting is merely a witness, the sensitive plate that saw what happened."[155] The F 27 I board thus holds a volcanic fire within it. Treacly lava flows, do we see right? Any *resemblance* to the visible world is entirely fortuitous and should not be sought. The eruption seen in this work comes from the depths of the dreamworld. Intact. Yves Klein makes matter dream so that it may lead him to the immaterial and the invisible, just as air architecture exceeds itself in pure space.

"Enough. Shut up! These are errors whispered in my ear, magic spells, alchemy, mystic notions, feigned perfumes, callow music." (Rimbaud)[156]

Yves Klein often compares his work to the patient efforts of the alchemist, all absorbed on his Great Work and the transmutation of matter. This quest definitely exists in his desire to master air, water, and fire, and to unveil their nature, although in this case freed from all its obscure esotericism. He cannot stand the *black mud of occultism*.[157] "Art is not magic or occultism, as some seem to believe. From the standpoint of art, magic, like occultism, is an unwarranted, unhealthy, tasteless, and unwelcome deviation."[158] Yves Klein's unclouded and healthy alchemy lies where poetry and the arts meet. It's a "transmutation of painting (pigment, color) on a living surface, a sort of skin, a presence."[159] Breast flesh draped in aurora. Cracked flesh with golden skin. Charred flesh, throbbing deep within.

"Live coals raining down in frosty gusts – Delight! – fires in the diamond-wind rain flung down by the terrestrial heart eternally charred for us. Oh world!"[160]

The flame impresses in the cardboard its landscapes cloaked in warm ochre, with "no claim to realism . . . a pictorial presence created by the painter," as

Untitled colored fire painting (FC 14), ca 1961

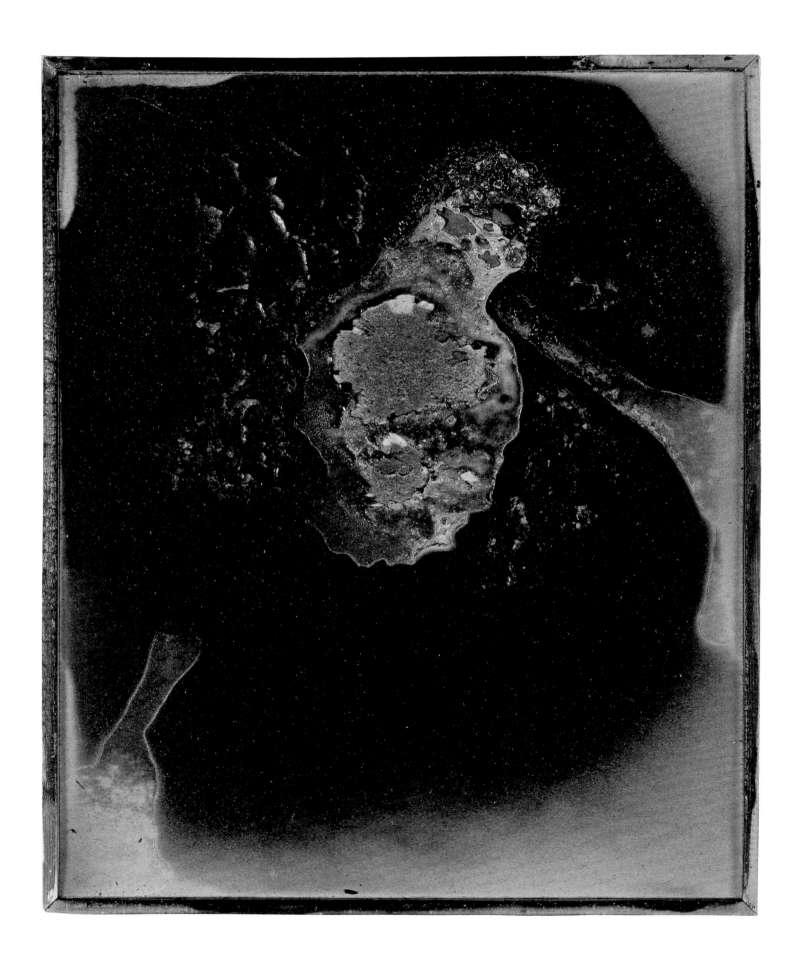

with Rembrandt. "The painting beholds an instant, the *indefinable* between a man truly free poetically and itself, and is witness to the *pictorial moment* for all the centuries of eternity."[161]

Live coals raining down in frosty gusts
– Delight! – fires in the diamond-wind rain
flung down by the terrestrial heart eternally
charred for us. Oh world!

Rimbaud

Here lies all the alchemy that fans Klein's spirit. His immortality is the instant forever fixed in "living pictorial matter . . . life eternal, or at least permanent."[162] What about transmutation? The transmutation of a body, ours, which recognizes its flesh as being a component of the world, along with fire, air, water, and earth. In order to feel this, one must reach out to pure matter when it is in a state indifferent to form. Art competes with science. Its atomic microscope is the *pictorial sensibility in the original state of matter.*[163]

If Yves Klein provides no *figuration* of the real world in the monochrome, he does it so as to ignore its forms and plunge into the element itself. A physical affinity between the work and the viewer might then circulate. In order for the soul to reconquer the element, the imaginative *dimension* of oneiric reality must be restored. "The authentic quality of the canvas, its very *being*, once created, is beyond what is visible."[164]

If air in the immaterial city envelops us with its pellucid flesh and makes us lighter, fire, by making the invisible resurface, expresses this revelatory power. The flame, a living brush, is the painter's *elementary person*, whose role is one of pure action.[165]

In his fire paintings, Yves Klein achieves a match-up with materiality: a type of fate beyond the human condition. Fire is its future. A *sympathy* binds him to his matter.[166] Like flames on cardboard, "Painters should resemble their paintings, which turn into examples for them . . . they create, they engender art, or rather they don't: what they create is life itself, the first life, life in itself."[167]

Untitled fire painting (F 125). January 1961

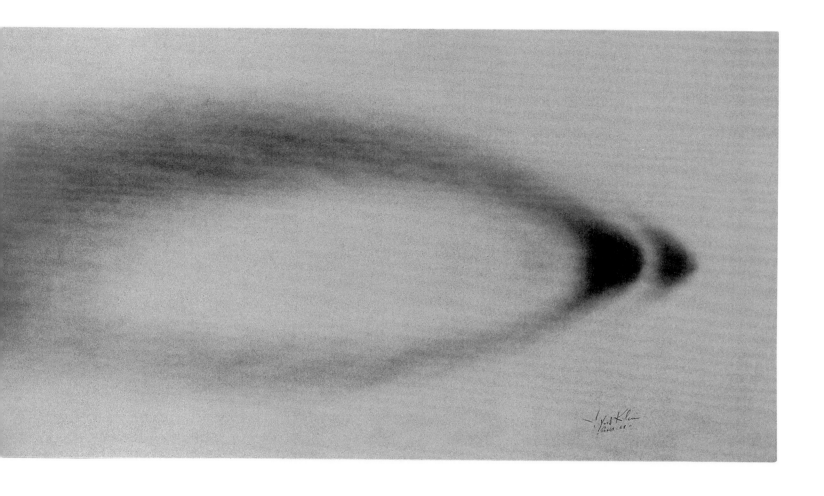

Le feu de l'esprit et l'empreinte de l'amitié [The Fire of the Spirit and the Mark of Friendship] (F 94), 1961

The Nature of Fire

It is not enough to *perceive*: one still has to *imagine*. More than its heat on the skin and its light on the retina, fire is also more than its flame: an imaginary being. Hence the enchantment of Yves Klein's paintings. They have no mimetic ambition. They express it immediately in its element. Fire paintings and invisible cities stir up a pure and elusive imagination in us. This soaring and wheeling is just what Yves Klein wants.

Each element is quickened by a dynamism of its own, whose advice and pointers towards change we are eager for. We want to seize the energy from their matter and renew ourselves, in *their image*.

The invisibility of air gives flesh to this abstract idea of dimension. And ours is *imagined* through its tenuous matter, having reached the minimum of its substance. Fire shows this operation at work.

If the flame concentrates on its being, air is suspended as if within itself. One is a flash, the other is transparence. By empathy, we imagine ourselves to be incandescent and free. Both arouse a basic indifference to weightiness and sadness. Morality somewhere between hedonistic joy and stoic serenity.

Fire does not compare only its strength with water, its counterpart[168]: they also swap qualities. In the blazing fountains, it was already pouring upwards into the sky. "A flame is wet fire."[169] At the Centre d'Essai de Gaz de France, which was turned into an experimental studio, Yves Klein plays with different combinations. Under his instructions, young models press their wet bodies on the sheets of cardboard arranged there. Their outlines are singled out with sprayed water. Once they have withdrawn, the cardboard is torched at arm's length. The invisible silhouette then surfaces by contrast. Yves Klein also binds fire and water simultaneously. A powerful jet of water is trained on the cardboard, while the fluid flame licks at it. Before being sprayed, it drips and burns instantaneously. The dazzling contact between the two elements brands the signs made by the gushing and almost incandescent splashes. The flame actually memorizes water rather than being more concerned with annihilating it. A false paradox foiled once again.

In this twin rivalry with water, fire is set against itself, in its essence, where the inclination to procure pleasure is at loggerheads with the instinct to cause pain. "The discordant comes to an accommodation with itself; the agreement of opposite tensions, like that of the bow and the lyre" (Heraclitus)[170]. Its ambivalence—setting it against air—provides a model championed by Yves Klein: "One has to be like the fire within nature; to know how to be both gentle and cruel, to know how to contradict oneself. Then, and only then, does one really belong to the family of the 'universal principles of explanation.'"[171] As a phenomenon of the world, fire shares with it a savage nature—an intrinsic indifference to human morality, *beyond good and evil.*

Untitled fire painting (F 71), 1962

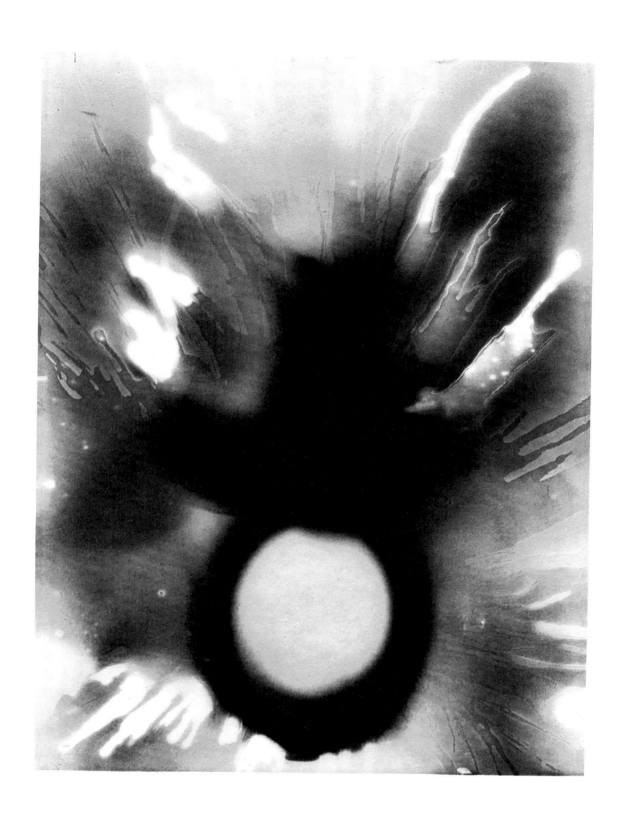

Untitled fire painting (F 67), 1962

Sentinel soul,
Let us whisper the confession
Of the night full of nought
And the day on fire

Rimbaud

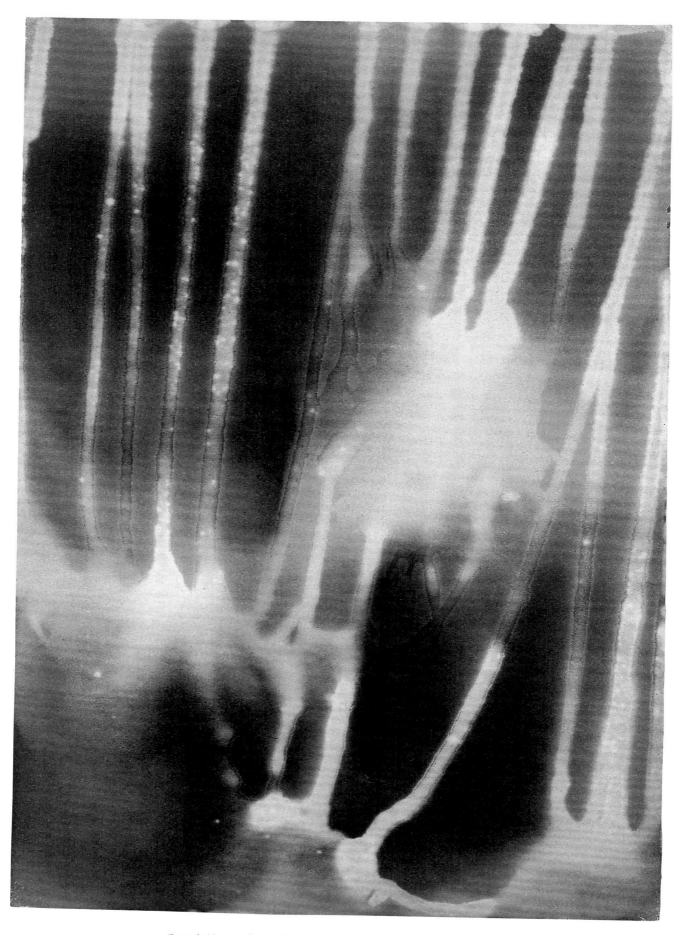

Carte de Mars par l'eau et le feu [*Map of Mars by Water and Fire*] (F 83). 1961

Untitled colored fire painting (FC 13), 1962

"Those dear ancestors around their fires" (Rimbaud)[172]

There is subversion in using fire as both brush and matter, as well as danger in handling it.[173] Accompanied by his friend the art critic Pierre Restany, Yves Klein had astonished the chief executive of the Air Liquide company (Paris) by asking him to help set up his immaterial architecture.[174] The answer was a flat refusal. The managing director of the Centre d'Essai de Gaz de France turned out to be more amenable. In March[175] and July 1961, he agreed to give him the run of his workshops and to put all the necessary safety equipment at his disposal.

Fire is unforgiving[176]: the first thing you learn about it is that you mustn't touch it. Anyone breaking this rule of social behavior must show the greatest adroitness, like Prometheus, the "forethinker." Fire is admired long before it is defied. Within all flames lurk other fires: the very first ones on the earth and in the universe. "No god or man has made this world, which is the same for all, but there has always been, is now, and will forever be an ever-living Fire, lit and put out with moderation" (Heraclitus).[177] The imagination combines two spaces through the flame one contemplates: what I hold to be mine around me, and the infinite which envelops me. *"It's nature's first day*: it's there today." Fire is *"always the same."*[178] A brand new flaming eternity.

> "Sentinel soul,
> Let us whisper the confession
> Of the night full of nought
> And the day on fire." (Rimbaud)[179]

Fire is nature's memory.[180] Between the flame of the match and the sparks from the magma's lava there is only a difference in scale. They are united by the same value. If the invincible beauty of fire, which fascinates Klein,[181] were to divulge its secret, it would not be hard to imagine all of nature's secrets revealed. This burning desire to penetrate the enigma is what Gaston Bachelard calls the Prometheus complex: "all those things that urge us to know as much as our fathers, more than our fathers, as much as our teachers, more than our teachers."[182] Driving fire into its secrets, the principle of life, is to ask about the origins of nature and civilization, *engendered*[183] by his work. Yves Klein seeks the primal cause: "I take it as given that in the heart of the void, just as in the heart of man, there are fires burning."[184] The skill lies not in *peeling away* its image—its inner flesh—but in creating an oneiric metaphysics[185] where sight *conceives* the invisible *conceived* by flames. "Beauty is the experimental proof that incarnation is possible" (Weil).[186]

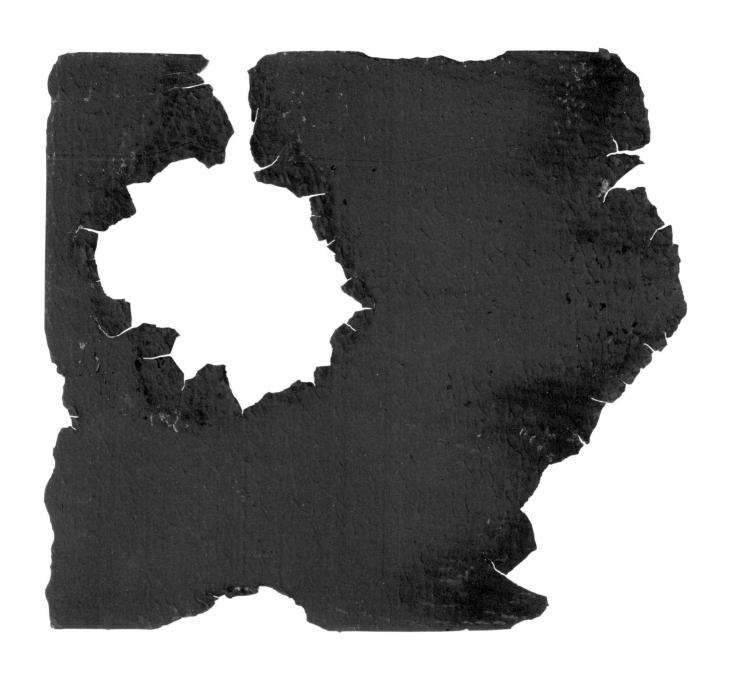

Blue Monochrome holed by fire (IKB 25, recto), ca 1959

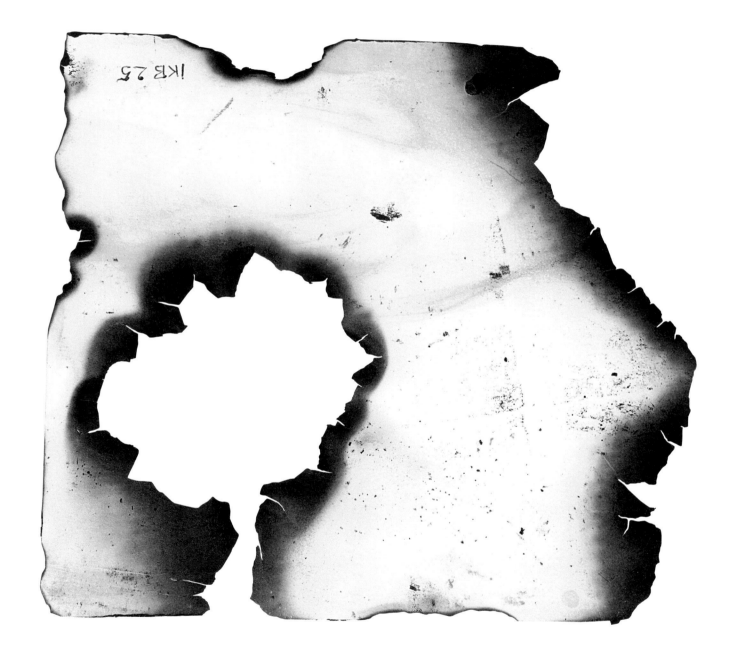

Blue Monochrome holed by fire (IKB 25, verso), ca 1959

Of seas removed,
of subterranean conflagrations
Rimbaud

The Drift of the Imagination

The charred edges outline a landscape. Of course, it immediately brings to mind the map of an island, with its brown coasts lapped by an unknown sea. The brittle scorched border is the high-water mark of the flames. The burnt paper conjures up the empty depths surrounding it and is itself a kind of surface residue.

"Of seas removed, of subterranean conflagrations." (Rimbaud)[187]

For the imagination, the work[188] is a transition space. Have the flames finished their work? Looking closer, maybe not. Instability lies in these ashes. The ring of smoke is fading, as if blazing heat were still burning the paper. Invisible fire. How far will it go this time? Right to the end. Then what? This is what we have come to: from flames to ashes, then to an immaterial fire and finally the void. In the embrasure.

The *Monotone-Silence Symphony*: "Its day! All moving and sonorous suffering dissolving in more intense music." (Rimbaud)[189]

While the monochrome floods us[190] with its silence . . . radiance . . . Yves Klein's *Symphony* plunges us into its own—resonance . . .

The *Monotone Symphony* rings out at 10 p.m. on March 9, 1960, in the grand salon of Maurice d'Arquian's Galerie Internationale d'Art Contemporain, before an audience of around one hundred. Three nude models walk onto the stage. Using a sponge, they cover their bodies with blue paint and print themselves on the paper. The voices of the choir and the instruments of the orchestra resound in a single, continuous note.

Yves Klein says he had the idea for this symphony at the age of twenty, in 1947 or 1949.[191] In this sense it links his history to all his work to come, for which it acts as an *archetype*. From the very start music and painting aim at a single thing, be it notes or colors.[192]

The musician and composer Eliane Radigue[193] is a close friend of Yves Klein's. She worked with Pierre Schaeffer and Pierre Henry in the Club d'Essai de la Radiodiffusion-Télévision Française, where electroacoustic concrete music was invented. In 1959, she introduced Yves Klein to the composer

Yves Klein coordinating the *Anthropométries de l'époque bleue* [*Anthropometries of the Blue Period*] performance, March 3, 1950

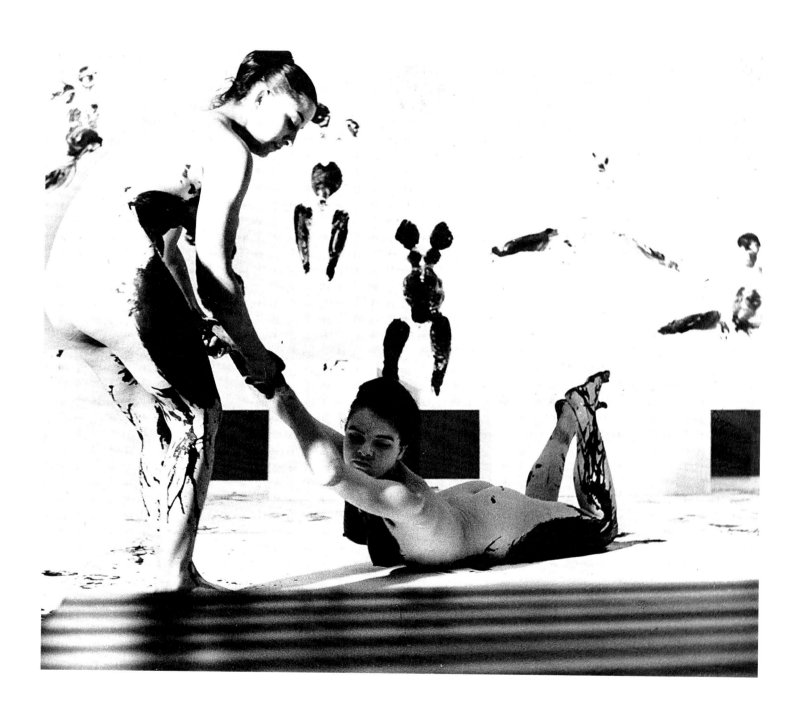

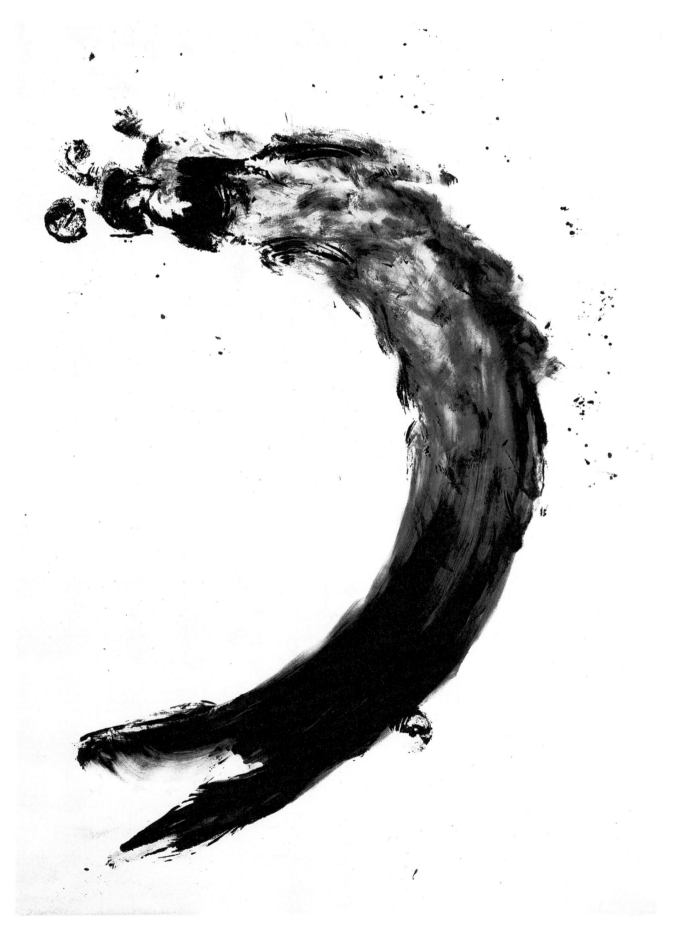

Helena (ANT 111), 1960

Louis Saguer,[194] who agreed to actually compose the symphony which had been haunting Klein for over ten years. Among all the arrangements he considered, from the most restrained to the most sophisticated, using simple tonal, simple atonal, etc., what eventually grabbed Yves Klein was the most *elementary*: the *D* major chord.[195]

This work consists of a "continuous high-pitched" sound that suddenly gives way to total silence. The length varies. The *Symphony* can be divided into a first 5- to 7-minute sequence followed by a 44-second "absolute" silence or into two even halves of 20 minutes. On the IMMA 43a score, Klein mentions a three-section orchestra: strings (ten violins, ten cellos, three double basses), brass (three horns), and woodwind (eight flutes and eight oboes). Twenty singers are added, divided into two groups taking turns. The choice and volume of the sections depend on the acoustics of the venue for the performance. Alain Bancquart, a pupil of Louis Saguer's, gathered six strings and three singers at the d'Arquian gallery on March 9, 1960. The important thing was to produce the "striking effect Yves had been asking for,"[196] wrote Philippe Arrii-Blachette, who conducted the *Symphony* before Yves Klein, for the recording on July 17, 1961 of an anthropometric sequence for the documentary film entitled *Mondo Cane* (1962), an official entry at the Cannes Film Festival.[197]

"Turn one's audacity into yet unknown beauty" (Rolland)[198]

Pierre Henry was one of the first to perform Yves Klein's *Monotone Symphony*. They became firm friends in the last months of 1956 as they discussed a new form of collaboration between the arts (painting, music, temporary architecture)[199] and the invention of *environments*.[200]

At the time Pierre Henry was a pioneer in technological sound research in France. He was breaking new ground: *musique concrète*, also known as electroacoustic music,[201] "because in the end all music comes down to instrumental concrete sound."[202] This was the path Yves Klein wanted to travel. His painting was seeking the element of color like the sky behind the air we breathe.

Yves Klein had enjoyed Pierre Henry's *Le Voile d'Orphée* (1953), the first symphonic electroacoustic work. Long drawn-out notes, suddenly cut with screeches and mechanical noises, from which emerged the lost words of myth. He was aware of his 1947 manifesto, *Pour penser à une nouvelle musique*—a call for a daring gesture. To destroy what is killing music. To destroy *false foundations*.[203] And extract organic music one would have not imagined from the coarse sound produced by a machine, the human voice and within nature.

Fountains of fire, air architecture, IKB monochrome, *Monotone Symphony*, flesh imprints: through all his *immaterial* works, Yves Klein conjures up the world from its elementary, latent, and murmuring state.

Musée de krefeld (Ruhr)... [Krefeld Museum (Ruhr) . . .]. 1960

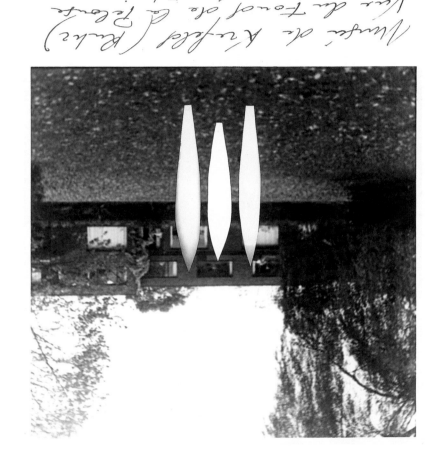

It was a study at first. | turned silences
and nights into words. | noted down the
unutterable. | fashioned dizzying heights

Rimbaud

In March 1961 while standing in front of his paintings made of crude flames, Yves Klein speaks of *music of the sun,*[204] with probably at the back of his mind the husky growl of the *torchères.* The *Monotone Fire Symphony*[205] had been played the previous month, in Krefeld. A *concrete* Symphony. A flame shooting up from the ground in a guttural croak.

The *Monotone-Silence Symphony* went through many versions.[206] The very first were electronic.[207] But Yves Klein preferred a warmer, more fleshy sound.[208] He wanted to conduct a classical orchestra with 150 musicians. Only the tone[209] and the grain of the woodwind and voices would be able to express this sense of the world's buried depth and draw out the flesh element. For Pierre Henry "it was a unique sound: a keynote played by musicians whose variations came only through playing.

It was a fabulous sound. The footprints were there, and so were these musicians all dressed up and playing very seriously. The whole thing was extraordinary."[210]

"At present, the eternal inflection of the moments"(Rimbaud)[211]

By placing the invention of his *Monotone-Silence Symphony* in 1947–1949, Yves Klein confidently included it among avant-garde experimental music.[212] "It was a study at first. I turned silences and nights into words. I noted down the unutterable. I fashioned dizzying heights" (Rimbaud).[213]

Winding in space and in the instant. It opens on a unique chord—or a note— permeating space.[214] A still, yet moving expanse.[215] Just as a flame, with its vanishing tip, leads to great imaginary spaces, so the continuous sound envelops and resonates. The point is to "imbue oneself, by becoming one with life itself, which is this space where reigns the tranquil and tremendous force of pure imagination . . ."[216]

We are immersed in this music, like the monochrome. In *living* it in its fleshly essence, we fully experience its space. The *Symphony* works. Simply.

"Eternal spinner of motionless blues" (Rimbaud)[217]

The oxymoron is one of poetry's tricks. When the intellect is tied up and paralyzes the mind, it goes straight to the point and the source flows back. It pulverizes logic and makes intuition tremble. And this applies to *fundamental static motion.*[218] Yves Klein's formula. What is it?

Eternal spinner of motionless blues

Rimbaud

Score for *Symphonie monoton-Silence* [*Monotone-Silence Symphony*], 1949–1961

"The intellect is not made to think about evolution, that is, the continuity of change which is pure mobility . . . The intellect is characterized by a natural inability to understand life."[219] And indeed, throughout all his work Yves Klein went right against learnt reflexes and the inertia of reason. He served up paradoxes and made play of their inanity. Poetry is restoration. It revives.

His vision: a being is pure movement and movement molds a being. Not an essence thrown into life and which crosses it changing all the while. Movement is not an object that displaces itself. It's an attribute of life itself and never stops.

In this sense music is superior to the image. While the eye "cuts out" objects in its field of vision and assigns them to a *position*, music alone is capable of expressing this pure mobility of life. Not that of the *moving* being but of *moving-ness*. For music always echoes deep within man. It connects to something which answers back. Within us, "there is simply the continuous melody of our inner life—a melody which picks up and continues, indivisible, from the beginning to the end of our conscious existence."[220]

This music, from which a being launches itself, is precisely what Yves Klein wants in order to attain an emotional upwelling. Hence the tale from ancient Persia he liked to tell: one day a flute player started playing just one single note. Twenty years passed, and he told his wife who was complaining about this monotony that he had found the note everyone had been searching for.[221] In 1959 Klein presented a design to the secretary of the XII Triennale of Milan for a theatre set where the music became the fundamental and moving heart of the structure: from the "blue depth"[222] of a 3 x 3 m polymer block would emerge the *Monotone Symphony*, beneath an air roof onto which colored water would splash.[223] Continuous immobility in flowing air.

With No Beginning and No End

Yves Klein's *Symphony* puts the value of the note at the very heart of the composition.[224] As the *monotone* note sounds over a period of minutes, we feel its full dimension: a *depth* which should never end and never have started, as if time preceded being, a "music before all else" (Verlaine). [225]

How could he suggest this impression of depth before all else in music? How to convey the *uncreated* as the foundation of everything? How to start such a symphony, this permanence with no initiation? What kind of music for this *fancy of the mind*? Yves Klein, who dreamed of "great naked symphonies,"[226] has a simple and clear idea: remove the attack at the beginning of the piece, and remove the end, to "create a feeling of vertigo and of sensibility being sucked out of time."[227] Suddenly the sound emerges . . . lasts a long time . . . and slowly disappears in the silence where music does not stop.

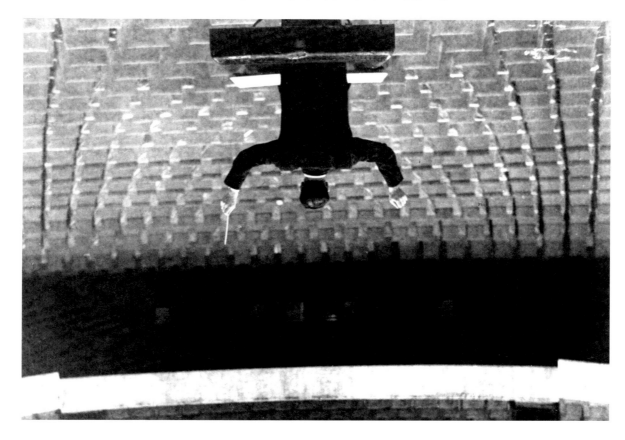

Yves Klein conducting, Gelsenkirchen opera house, 1959

His day! All moving and sonorous suffering
dissolving in more intense music

Rimbaud

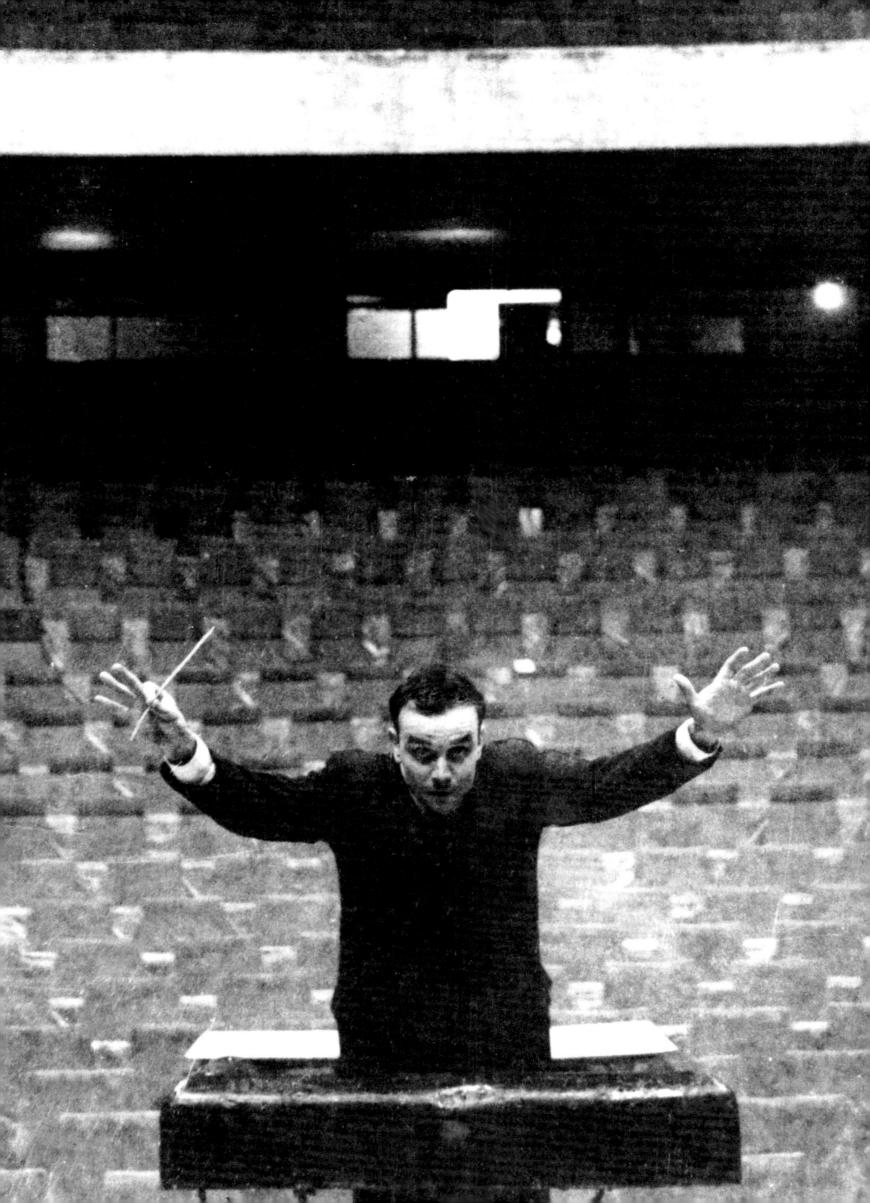

A rap of your finger on the drum
unleashes all the sounds and
launches a new harmony

Rimbaud

Is the idea of removing the attack absurd and impossible? Not at all. Since 1948 Pierre Schaeffer had been performing just this kind of experiment on magnetic tapes in his laboratory in the Club d'Essai de la RTF. He had already come to grips with preconceived ideas: "In our mind, the attack was so linked to a location in time that if we cut the beginning of the sound, we would be quite sure of wiping it out from our hearing."[228] Mistake. Neither Schaeffer nor Klein is a pipe dreamer. Both assert that the start of the sound[229] is not the same as the *attack*. Cutting the latter does not mean removing the former: it's a question of modifying psycho-acoustic perception. So, as Schaeffer writes, "by striking one of the bells I grasped the sound *after* the attack. Being percussionless, the bell turns into an oboe sound."[230]

> "A rap of your finger on the drum unleashes all the sounds and launches a new harmony" (Rimbaud) [231]

The *Monotone Symphony* is associated with the "closed groove" experiment on magnetic tape, performed by Pierre Schaeffer. By locking the sound in a loop, it is isolated from what comes before it and from what follows. Only the body resonates, freed from the attack of the percussion and its final dying away. Like Schaeffer, Yves Klein wants to disorientate his audience by unleashing a feeling of *vertigo* when facing a sound as *pure resonance,* [232] which continues to vibrate in the silence.[233]

At Yves Klein's request, Pierre Henry made an electroacoustic version of the *Symphony,* minus its initial attack.[234]

The Silence of These Infinite Spaces Creates Me

"Silence . . . that is my real symphony and not the sounds during its performance."[235] If we are open to this music, we have a true inkling of the nature of mystery.

From the mid-1940s silence became increasingly important in John Cage's musical compositions. Even though the idea of a continuum "of sound and silence" suggests a resemblance with Yves Klein's work, the approach of these two artists never, in fact, dovetailed.

In 1952, Cage finished a work entitled *4'33,* which is divided into three movements of equal duration. The pianist[236] sits still in front of his instrument, the keyboard cover down; he then raises and lowers it for each movement. The silence becomes an area of resonance for residual noises. It supplies its nakedness to explore the world through its magnifying glass. *The tiny changes scale.*

Yves Klein's silence and immateriality give another awakening: not to the world, but to *enhanced reality*.

Untitled monogold (MG 29), 1961

Examining the invisible and hearing
the unheard is quite different from
recapturing the spirit of dead things
Rimbaud

Just like the immaterial city or the monochrome, the *Monotone-Silence Symphony* gives us a sense of the world as a *pool of possibilities*, a *power*. It's not the tiny residual that is considered here. What Yves Klein wants to bring out is not a problem of scale, for either our eyes or our ears. It's a *fundamentally* invisible world but wrapped around ours.

> "Examining the invisible and hearing the unheard is quite different from recapturing the spirit of dead things"(Rimbaud). [237]

Virtual Harmonics

In the clearest and certainly most surprising way, Yves Klein's *Symphony truly* gives birth to an immaterial music.

When the single *monotone* note suddenly stops, the music continues as the sound is *communicated* to silence. It drifts within it. That is when our ears perceive the invisible flesh of the sound: its resonance. The blue note. The void *voids itself* of its nothingness. How?

A fundamental *D*—by the orchestra or thanks to an electronic device— is all it takes for the vibrations of this sole note to immediately spark off the first *F* sharp and *A* harmonics, rising up to *C7*. Do these quite audible sounds stem from an instrument? No. They resonate by vibratory sympathy with the fundamental *D*. A *virtual reality*, in the full sense. In the *Monotone-Silence Symphony*, the hearing first enters a *tone space*, a sound depth whose spectral quality is soon transmitted to silence. The sound continues to exist through a psycho-acoustic inertia effect.[238] It reverberates in the silence, immaterialized. The ear reconstitutes the virtual *D* chord.

> "Invisible harmony is better than the visible one" (Heraclitus).[239]

Flame and Music: Concrete Abstraction

Yves Klein's *Symphony* is fire set to music. It tapers into silence like a flame thinning out in the air. Footloose and fancy free, like the one which in *Rêve de feu* radiates out with no root, suspended in Yves Klein's palm.

Le Rêve du feu [The Dream of Fire], ca 1960

Le Rêve du feu [The Dream of Fire], ca 1960

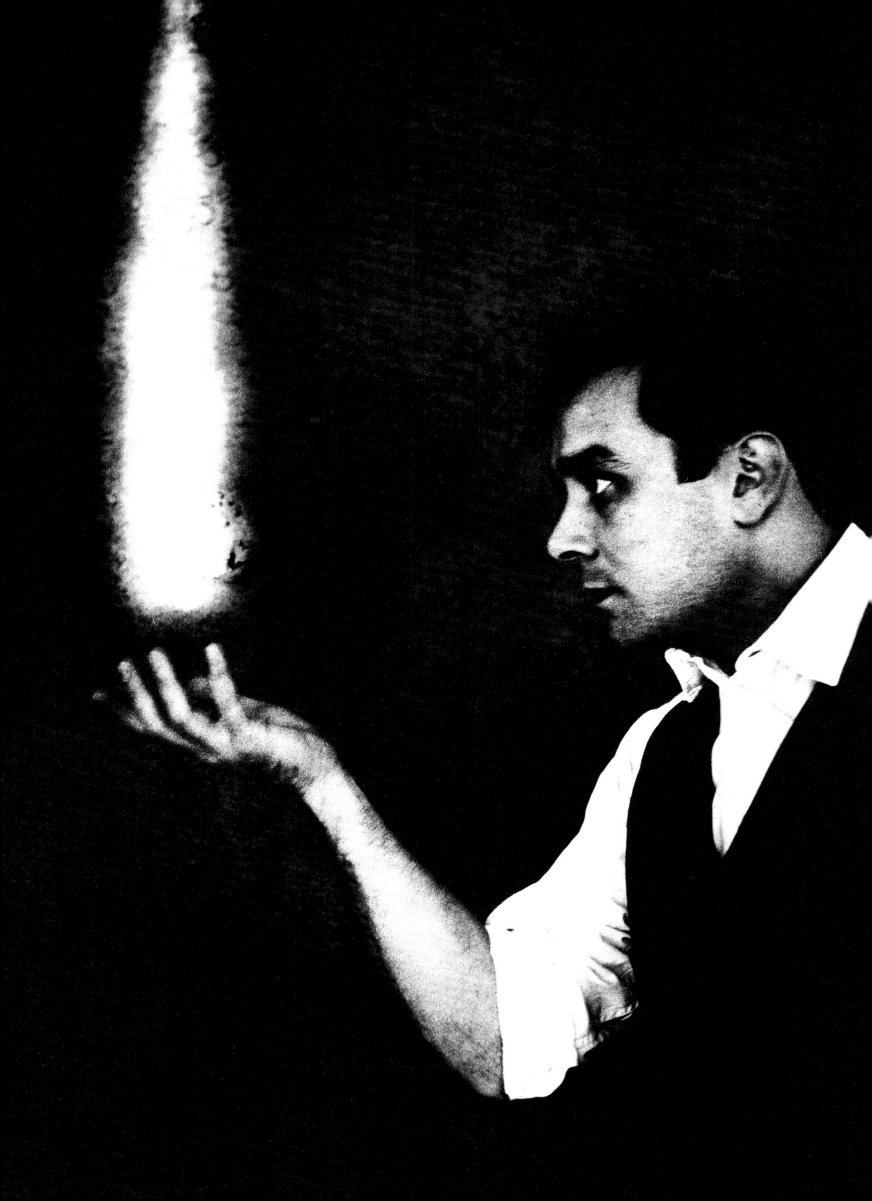

Embouchure du Loup... [*Mouth of the Loup...*] (COS 4), March 23, 1960

And there my young poetry was able
to pulse and fly, in dreams and silence
Rimbaud

The flame burns the transparent air that replaces it and the *Symphony* rushes to fill space where the vanishing note draws out harmonics.

"And there my young poetry was able to pulse and fly, in dreams and silence"(Rimbaud). [240]

Fire and music *concretely melt* in their flesh. This is the path also followed by Pierre Schaeffer.

Until then "music, with its immaterial harshness, stemmed from an inner reality."[241] It was transcribed using musical notation, and then played by instruments. From now on, the important thing is to collect the concrete sound directly, wherever it may be, and to extract "the budding musical values it contains."[242] Schaeffer calls for a new attention to the sound world: *reduced listening*, capable of detecting the hidden musicality of all things.[243] In the same way as, through his sensibility to the immaterial, Yves Klein "returns to genuine realism"[244] and declares himself to be a *figurative*[245] painter, so Pierre Schaeffer invents a *"concrete, figurative"*[246] music.

Until now, all the musical instruments invented and perfected by human ingenuity have been either *musical* instruments (meaning designed only to *produce* sounds and a melody) or *instruments* of music (where technique prevails). From now on the world is in itself an *instrument of pure music.*[247] Music is already within it, enclosed. What is needed now is just to *express* it.

Immaterializing concrete matter for Yves Klein also means separating his *raw* material and liberating it.[248] He *dis*-covers it, in the same way as an explorer reaching an unknown land is said to be its *inventor.*

Concrete Painting and Living Brushes

Just as a fifteenth-century conqueror[249] would spread out a map of known lands, Pierre Schaeffer and Yves Klein magnify the world with the enclosed depth which has always been there. The former's music, made from raw sounds, is answered by the latter's imprints of the five[250] elements: fire extracted from fire, air from the wind, water from rain, earth from sand and flesh from the body. "My purpose is to extract and obtain the trace of the *immediate* in natural objects,"[251] wrote Yves Klein.

The footprints of nature Yves Klein calls his *momentary states*[252] are snapshots of the world's animation. Catching the rain, the scorching fire, a draught, is to record fluttering, cadenced details, such as a drumming

Cosmogonie de la pluie [Cosmogony of the Rain] (COS 29), 1961

shower, the whirling wind,[253] the gorse drifting away on the water, or the undulating crests of sand. The engraved sign of the *immediate* is a signature. It constitutes a visible insight into raw being, linked to a general order.

Michel Foucault wrote that during the Renaissance the knowledge of the natural world was based on interpreting things through the similarities and correspondences that secretly bound them. Underlying it was this notion: "hidden similarities must be visible on the surface of things." So God gave man the great benefit of a system of marks and signs: "the invisible form of what, from the depths of the world, made things visible." Knowledge was acquired by finding and deciphering these *signatures*.[254]

Cosmogony is the name Yves Klein gives to the marks he found, for each time he wants to release its hidden principle, appearing in the image in a strange *lyricism*.

Hence this sheet of paper left under a spring shower. The rain strikes the expanse of blue pigment. Every splashing drop attracts the powder to it and encapsulates it. The rain spontaneously *reveals* its capillary effect, just as the volcanic fire lurking within the thickness of the F 27-I cardboard has something to teach: a covered fire burns fiercest. Nature *quivers*[255] as it burns in confirmation.

Another *cosmogony*, found at the mouth of the Loup, in Cagnes-sur-Mer, retains the elements of landscape. The blue-stained stalks of the gorse bushes draw slender lines. The silt folded by the water leaves ochre curves like burns or scars. The river on which Klein applied his paper is transferring its meanders. The close green moss leaves a spongy mark. In a nutshell, the whole microcosm of the mouth has been tattooed. The cosmogonies are a way into the matter of the imagination and the imaginative world of matter: ". . . a chance of illuminating colored pictorial matter in itself, so that all things physical—stone, rock, bottles, clouds—can, through permeation, become a journey object for the human sensibility."[256]

And what more sensitive transports than those of the body . . .

> "Man of normal constitution, was flesh not
> a fruit hanging in the orchard? – O infant days!
> – the body, a treasure to plunder; – O to love,
> Psyche's peril or her power"(Rimbaud). [257]

The evening of June 5, 1958 is a big night. Less than a month after his oracular exhibition of the "Void" at the Iris Clert gallery, Yves Klein presents a new example of his research into pictorial sensibility to around thirty guests.[258] A model makes her entrance at the end of the dinner in his friend Robert Godet's flat on the Ile Saint-Louis in Paris.[259] The young woman covers her torso and thighs with blue paint. Following Yves Klein's instructions, she heads towards a huge sheet of paper laid on the ground and starts rolling over it.

Barbara (ANT 113), ca 1960

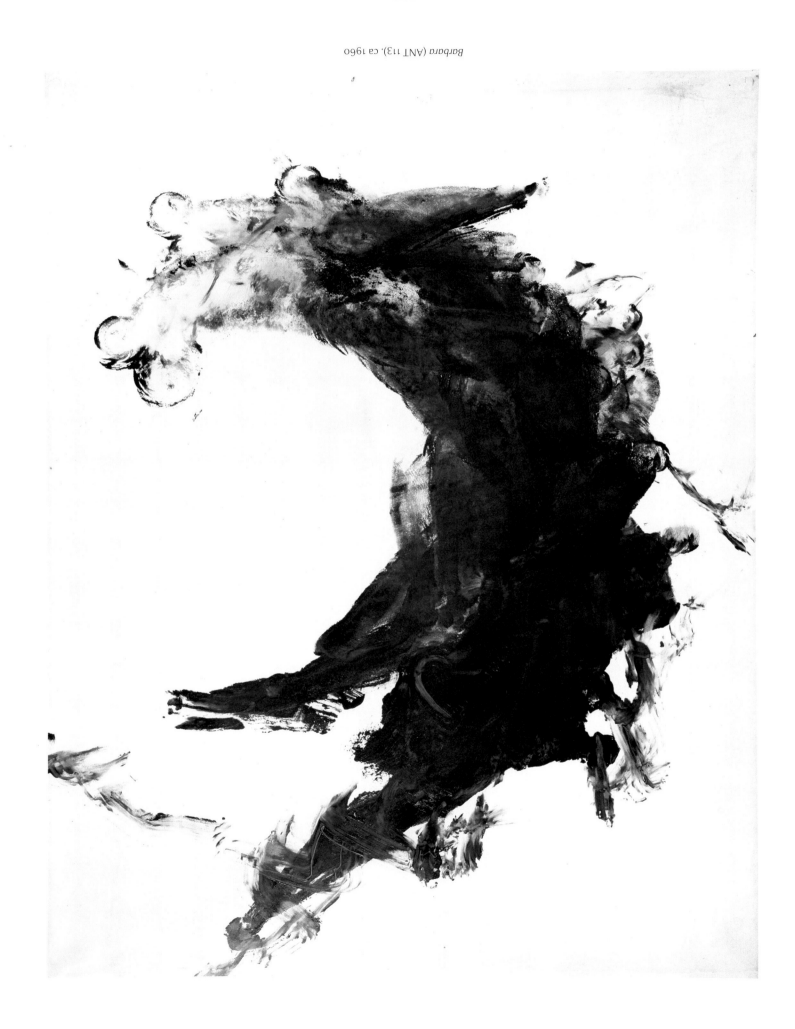

The masses of color mingle and cover one another.[260] The model acts as the artist's brush. Impregnated with blue, she impregnates her flesh.

Looking at either of these prints made by Yves Klein over fifty years later, one is struck by the fact that this flesh is still intact.

On Judo, Considered As One of the Fine Arts

Yves Klein had already been practicing Judo for five years when he arrived in Yokohama in September 1952. He was to refine his technique in the famous Kōdōkan[261] in Tokyo over a period of several months. In February 1954, he finally returned to Europe with a rare 4th Dan black belt, obtained on December 18, 1953. His Judo continued to develop throughout his work, as he himself acknowledged.[262] The Kōdōkan put spiritual principles at the heart of its teaching.

The *Kiai* is a battle cry whose meaning and effect fascinate him.[263] Emitted at the decisive moment in the contest, the *Kiai* is the lightning unity of will and action. "*Kiai* and *Aiki*[264] are dynamic or static ways of winning, using only man's deep inner energy; this indefinable force is *Ki*.[265] As a judoka artist, Klein seeks this *breath* and this *radiant will*. "The true judoka practices using the mind and pure sensibility."[266] "My active presence in a given space creates the climate and the radiant pictorial environment that usually reigns in the studio of any artist endowed with real power."[267]

Yves Klein points out a formal and spiritual analogy between the writhings of his models on the paper and that of the judoka on the tatami.[268] Turning oneself into a living brush is similar to the spirituality and gesture of this art, whose name means the *Way of Gentleness*. Strength and grace, as in Hokusai's *Great Wave off Kanagawa* (1831), which Yves Klein used to illustrate the first part of *The Foundations of Judo*, a book he had published by Grasset in 1954 when he returned from Japan.

Robert Godet hosted the first anthropometric meeting in his living room on June 5, 1958. This extraordinary character, keen student of Hinduism and

Yves Klein executing a kata judo hold, 1953

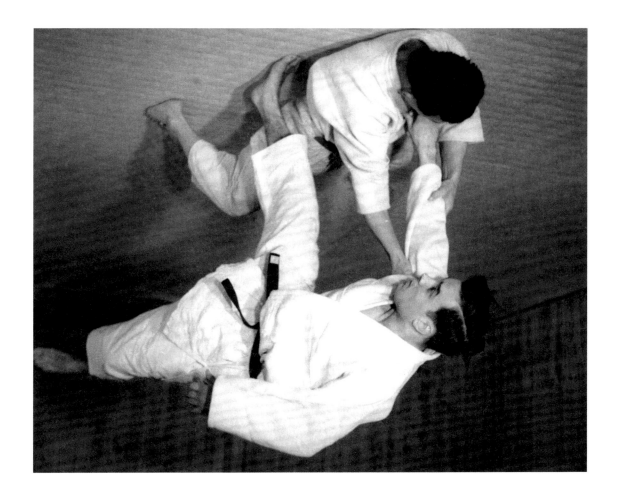

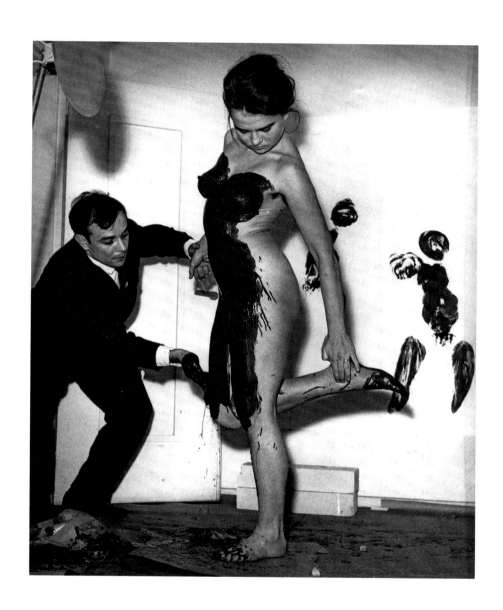

Creating an anthropometry, 1960

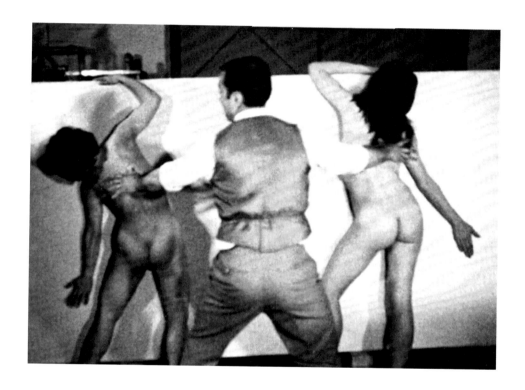

Top: Yves Klein creating a colored fire painting (FC 1), 1962
Left: Yves Klein executing a judo hold, ca 1955

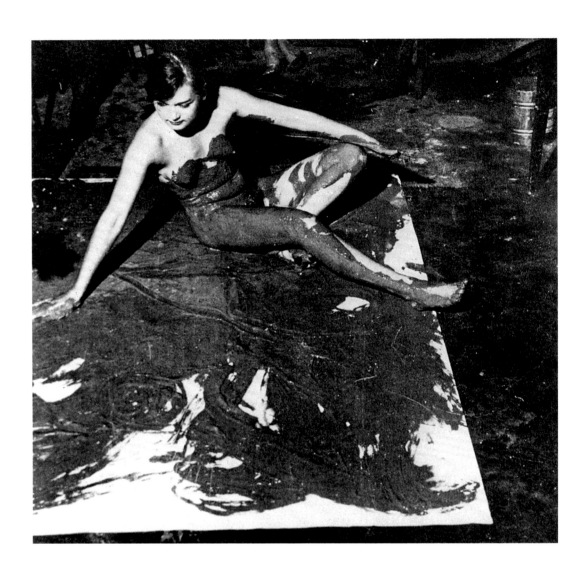

Living Brushes performance, at Robert Godet's flat, Paris, France, June 5, 1958

publisher of work by painters and poets,[269] was also an experienced judoka, like Yves Klein. In the short 1964 pamphlet entitled *Le Judo de l'Esprit*, he wrote: "The mat is the World / The Kimono is the Focus / The Belt is the Will / The Hara is the Faith / The Hold is the detachment / Attention is Awareness / The Enemy is our own self."[270] Monochromes, flesh-prints, fire paintings, judo mats: all this is indeed a scene and a dawning *world*.

Kata—"fundamental form"—draws on the sources of Judo, perpetuating the tradition of the masters. "[*Randori* and *Kata*] are bound by a profound relationship. It is the same relationship that we find between grammar and creative writing. Grammar teaches the rules, it is the basis of writing and speaking correctly, this is *Kata*. Creative writing, or free practice, is *Randori*."[271] Before one can achieve this freedom of gesture, one must structure it through a long apprenticeship in *Kata*. The same applies to anthropometric models. "First multiple repetitions: sliding, rolling, falling, twisting," wrote Yves Klein. "Hours of fine tuning for a few minutes of highly precise performance. Like an attack in Judo."[272]

On June 5, 1958 the model created a painting where the *interlacing* streaks tended towards a monochrome uniformity. Soon after, Yves Klein began to consider ways of making *distinct* prints from the torso and the thighs.

In the first months of 1960,[273] he directed experimental workshops in special garb in his studio on Rue Campagne-Première. The female models[274] pressed their bodies on a sheet laid on the floor, or hung on the wall and even around a rolled-up carpet. Yves Klein also formed big blue commas by pulling on the models' arms, in the same way as he later held the *torchère* to "print" the flame.

On February 23, 1960, before Pierre Restany and Udo Kultermann,[275] director of the Städtisches Museum in Leverkusen, the models finally went beyond the *Kata* grammar to free composition, *Randori*. Faced with this novelty, Restany exclaimed: "These are the anthropometries of the blue period."[276] The main workshop was held in Count d'Arquian's gallery a few days later, on March 9. The *Monotone Symphony* was played for around a hundred guests, including Arman, Pierre Henry, Eliane Radigue, Rotraut Uecker, Louis Saguer, Georges Mathieu, Raymond Hains. Three models began their *ballet*, "new lyricism of gesture."[277] Yves Klein wore a black dinner jacket and the Maltese cross of the Order of Saint Sebastian. Wearing white gloves, he directed the ceremony lasting slightly less than an hour.

California (IKB 69), 1961

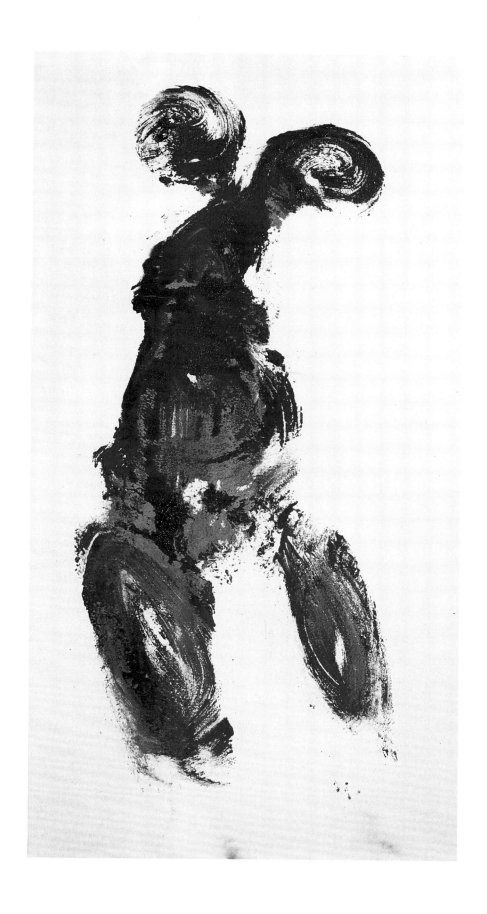

Untitled anthropometry (ANT 174), 1960

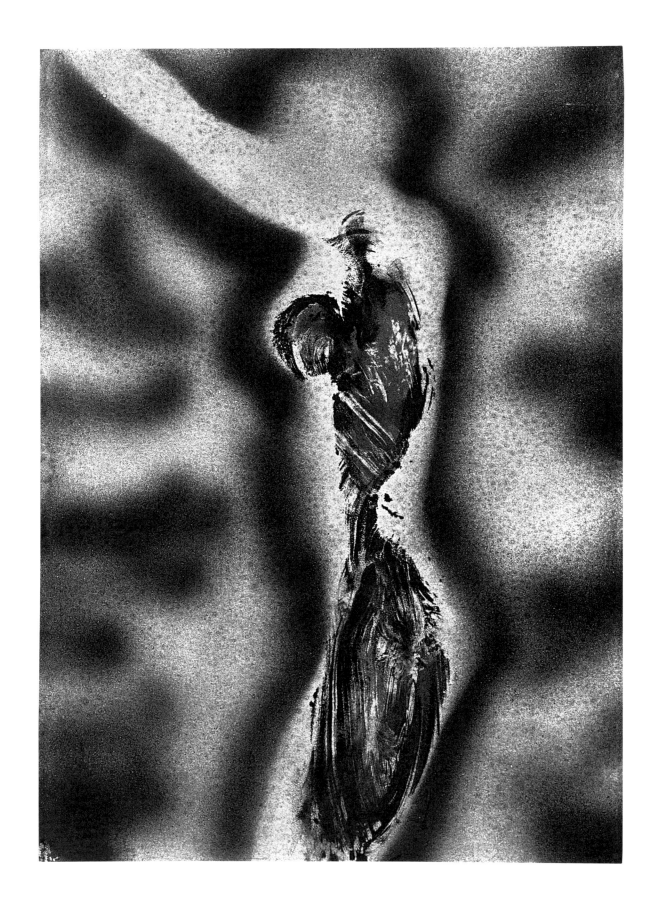

Untitled anthropometry (ANT 134), ca 1960

"The affective climate of the flesh"[278]

In the genealogy of the living brush, *impregnation* precedes *printing*[279] . . .

IKB is the result of a chemical process enabling the ultramarine pigment to retain within its matter the dark light it holds in its natural state. This is why the big monochromes seize you, immerse you, and radiate all together. Their inner flesh—showing through thanks to the transcendence of the IKB—can be singled out. The ultramarine monochrome is to the air enveloping it what a compact and dense space is to a clear and diffuse space. On the one side a saturated depth, and on the other a fluttering vibration.

> "And while the strip at the top of the picture is composed of the swirling, pounding noise of seashells and of human nights,
> The flowered softness of the stars, the sky and all the rest tumbles onto our face over the slope, like a basket, creating the flowering blue abyss down below" (Rimbaud).[280]

The flesh's invisible atmosphere is what Yves Klein feels and hopes to disclose. And he distinguishes clearly this flesh from the body. "The shape of the body, its lines, its strange colors hovering between life and death, hold no interest for me," he wrote. "Only the essential, pure affective climate of the flesh is important."[281]

The studio experiences an incarnation,[282] neither completely physical nor wholly spiritual. How to describe this *flesh*? Yves Klein is aware of the paucity of language. That is why he speaks of *emotional climate, radiant ambiance*, or even *atmosphere*. In search of a word that would express—as the element does—what is neither matter nor spirit but that is nonetheless felt within, *in our flesh*.

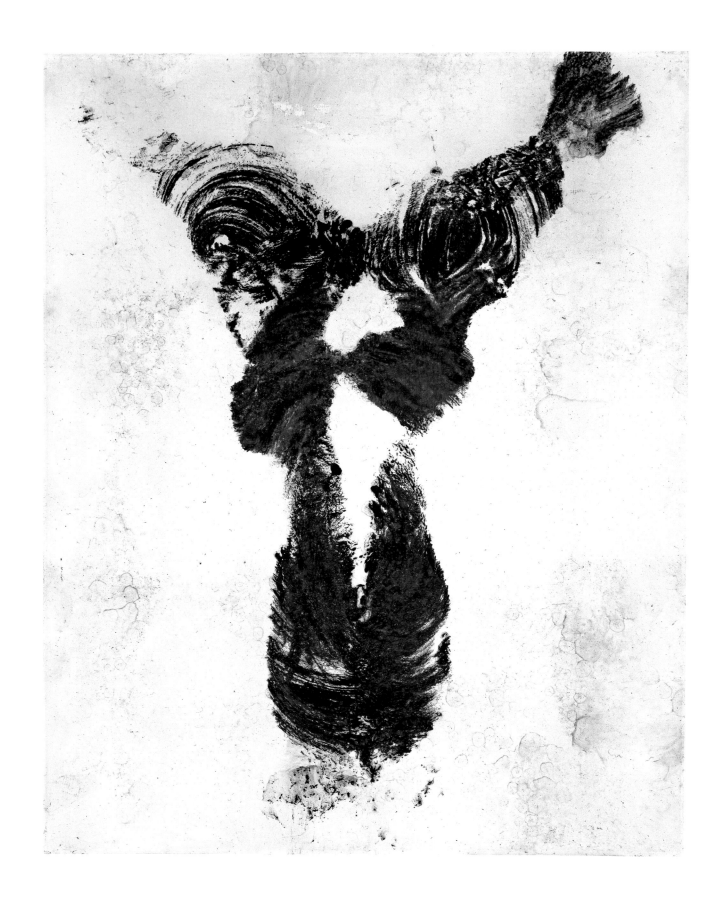

Untitled anthropometry (ANT 177), 1960

Something continuous unites the monochrome with the body facing it. This is why impregnation precedes the print. "The naked model brings sensuality to the atmosphere . . . and creates a sensual climate."[283]

Yves Klein wants at all costs to avoid "the danger of shutting [oneself] off in the overly spiritual spheres of creation"[284] or conversely in the too physical ones of body *performance*. Wearing a dinner jacket and choreographing models at arm's length represent so many ways to brush aside suspicions that this is licentious, or worse, smutty art. The anthropometries ceremony has nothing to do with sexuality,[285] but incarnation.

If Klein makes his flesh print only from chest to thighs, it's because this area concentrates "only the body (which) is alive, all-powerful, and unthinking."[286] The direct element of life is there. "The essential mass is the trunk and the thighs. It is there that one finds the true universe, hidden by our perception."[287]

"*The mark of the immediate*. This is what I needed!"[288] he exclaims. The living brush—subject, object, and tool—is an event rolled up in itself: it is its own cause, ending, and means.

"A whole phenomenology suddenly appeared."[289]

The brush makes its own line. Like a flame, it forms its direct image and its "indefinable"[290] flesh.

The Sirens, "De Profundis"

In order that the model's body may tell us much about him and more than our eyes can see, it must *yield* to something vaguely felt deep inside. Something both familiar and unknown.

The automatic writing of the surrealists posited an escape within oneself, towards the raw domain, the *magnetic fields*. There is hardly anything more difficult for the model than this kind of spontaneity. Yves Klein actually witnessed a discomfited exaltation: "I directed the operation standing up, moving quickly around the entire perimeter of that fantastic surface on the ground, guiding the model's every movement, repositioning her. The young woman, so inebriated by the action and by the close contact of her flesh with the blue, ended up no longer able to hear what I was shouting at her . . ."[291] A feeling of a return to the original element. By flowing within her freedom, the model is carried away towards her flesh and that of the world, both united. Elena Palumbo-Mosca, one of the three *living brushes* of the d'Arquian gallery, remembers experiencing the weird and lovely sensation of swimming.[292] Just as automatic writing leads to inexhaustible murmur, so the anthropometric experiments are vehicles leading towards remote regions.

"The Poet makes himself a seer by a long, painstaking, and reasoned disordering of all the senses. All forms of love, suffering, madness; he

The Poet makes himself a seer by a long,
painstaking, and reasoned disordering of all
the senses. All forms of love, suffering, madness;
he seeks himself, he exhausts all poisons within
himself, keeping only their quintessences [. . .]
He reaches the unknown, and when, horrified,
he might end up losing the sense of his visions,
he has seen them!

Rimbaud

seeks himself, he exhausts all poisons within himself, keeping only their quintessences [. . .] He reaches the unknown, and when, horrified, he might end up losing the sense of his visions, he has seen them!"[293]

When the *Monotone Symphony* rings out, a sound rises from the tree bark of the world and fills space. And then a climate begins, supporting this basement music. The scented air conjures up the *pure flesh of the world*. Music leads to its invisible silence.

Maurice Blanchot addressed the question of the imagination via the myth in the Odyssey of the sirens dragging the sailors to the bottom of the seas. "By means of their imperfect songs that were only a song yet to come, they led sailors towards the space where singing might truly begin . . . What was this place? One where there was nothing left but to disappear, because music, in this region of source and origin, had itself disappeared more completely than in any other place in the world: a sea where, ears blocked, the living sank, and where as proof of their good will, the Sirens had themselves to disappear one day." The *ineffable* region. Blanchot adds: "We mustn't forget this song was aimed at sailors, men who take risks and take bold actions, and it was also a way of sailing: it was a distance, and it revealed the possibility of traveling this distance, of turning the song into the movement towards the song, and of making this movement the expression of the greatest desire."[294]

The two prints *Héléna*[295] and *Barbara* show this ineffable fluid of the blue flesh squeezed out from the body, left behind like a big insect's translucent slough.

"Put your trust in the inexhaustible nature of murmuring" (Breton)[296]

"The deepest thing in man is his skin."[297] The horizon is the most distant point where earth and sky seem to be welding their depth in order to be one. In the same way, when the skin is squeezed, it bears one off to its buried domain, its reserve of power. Of this feeling, Yves Klein obtained an impossible image of this sensation.

In 1961, in the workshops of the Centre d'Essai de Gaz de France, a naked model, dripping with water, rolled over cardboard, imprinting her flesh. The model left her print, a tiny invisible layer. A flame then came into play. The cardboard darkened. And then a blurred image emerged from this flesh, in its dull ochre light. The tanned shape of the breasts and thighs materialized as a halo. It surfaced. The blurred contours could almost be mistaken for limbs. Beautiful and sensitive image of a diffuse flesh from which a denser flesh barely emerges.

147

Untitled blue monochrome (IKB 67), 1959

Full of leaden ochre skies and drowned forests,
Flowers of flesh blooming in starry woods
Rimbaud

Sweet unity of the element. All is the work of color here: a latent, orangey ochre presence washes over a visible, brownish ochre presence. "This world of color is a latent and mysterious world suspected of concealing a far greater power than that contained in the atom, yet almost incommensurable."[298]

Yves Klein had experienced this feeling of body to body impregnation lying on the beach in Nice, reassessing the uniform sky in his first monochrome. This initiation was to inform all his life, both as painter and man: "I did not like nothingness, and this is how I came to know the void, the deepest void, deep blue! Having arrived at the monochrome adventure . . . I, without the 'I,' became one with life itself. All my gestures, movements, activities, and creations were this original, or essential life itself."[299]
Blue is "the most abstract thing in tangible and visible nature,"[300] wrote Yves Klein. So the only reality he can recall is unabridged infinity, sea and sky.

Yves Klein is associated in his being to the imagination of air and fire, which are far rarer than those of water and earth. A brilliant flame in the air of the sky, infinitely fine, "infinite matter holding color in its volume, but without ever being enclosed." In its vast uniform blue, it is this power with no action we subscribe to, in its translucence and immateriality. The peculiarity of the aerial dream is that its depth is its dimension and all its dimension.[301] Bottomless escape in dripping air promoting flight. The absolute becomes perceptible. And by experiencing it on its flesh, it becomes miraculously *tangible*.

The flesh of the world is this mysterious element. In the silent orange atmosphere where all light and all noise are deadened, the element central to being is invisible, waiting, "Full of leaden ochre skies and drowned forests, Flowers of flesh blooming in starry woods."[302]

The Inner Demiurge

Art, *life itself*.[303] "To be one with nature, always the great universal and extra-cosmic nature."[304] Is this some pantheist faith? No, because Yves Klein does not sense God's immanence in nature but the presence of a nature *containing* the visible world and the cosmos. And he feels assimilated to this enveloping depth.

149

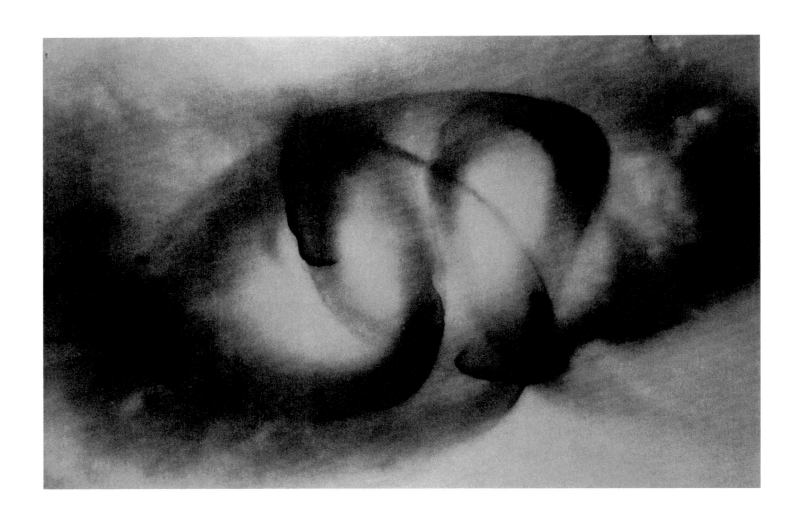

Untitled fire painting (F 115). March 1961

Fire paintings, *Monotone-Silence Symphony*, monochromes. Through his work, Yves Klein accomplishes a demiurgic action: arousing the life element, neither matter nor spirit. "Paintings create . . . sensitive climates, phenomenal states, and special natures that are perceptible yet intangible, at once mobile and static!"[305] In going beyond art, science, and religion,[306] he senses an initiatory liberation, the casting off of a weight: "(we) shall thus become aerial men. We shall experience the pull of heights, towards space, towards that which is at once nowhere and everywhere. And having mastered the force of attraction, we shall literally levitate in complete physical and spiritual freedom."[307] A body as light and lighter than air, just as we shall live naked in the city of Eden, where the air is as hot and softer than the body.

The Embrasure

A paradox that comes true is no longer a paradox. Fountains of water and fire transmute the elements: fire pours out from fountains and water kindles the flame, as occurs in the F 81 painting where three marks spiral in the charred halo of a dark fire fuelled by the splashing water. "Water is a burnt body" (Balzac).[308] Another paradox unmasked: the *Monotone Symphony* opens with a silence where virtual harmonics vibrate. The IKB monochrome is also an apparent impossibility, the source of radiant blue and of static movement. "Color . . . is that which is most immersed in cosmic sensibility. Sensibility has no hidden recesses, it is like humidity in the air."[309] Monochrome is *elemental*, in all senses. Yves Klein can thus brazenly claim it is *classical*, in itself, and *figurative*.[310]

This paradox also affects the *flesh*. Because this flesh is not matter made from clustered atoms, nor psychic material, nor a fantasy projection of the mind. It is an *element* like air or fire. At the point where the visible and the invisible meet blossoms a clear zone around which two worlds *pivot*. This is where Yves Klein's work is. *In the embrasure*.

Color is the best way of understanding the flesh of the world. It is neither an essence nor an event, just like itself. Neither subjective, nor objective. It's a sensitive medium enveloping us. "When we begin to open our eyes to the visible, we have long since committed ourselves to the invisible" (Gabriele D'Annunzio).[311]

Yves Klein arouses far more than an intelligence of the world and a sensual experience of what it is. He demands true *sensibility*, where perception and intuition are intertwined. In architecture, painting, and music, he draws out the reserve of the visible. Fire and water are excellent *oneiric conductors*: they open within and exchange roles on the outside.

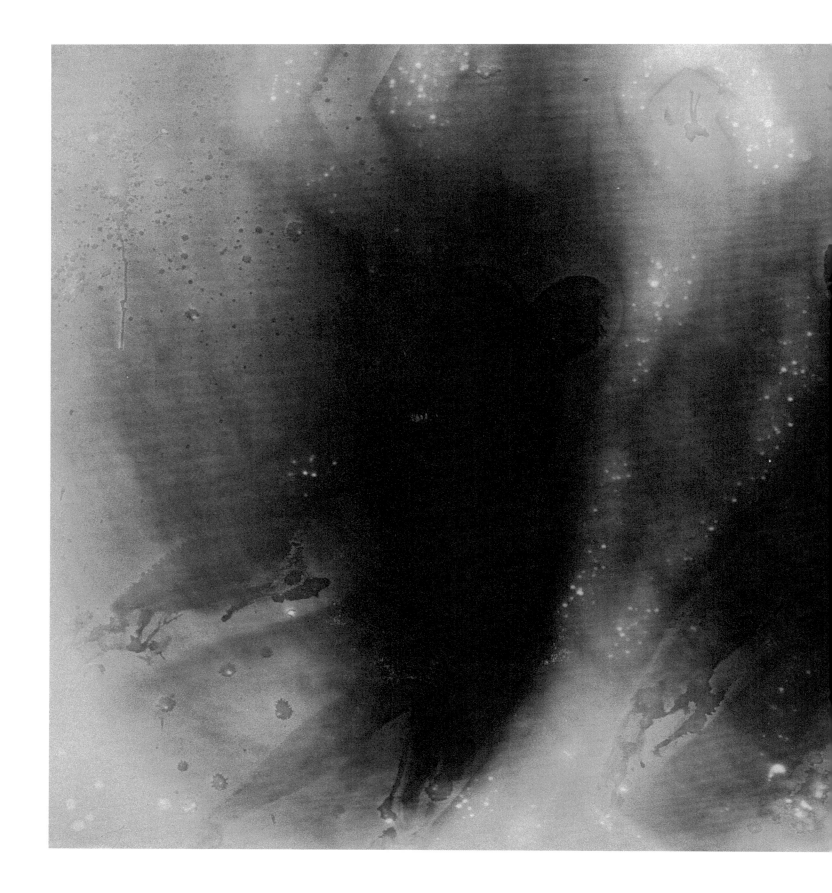

Untitled fire painting (F 81), ca 1961

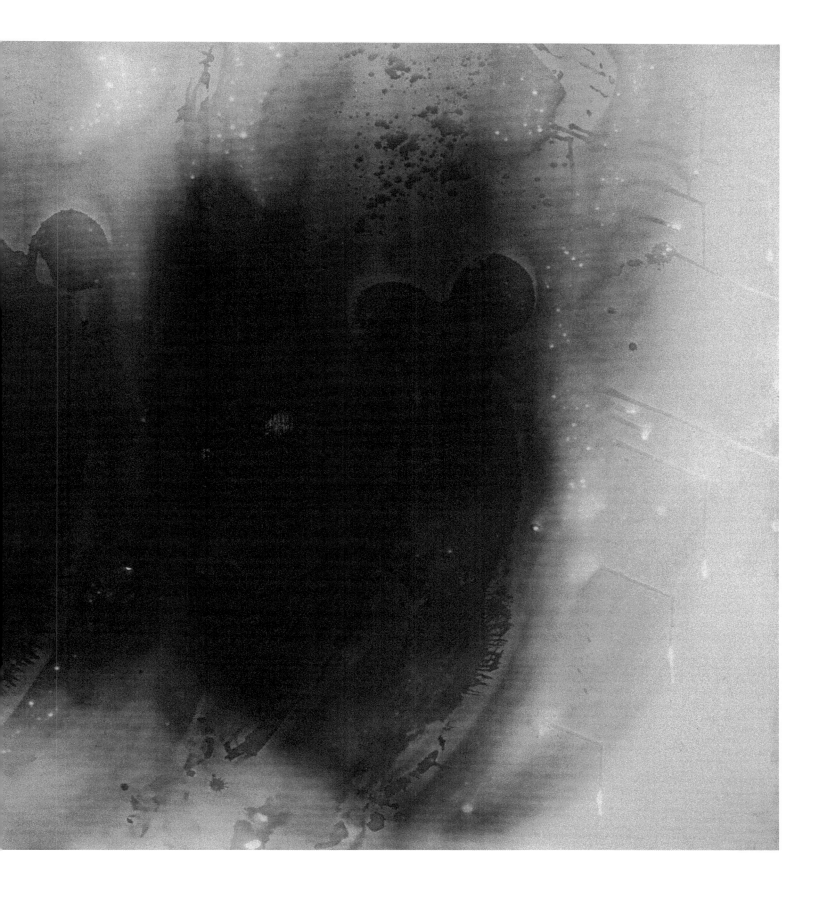

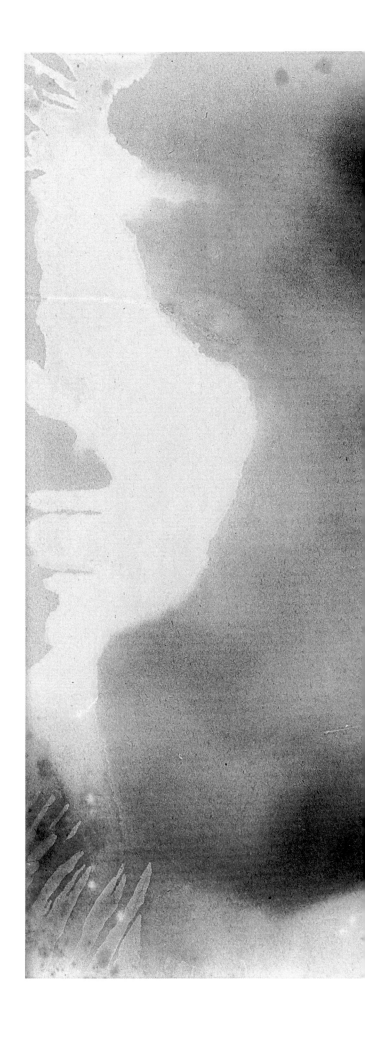

Untitled fire painting (F 119), 1962

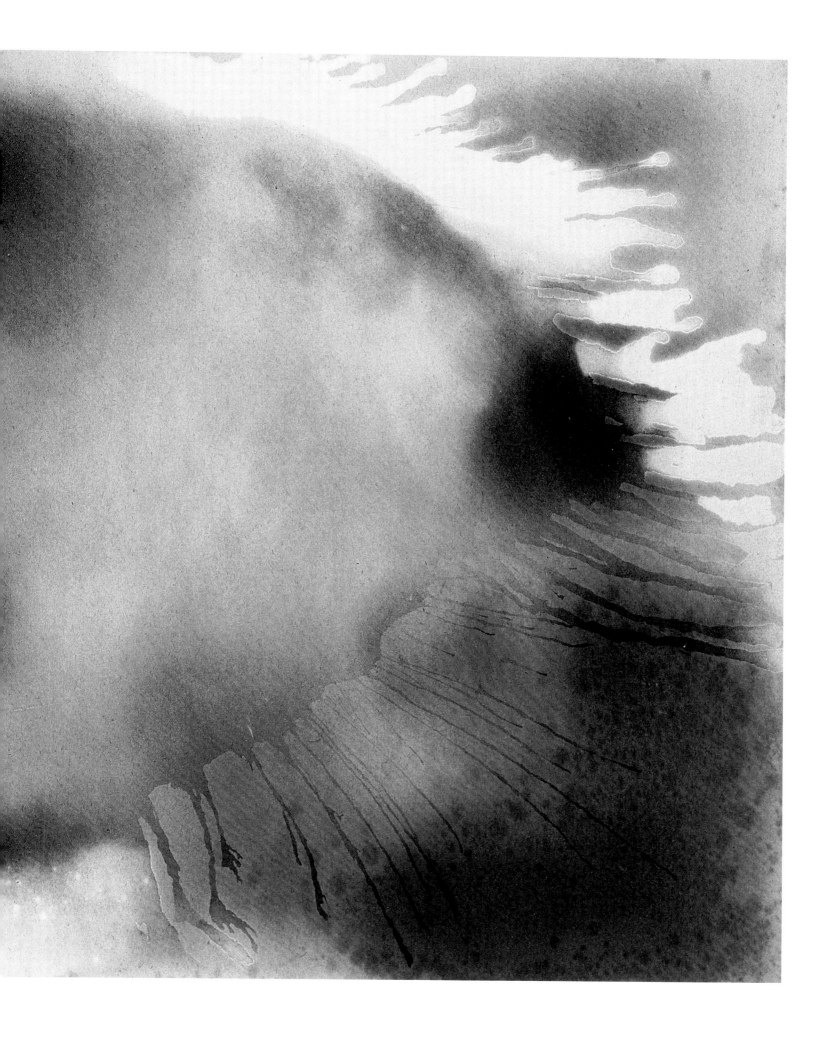

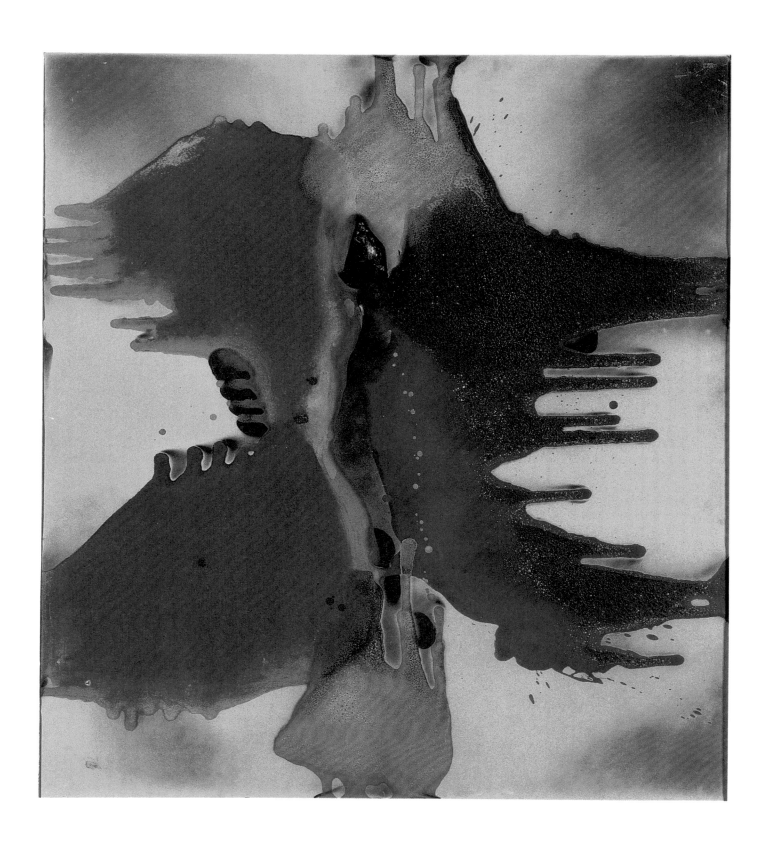

Untitled colored fire painting (FC 17), 1962

Under the boundless brightness of the blue waters,
a flesh flower that the wave perfumes
Rimbaud

The Fold

Yves Klein wrote: "The immaterial is the material dimension of the void,"[312] as his *Symphony* is the sound dimension of silence. In the same way monochrome permeates the space buried within, which it already potentially contains.[313]

Through the flame, "the coldest *metaphors* truly become *images*."[314] Like the visible and the invisible, swirling within the flame, one inside the other, the latent Eden is wrapped in the world. It is enough to be aware of this truth for it to come true. Thus emerges the image of a world with two wellsprings, real and virtual.

Fire paintings, *Fire-Colors*, and many other works. They are all examples of the *fold*. If the world were a sheet of paper, it would actually be a visible one, folded back on the invisible. Gilles Deleuze speaks of *plane of immanence with two facets*[315] in the same way as a sheet is both recto and verso. Yves Klein opens this area of paradox out: not a surface, but a *contact*: the *embrace* of two regions.[316] A *fold*.

**"The secret terror of the flesh
like quivering lightning."**[317]

How to suggest latent invisibility in painting? Yves Klein has two ways: by superimposing the planes, or by making use of the recto and the verso of the work.

The painting entitled *Les Éléments et les couleurs* (1962) is emblematic of the first process: after torching the panel in order to impregnate the ochre flesh with fire,[318] Yves Klein pours on liquid blue and pink. The *primordial* orange ground shows through under the colors.

The work can develop on both the visible side and on the reverse. The fold is the key point. *Anthropométrie 6* comprises two images: a body seen in profile bathed in the blue density, and on the back, *stolen* from sight, the mark of an eight-flame gas burner repeated twenty times, like an under-skin tattoo of strange burned asters. "Under the boundless brightness of the blue waters, a flesh flower that the wave perfumes."[319] In the same way, the perforated *IKB 25* paper is virgin and burned on the recto, and uniform blue on the verso.

The *monogolds*, described as *frémissants* (quivering), are another expression of the flesh of things. Their leaves do not form only an old-gold moiré skin. They also vibrate every time a body passes close by. They quiver every time

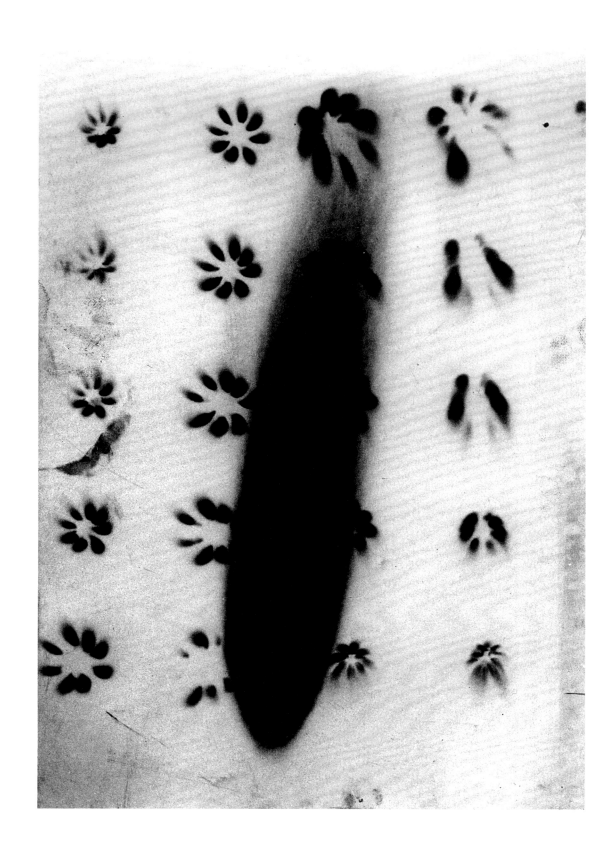

Untitled anthropometry (ANT 6, verso) 1961

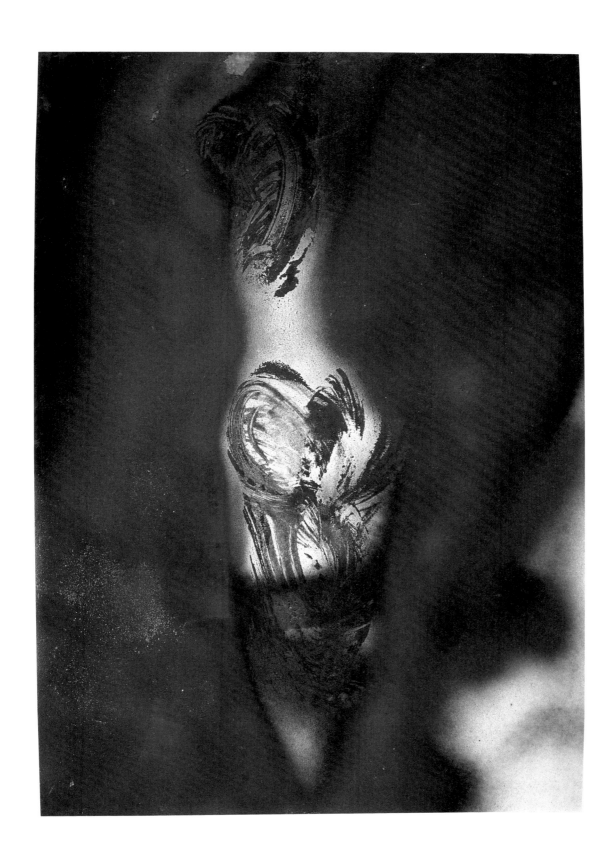

Untitled anthropometry (ANT 6), 1961

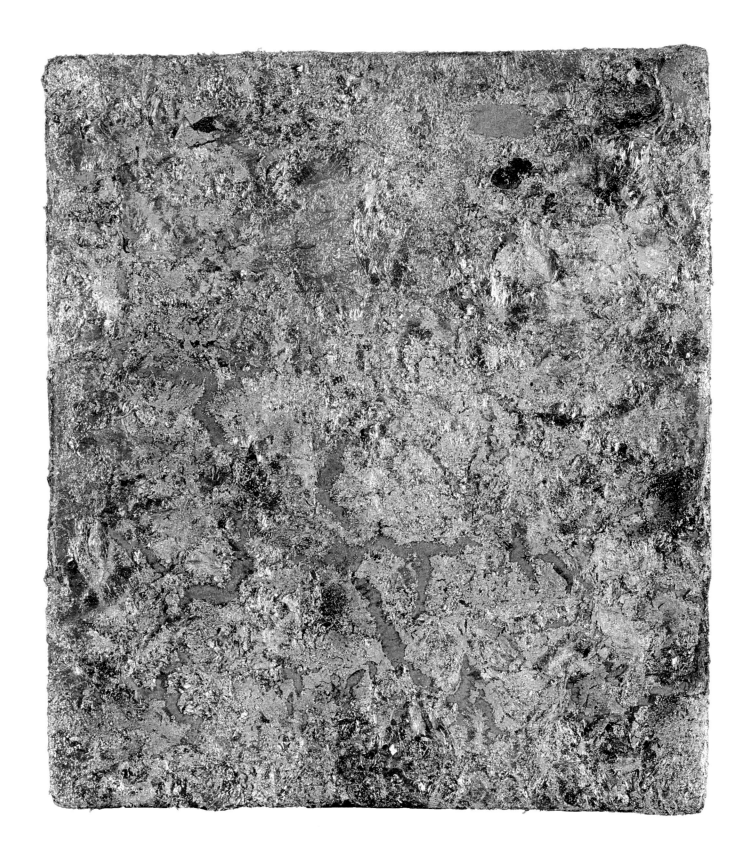

Untitled monogold (MG 3), 1960

there is immaterial contact. And the air that sighs past them conveys my presence. I *animate* them. Collusion blows between their texture and mine. Their quivering is the image of my own quivering before them; we look alike. Under their shivering skin lives their invisible flesh. Thus, on the back of the *Monogold MG 19* is an IKB monochrome.

"So it must be a direct and immediate assimilation-perception no longer relying on any effect, trick, or stunt beyond the five senses, in the realm shared by man and space: sensibility."[320] What can be seen can be touched with sight. The flesh is impregnated with diffuse sensibility, as if by osmosis, like the drops of water in *Cosmogonie de la pluie* (1961), which attract blue pigment to them and concentrate it. "Matter of the soul"[321] "sensuality of the mind"[322]: Yves Klein envisages a union of the soul and the body[323] through the experience of this flesh.

This World, a Possible Eden

Where is this union taking us? Towards the ideal realm, where imperfect reality is dissolved? Not at all. Here, transcendence is a feeling of *fulfillment* or *bliss*. It is not concerned with a shadow world we might catch a glimpse of, like the mystics, and where we would go after this life. The visible world transcends within itself, and reaches deeper without losing touch with itself. A possible *potential* world: this is what Yves Klein wants to achieve. Not the potential of a hereafter, but of an *already here*, latent and profound. This is what his *Symphony* conjures up. This is what, in *its image,* several *Monogolds* such as *Le Silence est d'or* or *Résonance* also point towards. Gentle craters dent its surface, appearing as so many muffled percussions. Resonance is the mark of a sound which lingers. Under the golden skin of the *monogold*, one can imagine an elastic flesh for absorbing the impact: the vibrations continue within. The mass, within its outlines, softly surfaces under the skin. In other works, Yves Klein torches the *monogold* so that the gold peels off and a still unblemished flesh shows through beneath the scars. Fire, the *ultra-living* . . .

Yves Klein's work does not aim to capture the impossible essence of things which always turns the world into a pale reflection of the ideal being. It is as one with life, in the most luminous way. Such is its transcendence. Klein made a gift of a *monogold* entitled *L'Âge d'or* (*MG 42*) to his spatialist friend Lucio Fontana, who slashed his canvasses with a razor blade to suggest a background. A possible Eden regained. In this tension between visible and invisible, between perceptible reality and latent power, Yves Klein has a solid ally in Novalis, of whom Bachelard wrote: "Instead of saying that Novalis is a *Seer* who sees the Invisible, I would rather say that he is a *Toucher* who touches the untouchable, the impalpable, the unreal."[324]

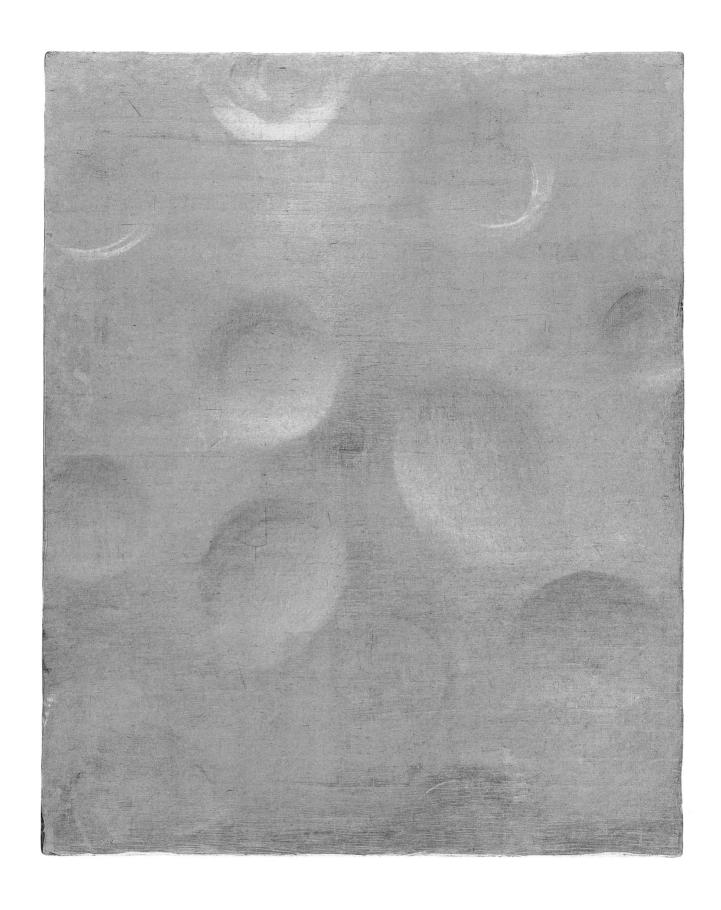

Résonance [*Resonance*] (MG 16), 1960

One should therefore imagine Yves Klein on fire hunting in the void and stirring up the world's power under the skin. Like fire, he "makes the space before him draw back."[325] In oneiric reality, concrete reality persists and drifts away. For it is impossible for Being to break away from these images which are such a part of it. As Yves Klein writes: "This imagination I'm talking about is not a perception . . . It has nothing to do with the five senses, with the realm of feeling or even with the purely and fundamentally emotional."[326] It explores Eden and returns full of fleeting images. As the *monogold* entitled *MG 5* has a skin blistered by something squeezing it. Just like air, fire, water, or flesh, imagination is an element *in life* and a *life* element.

In the face of the irony of the blasés, Yves Klein displays an insolent calmness.

> "I settled for feeling; I came back and sought sanctuary in impeccable naïveness"(Baudelaire).[327]

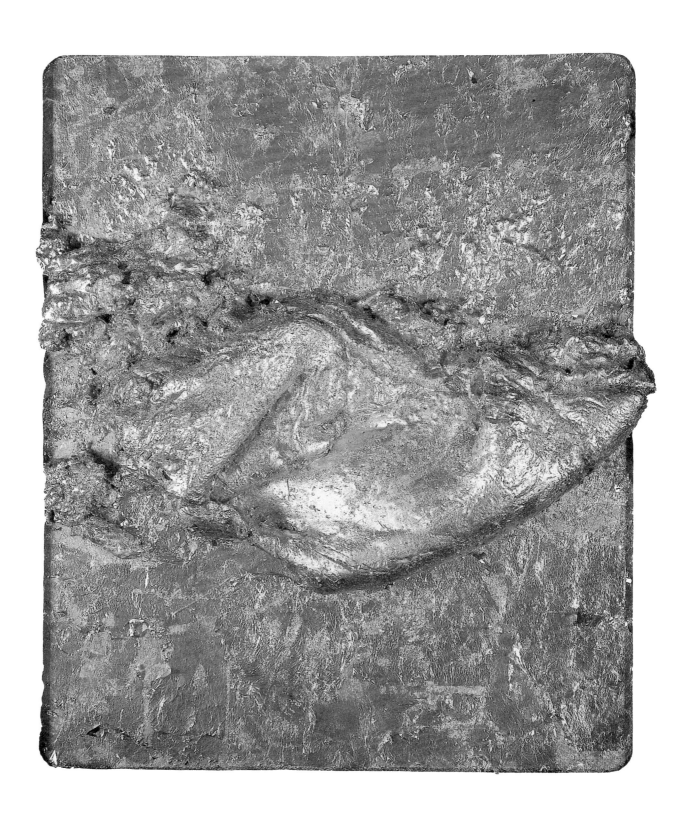

Untitled monogold (MG 5), 1961

IN BROAD DAYLIGHT

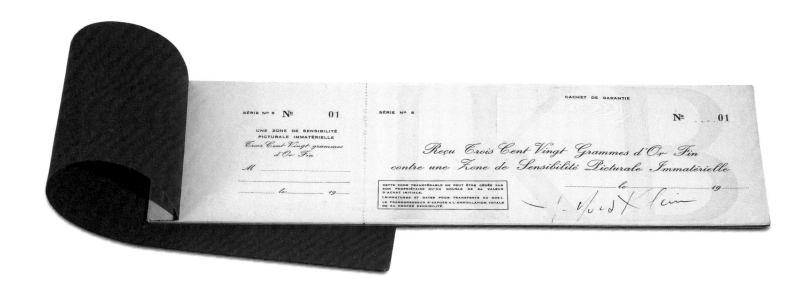

Top: model for a counterfoil book (Series A Certificat no. 2), 1959 | Bottom: receipt book for the *Zone of Immaterial Pictorial Sensibility*, 1959

**The instant is a particle conceded by time
and inflamed by us.**[328]
Char

February 10, 1962.
Stairs of the Pont au Double, Île de la Cité embankment, Paris

The time has come. Yet something is still holding me back. My hand hesitates, clutching the gold I am about to throw into the river's maw. But before that, just a moment more.

Standing in front of the world, I breathe. I wonder. For under the air, behind the façades and the waters, something is there; I can feel it. My life turns in on itself, and so does the world. The ingots seem to be heavier, as if, deep down, they were resisting the gesture I am weighing up. I now realize their value has grown immeasurably. Who is the offering for? There lies the mystery. We are ourselves the instruments of our grace, of a gesture with which we get rid of ourselves.

A question haunts me as this gold will soon disturb the river's eddies. Have I got all life long? I want more. I want all my life. "Oh, but to vanish like the trackless cloud! / Wrapped in wetness and in dew."[329]

The time has come. With one sweep the ingots are thrown into the river. I am watching them arc through the air. I am that look. I am

"Close, invisibly close and so close to my fingers" (Char)[330]

"I was about to receive as a gift a piece of immaterial pictorial sensibility, which would enter into me and never leave me, until my dying day, or maybe even beyond."[331]

On February 4, 1962 Dino Buzzati adhered to the ritual conceived by Yves Klein for the cession of the *Zone of Immaterial Pictorial Sensibility*. This projection of being into a vast, secret region awoke in the Italian writer a thought he was fond of and on which he had based a novel in 1949: *The Tartar Steppe*, the story of the exasperating wait[332] of Lieutenant Giovanni Drogo, posted to Fort Bastiani, on the edge of the desert. The young officer stays at his post for thirty years. He grows old, and suddenly one day the enemy shows up, as if from a dream. At last the fighting he had imagined a thousand times begins. Something is fulfilled, the hope of a vital event.

The great depth of monochrome—preserved in the IKB pigment—awakens the depth of the surrounding world. It shines there. "The presence of the painting invades both the space and the viewer."[333] Yves Klein took his first steps along the path to immaterial art in Colette Allendy's gallery in May 1957. All his work to come was already there, in its essential structure.

The exhibition is an initiatory journey.

Paravent [*Folding Screen*] (IKB 62). 1957

The first works are made of blue skin and flesh, suggesting invisible and buried regions. Here, a blue folding screen with five open panels. Further along, a tall tapestry, also ultramarine, suspended over the void. Both conjuring up a background. A few meters away, in a big pool, lies a bed of IKB pigment, like water without clarity. A "buried water" (Rimbaud).[334] There are also sculptures of projected shadows. Finally, a blue monochrome inlaid with Bengal lights stands on an easel in the garden. These lights crackle as they blaze in the incandescence. And when everything goes out, the blinding image lingers a moment in the retinal memory. The artwork reverberates in the imagination and immaterializes itself.[335]

The journey goes on. It takes us to the bottom of a staircase. There, the visitor is invited to climb to the first floor, where *Surfaces* and *Blocks of Pictorial Sensibility* are on display. Yves Klein accompanies the visitor and shows him an uncompromisingly immaterial, impalpable, and invisible work. An archive film[336] shows him soberly executing a gathering gesture. Sensitive as he is, the visitor cannot find any way of getting his bearings. *Poetic energy*[337] spreads with no landmark, like the immaterial city vibrating in the air.

Time for imagination to get to work.

A year later, Yves Klein introduces a new *pictorial climate*[338] at the Iris Clert gallery (April–May 1958). After emptying a room of all objects, he paints the walls white and then leaves. This freshly created empty space is now home to the void. Welcome: come in and feel your whole self reverberate, as music does in the silence of the *Symphony*.

The exhibition caused quite a stir. Albert Camus attended it and slipped a sheet with the NRF letterhead into the visitors' book, on which he wrote: "With the void, full powers."

Yves Klein's artistic adventure intrigued him. He owned a red monochrome[339] and a second, blue one.[340] His novel *The Fall*, published in 1956, was particularly concerned with the theme of presence leaving a void in its wake. In it he tracked the peregrinations of the famous panel of the *Just Judges* on *The Mystic Lamb* altarpiece (1432) by the Van Eyck brothers. One night in May 1934, a thief broke into Saint Bavo Cathedral in Ghent and stole it. It disappeared without trace. Jean-Baptiste Clamence hid the painting the whole world was looking for in a hotel bedroom. One night, a bouncer at Amsterdam's Mexico-City bar took it down from over the bar and gave it to him to look after, leaving only the outline on the wall: "You see for instance that empty rectangle above his head on the back wall, marking the place where a picture was taken down. Well, there *was* a picture there, and a particularly interesting one, a real masterpiece."[341]

What would happen, wonders Yves Klein, if a painting were to be removed from a room where it had hung for a long time? First of all its absence will be noticed. "But after a while people will get used to it and start to perceive a

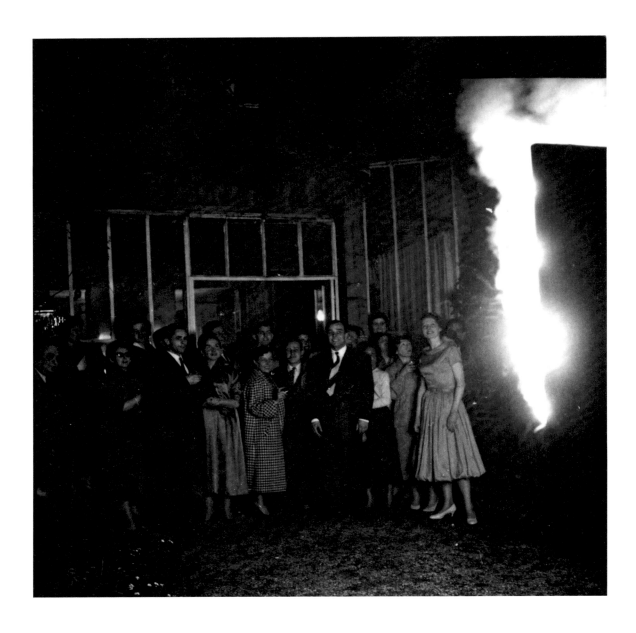

Creation of *Tableau de feu bleu d'une minute* [*Blue Fire Painting of One Minute*] (M 41), Galerie Colette Allendy, May 1957

Tableau de feu bleu d'une minute [*Blue Fire Painting of One Minute*] (M 41), 1957

Yves Klein presenting a "pictorial intention" in the room
reserved for *Surfaces et blocs de sensibilité picturale*
[*Surfaces and Blocks of Pictorial Sensibility*], May 1957

nrf

Paris, 17, rue de l'Université — 5, rue Sébastien-Bottin (VII⁰)

Avec le vide, les pleins pouvoirs.

Albert Camus

Albert Camus, *Avec le vide, les pleins pouvoirs* [*With the Void, Full Powers*], 1958

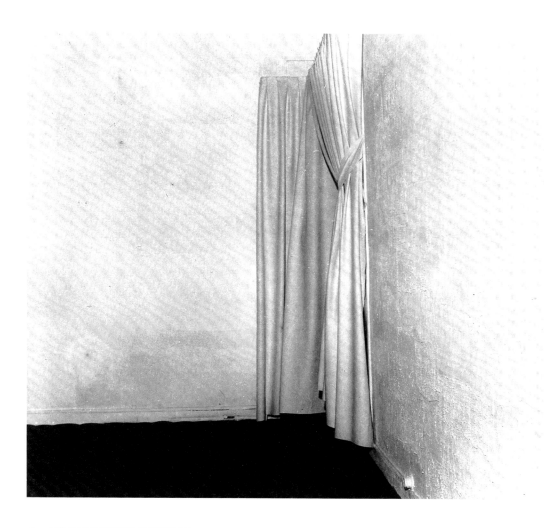

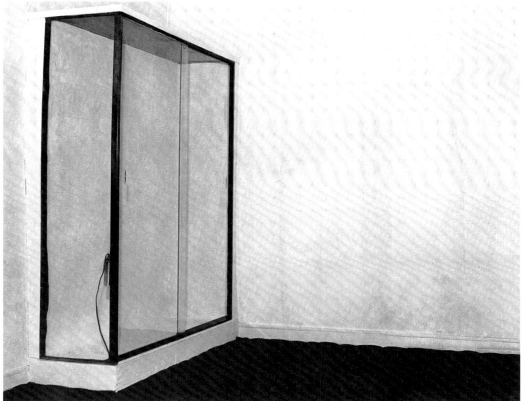

La Sensibilité picturale à l'état matière première, spécialisée en sensibilité picturale stabilisée
[*Pictorial Sensibility in Raw Material State, Specialized as Stabilized Pictorial Sensibility*], April 28–May 12, 1958.

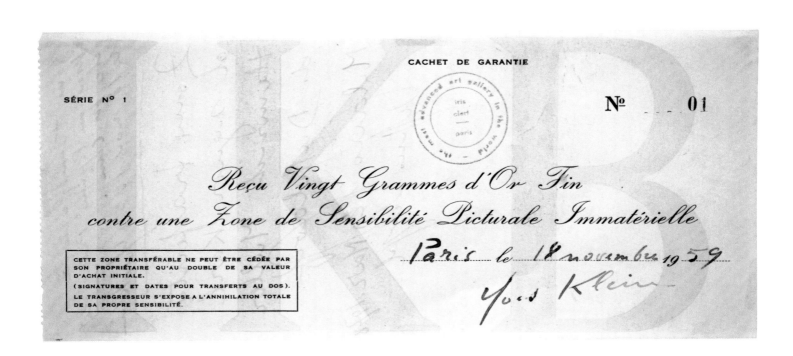

Receipt given to Peppino Palazzoli | Series 1, Zone no. 01, Paris, November 18, 1959

new presence emanating from and created by its past physical presence."[342] To speak about the void here would in fact be imprecise. It would be more accurately regarded as a zone of contact between the past and the mark it has left behind. Is the *void* thus actually the name given to what is virtual in the real, when time frames overlap? The *empty rectangle* of Albert Camus and Yves Klein is an instance of the concrete abstract: the enduring past, potential present. The depth of the world is not just a matter of the geography of the invisible and the visible, but a unified time incorporating all other times.

How to prompt an experience of the immaterial that is even more direct than is experienced through monochrome or music? Yves Klein views it as an initiation, and he arranges a series of rituals where art alone is "the great temptation to grasp life, the great stimulant urging one to live"(Nietzsche).[343]

Suspicion and the Market

The first *cession* of a *Zone of Immaterial Pictorial Sensibility*, to the Milanese gallery owner Peppino Palazzoli, was concluded in fall 1959. In order to authenticate this intangible transfer, he was given a signed certificate.

Yves Klein first drew up the terms of an immaterial transaction at the opening of the *Vision in Motion* group exhibition, in Antwerp, a few months earlier. On March 17, he wanted a one kilo ingot of pure gold in exchange for the invisible artwork he would present *in person* to the public. By the very act of putting a price on it, he was giving it substance in the eyes of the world. The performative principle of value: I *have value*, therefore I *am*.

Oh, a life of adventure . . .
won't you grant me such a life?
Rimbaud

Isn't selling the immaterial like selling smoke? And doesn't setting a price also lead to the suspicion of being embroiled in the market concept of added value? Yves Klein had to invent a protocol that would preserve the spiritual value of the operation, while acknowledging the demands of the art market.

Yves Klein started by discarding the word *sale* in favor of *cession* or *transfer*. Indeed, it was not the incidental cash gain he was after but a resurgence of life in itself.[344] The receipt book was larger than the checkbook, in order to underline the difference. The IKB blue cover was anointed by pure color, warding off the machinations of the market and on each detachable certificate had his three-letter monogram printed on it, like a purifying seal. Yves Klein only had to add the place and time of the transfer and sign it. Iris Clert's

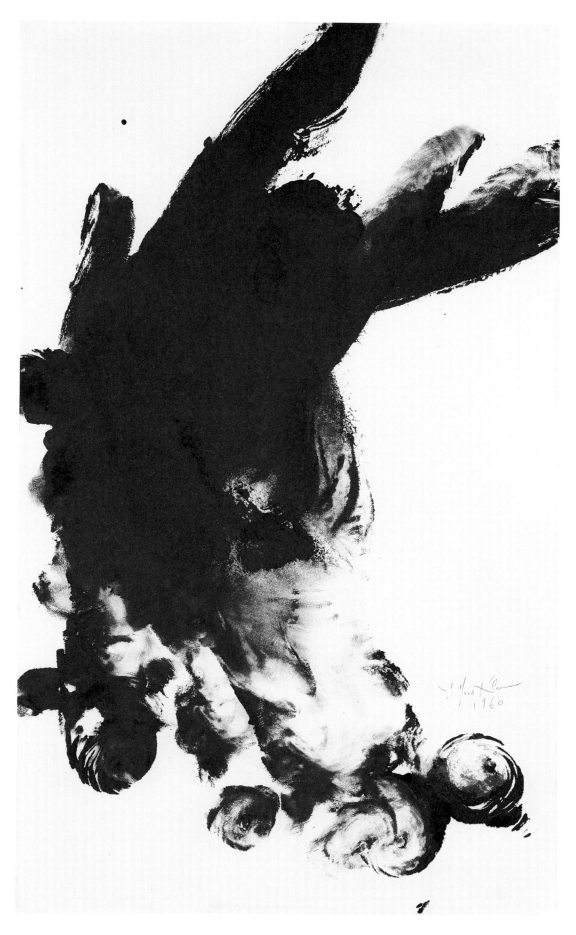

Untitled anthropometry (ANT 47), 1960

printer made six of these receipt books, with ten receipts each. A final one with thirty-one unnumbered zones (series n. 0) completes the set.[345]

Gold and gold alone. Paper money came up against his *natural* squeamishness. So Yves Klein jettisoned anything that could vitiate the meaning of the immaterial ritual as this operation was an act of faith. Besides, half of the sheets or ingots would end up in the sea, a river, or "some other place in nature where this gold cannot be retrieved by anyone."[346] Irreversible squandering is the exorbitant gesture of ritual . . .

The immaterial subverts the materialist principle of property. Possessing is not enjoying, as the *Règles rituelles* point out.[347] As long as the buyer of a *Zone of Immaterial Pictorial Sensibility* has not solemnly burnt his certificate, the only sign of the transfer, he cannot incorporate the immaterial within himself. Keeping the receipt means interrupting the operation before it has reached its natural conclusion, which is *communion*.[348]

Yves Klein accepts the transfer of receipts.[349] But on every certificate he warns: "This transferable zone may only be ceded by its owner for double its initial purchase price."[350] So, the greater the value, the more it costs to burn the receipt, and consequently the greater the sincerity when the act is at last performed. That is how Yves Klein bypasses the speculative mechanism. The added value reinforces the spiritual value of the action. Doubling the price is also a way of putting off the buyers who would actually be unresponsive to the immaterial and its ritual.

Between September 1959 and February 1962, Yves Klein ceded a total of nine *Zones of Immaterial Pictorial Sensibility*.[351]

Peppino Palazzoli, the first "buyer"[352] (series 1, zone 1), came across the IKB monochromes in Guido Le Noci's Apollinaire gallery in Milan in January 1957 and was immediately captivated.[353]

In December of the same year, three other transfers took place: one to Jacques Kugel[354] (series 1, zone 2), an antiques dealer specializing in outstanding silverware; one to Paride Accetti (series 1, zone 3), a Milanese lawyer, businessman, and art collector[355]; and one to Alain Lemée (series 1, zone 4), an auctioneer at Hôtel Drouot.

In 1961, Yves Klein "sold" two special zones from the 0 series. The first was transferred on February 28, 1961, two days after the Krefeld Museum Haus Lange retrospective closed. It was acquired by Paul Wember, the museum's director, who wrote the catalogue introduction for the *Yves Klein Le Monochrome* exhibition held in Leo Castelli's famous New York gallery in April 1961. On June 14, the second zone went to the painter and sculptor Edward Kienholz (1927–1994), founder in 1956 of the avant-garde "Now Gallery." Yves Klein met Kienholz in Los Angeles, where he held his second American exhibition at the Dwan Gallery (May 29–June 24).

The three most remarkable of all the cessions—except Krefeld's—took place

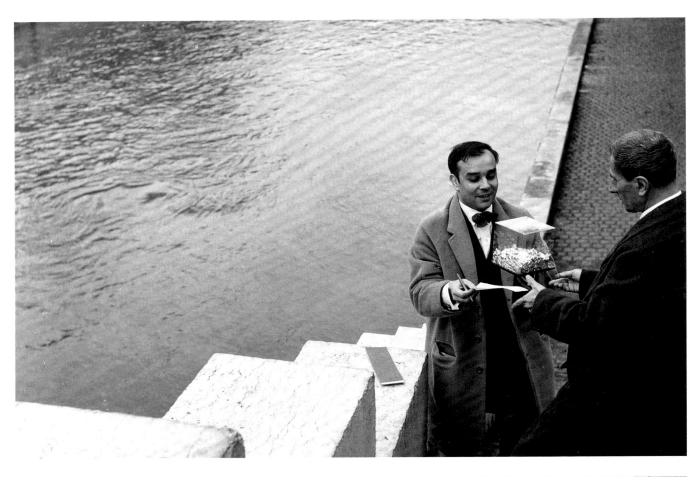

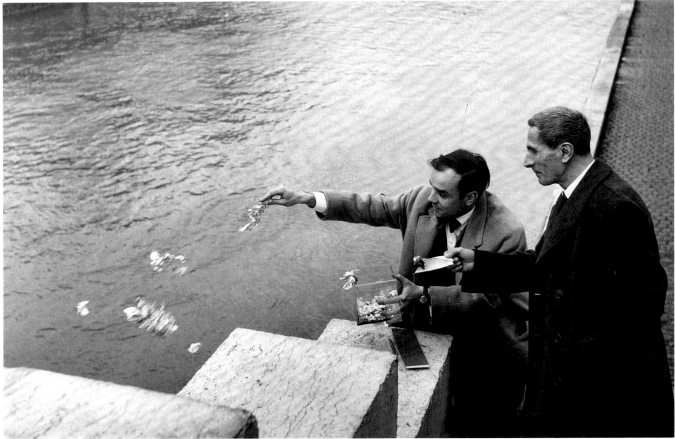

Yves Klein's cession to Dino Buzzati of *Zone de sensibilité picturale immatérielle* [*Zone of Immaterial Pictorial Sensibility*], series 1, zone 5, January 26, 1962

in January and February 1962, on the steps of the Pont au Double bridge, below Notre-Dame Cathedral, Paris. On January 26, the writer Dino Buzzati acquired zone 5 of series 1. He later gave an account of the transfer in his article "Sortilegio a Notre-Dame" published in *Corriere della Sera*.[356] On February 4, it was the turn of the poet Claude Pascal, childhood friend of Yves Klein, who received zone 6 of series 1. Finally, on February 10, the Hollywood screenwriter Michael Blankfort[357] secured zone 1 of series 4.[358]

"Oh, a life of adventure . . . won't you grant me such a life?" (Rimbaud) [359]

To change life through inner *enlightenment*. Yves Klein invents a donation ritual designed to focus attention on the world. The only transcendence one is led to is the transcendence of life itself, quickened to its very depths. It is *envisaged* within the world's invisibility.

The ritual is structured as a moment of self-dispossession, immediately superseded by a sensation of life rushing forward, unbridled. A single and only flesh mends between oneself and the world. The visible acquires mystery from the moment the gold is thrown into the river. The body and the immaterial exchange qualities. Life, strange and penetrating, is no longer quite the same nor quite another.[360]

This cession of immaterial recalls the *potlatch* ritual where a gift calls for other gifts in return, in a symbolic escalation. This anthropological concept originally applied to a gathering of several tribes of Native Americans for a feast where they exchanged gifts. The chain of gifts and counter-gifts was a battle in generosity between rival headmen: the winner was the one who had given away and destroyed the most wealth by the end. Yves Klein's ritual retains the *potlatch*'s principle of the squandering of luxury (the offering of gold) and the escalation, but does away with the aggressive rivalry.

Klein's *potlatch* is based on the paradox of the gift: giving is actually acquiring power. By responding to a gift with the donation of an item of greater value, the actors in a *potlatch* display their indifference to wealth as such and the importance they attach to the honor associated with generosity.

For the purchaser, the receipt can become what Marcel Mauss calls a *talisman*.[361] Is it just a coincidence that Dino Buzzati uses precisely this word in his article "Sortilegio a Notre-Dame"? This talisman must be burnt in order to incorporate the immaterial in oneself. To hold back would be to deprive oneself of the prestige accruing from the ultimate gift—a weakness Buzzati regretfully confesses.[362]

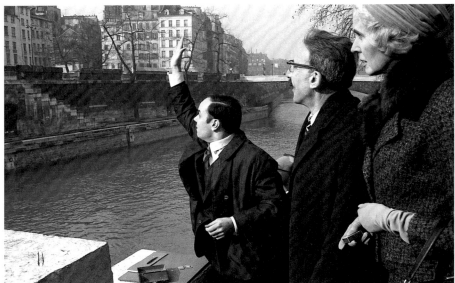

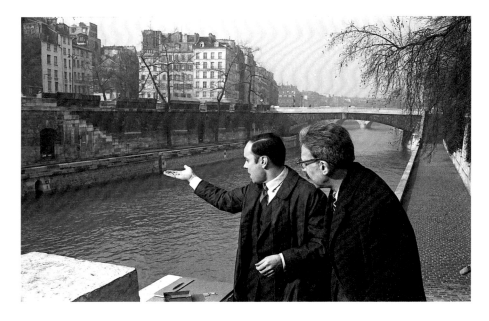

Yves Klein's cession to Michael Blankfort of *Zone de sensibilité picturale immatérielle* [*Zone of Immaterial Pictorial Sensibility*], series 4, zone 1, February 10, 1962

iL RESTE 14 lingots
 YVES FAIT LA PART DE
LA NATURE : 7 lingots...
....et se réserve SA part :
 7 lingots.

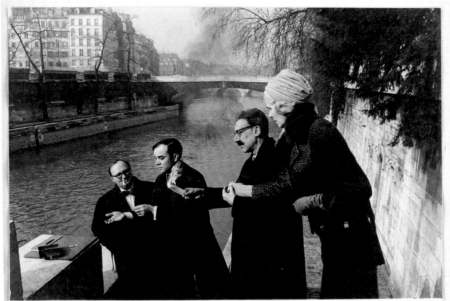

Michael BlankFort Rule
son Reçu

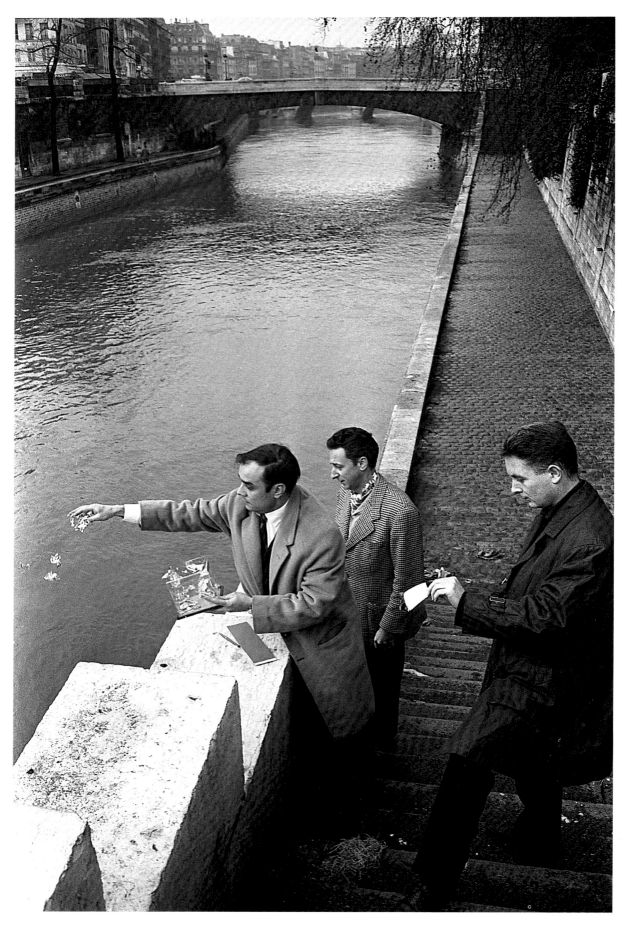

Yves Klein's cession to Claude Pascal of *Zone de sensibilité picturale immatérielle* [*Zone of Immaterial Pictorial Sensibility*], series 1, zone 6, February 4, 1962

*I had, in truth, undertaken to restore him
to his primitive state of child of the Sun—
and, nourished by cave wines and biscuits
of the road, we wandered, with me impatient
to find the place and the formula*

Rimbaud

Right under One's Eyes

The performance of the ritual requires witnesses. The artistic value of Yves Klein's act is substantiated by certificates provided by experts (museum directors, art critics, or art dealers[363]). But even before all this, the *potlatch* needs an attentive audience in order to achieve its aim. A person giving away his assets wants someone to bear witness to his act. "If he casts things out in solitude, in silence, no sort of *power* would result from the act; the person would experience only . . . a separation from power."[364]

Yves Klein claimed some of the cessions at the very start were secret, with no witnesses or certificate, "freed from all rules and conventions . . . anonymously . . ."[365] The three immaterial transfers of January and February 1962 on the other hand are thoroughly authenticated.[366] Those involving Dino Buzzati and Claude Pascal took place before Jean Larcade, Director of Galerie Rive Droite, where Yves Klein exhibited in October–November 1960.[367] The cession of the immaterial to Michael Blankfort required the assistance of six witnesses: François Mathey, curator of the Musée des Arts décoratifs ratified the operation, before Andrée Bordeaux-Le Pecq (Chairwoman of the "Comparaisons" art showroom), Jeanine de Goldschmidt (Director of Galerie J, in addition to being Pierre Restany's wife), Virginia Dwan-Kondratieff (a gallerist from Los Angeles), Jean Larcade, and Pierre Descargues (art critic for several magazines).

Yves Klein recorded these three cessions in an album of twenty-two photographs annotated on ink wash paper. He also added the English and French versions of his *Règles rituelles*, a portrait of him standing in front of the flying buttresses of Notre-Dame and four newspaper cuttings. Michael Blankfort claims—wrongly—that he was not told a photographer would be there. As he put it: "An immaterial ought to be altogether immaterial. Making a film recording seemed to go completely against the artist's intentions, as well as clashing with the sense of purity that was pervading me at the time."[368] But this ignores that the agreement included a photographic record of Yves Klein receiving a counter-gift.[369]

The photographic or film record of the immaterial is proof of the event as well as being an archive document. The *Blocks of Sensibility* were filmed in

185

Taking down pictures exhibited in the Salon Violet at the Musée d'Art Moderne de la Ville de Paris, January 26, 1962
Jacques Villeglé, François Dufrêne, and Yves Klein

Colette Allendy's gallery in May 1957, and a year later it was the turn of the *Void* in the Iris Clert gallery. On March 17, 1959 Yves Klein arranged for his invisible work to be photographed at the Hessenhuis in Antwerp. On October 19, 1960 Harry Shunk and John Kender photographed his *Leap into the Void*. A few months later, in February 1961, several snapshots show him from the front and from the back going into and coming out of the *empty room* in the Museum Haus Lange in Krefeld. On January 26, 1962, on the very day of Dino Buzzati's cession, Harry Shunk photographed Yves Klein, Jacques Villeglé, and François Dufrêne taking down the paintings in the Salon Violet in the Musée d'Art Moderne. The aim was to *empty* it and then *fill* the void with the works of the New Realists. In the center of the "Comparaisons" art showroom catalogue were two images facing one another: on the left side, the room with the works of Villeglé, Spoerri, Niki de Saint-Phalle, Hains, Dufrêne, Raysse, Rotella, Tinguely, Anouj, and Arman; on the right side was the same room, taken over by Yves Klein's void.

Illumination has *fire and place*. It incorporates a space which reformulates life.

> "I had, in truth, undertaken to restore him to his primitive state of child
> of the Sun—and, nourished by cave wines and biscuits of the road,
> we wandered, with me impatient to find the place
> and the formula" (Rimbaud).[370]

Reformulating the Place

At the very heart of the world, Yves Klein opens naked regions where the immaterial at last makes itself responsive.

So, thanks to *Void*, in April–May 1958 the Iris Clert gallery became a *point of encounter*[371] between the visitor and something indefinable, like a dimension. "[My painting] is absolutely invisible," declared Yves Klein. "It lies in a place, in a location, and at the moment for me my painting lies in this gallery, but I would like it to acquire an almost incommensurable dimension, to spread, to impregnate the atmosphere of a city even, or a country."[372] Yves Klein wanted the obelisk in Place de la Concorde to be the emblem of this *requalified* world and herald the arrival of the new, after nightfall. Spotlights trained on its corners and edges would have lit it up completely, covering it with a blue skin. Released from its base, left in the dark, there the obelisk would have been, hanging in the night, impregnating Place de la Concorde and all of Paris with its "wonderful realism."[373]

The *Void* room, at the heart of the Haus Lange Museum in Krefeld, is another of these *climate* spaces conceived by Yves Klein. On February 28, 1961, it is transformed into zone 1 of series 0. The immaterial sensibility impregnating it dissolves the envelope made of white walls, floor, and ceiling. The space opens out and bathes, bottomless.

VILLEGLE

HAINS

ROTELLA

Niki de SAINT-PHALLE

DUFRENE

TINGUELY

ARMAN

SPOERRI

RAYSSE

ANOUJ

Excerpts from the *Comparaisons* catalogue of 1962. Musée d'Art Moderne de la Ville de Paris, with photograph showing Yves Klein's action

Yves KLEIN - Le Monochrome : une zone de sensibilité picturale immatérielle.
Zone nº 1, Série nº 5.

La zone de sensibilité picturale d'Yves Klein, immatérielle, extra dimensionnelle, existe en soi. Son « merveilleux » constitue l'essence même du nouveau réalisme : ni les murs, ni les dimensions de la salle où elle se trouve exposée ne correspondent à sa vraie réalité. Son intégrité est ailleurs, partout ; inutile d'en dire plus.
P. R.

Vision in Motion-Motion in Vision exhibition at Hessenhuis, Antwerp.
At the vernissage, Yves Klein quotes a saying by Bachelard in his allotted space:
"First there is nothing, then there is deep nothingness, then a blue depth,"
and offers immaterial pictorial sensibility at the price of one kilo of pure gold.
March 21–May 3, 1959

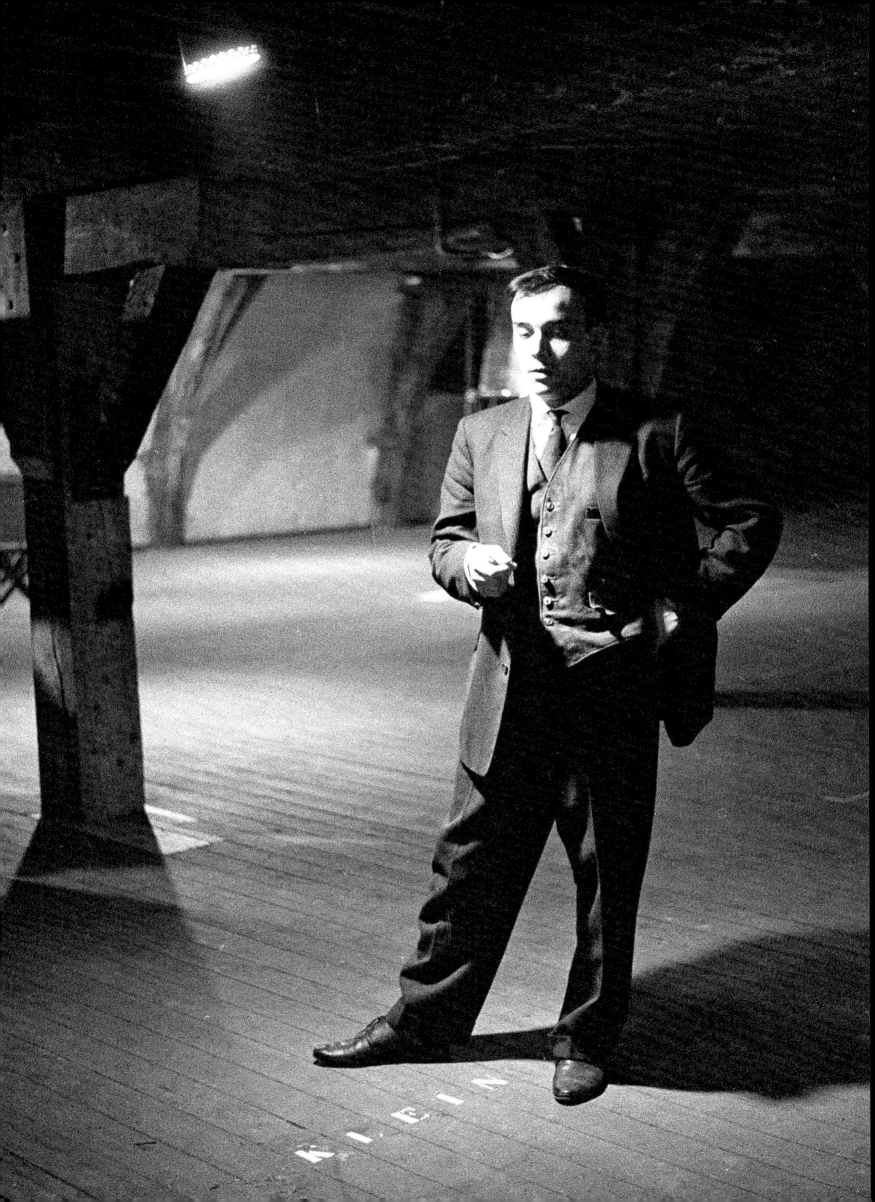

The obelisk and fountains of Place de la Concorde, Paris, with blue lighting effects, October 7, 2006

In January–February 1962, the *zones* given to Dino Buzzati, Claude Pascal, and Michael Blankfort this time encompass the whole world, since the event is to take place in broad daylight, on the banks of the Seine, on the island in the heart of Paris. The spreading city and the broad sky above the river are taken up by the echo of the centuries and the spirit of the cathedral. In this withdrawn place, the body and the world come into contact.

"Gold Burns Blue"

Fine gold is "the immaterial value of the immaterial acquired" (Yves Klein).[374] In the offering, it converses with the invisible and induces illumination.

The three cessions of 1962 adhere scrupulously to the ritual.[375] For Dino Buzzati,[376] Yves Klein puts 19 grams of gold leaf into a Plexiglas chest. The twentieth gram is slipped into a cardboard box intended for Jean Larcade.[377] When the time comes, Klein tosses half of the leaves into the wind and into the river. And immediately Dino Buzzati sees the gold flash in the water and turn into a glittering net,[378] as a photograph shows. He is charmed by the picture. The same procedure is followed on February 4 for Claude Pascal's cession, with the same 20 grams of gold. The transfer of February 10 requires greater ritual commitment, as Michael Blankfort takes it upon himself to acquire 16 ingots of 10 grams each. Two[379] are handed to François Mathey, who has to countersign the receipt; seven are thrown into the river by Yves Klein, who keeps the remaining seven.

A flame completes the ritual incorporating[380] the immaterial. Once the receipt has been burnt, the operation is concluded and no other transfer is possible. Although Dino Buzzati admits having recovered a fragment of his from the flames to keep as a souvenir, he justifies this weakness in the most charming way: in his wallet there is a "store of poetry or happiness"[381] he will be able to dip into when life, overwhelming him one day, urges him to do so. Following the example of Claude Pascal, Michael Blankfort decides to burn his certificate completely: "Since this is 'immaterial,' let's keep it that way," he tells Yves Klein. "Silently, we all watched the contract turn to ash, and when it began to float up into the air, Klein pushed it into the river . . . The Zone of Immaterial Pictorial Sensibility . . . was mine for the rest of my life."[382]

Yves Klein had the idea of burning the gold leaves, too, after learning that they would burn with a bluish flame,[383] the signature of the immaterial. "Gold burns blue."[384]

Owing to its verticality, fire is the image of the future. It invites one to look beyond and more than it. The imagination feeds off its tip, tapering as far as its strength allows. The flame always wants to burn more, higher, for it is the image of a purifying power in action, illuminating eyes and the soul.[385] Like an offering. And indeed, by contemplating the ingots thrown into the air and then

Pluie bleue [*Blue Rain*] (S 36), 1961

From the approval of men,
And common impulses
You dissociate yourself here
And fly off as you can

Rimbaud

swallowed up in the Seine, Michael Blankfort "[feels] purged, as [if he had] flown with them, leaving behind the baggage of daily life."

Air and fire stimulate a burgeoning. Blankfort sheds his old carapace by feeling in his own flesh some affinity with the flesh of gold and of the world. And this flesh turning out to be a lover of matter, in the same way as gold leaf and its glue are said to be *enamored* when they are ready to combine with one another.

Ecstasy, a Surge of Presence

"Slowly my hand lifted higher so as to reach the Seine some yards away, and in a sudden rush of ecstasy, I threw the pieces of gold into the river,"[386] wrote Michael Blankfort.

> "From the approval of men,
> And common impulses
> You dissociate yourself here
> And fly off as you can" (Rimbaud)[387]

Ecstasy, a paradoxical *transport* where the body feels swathed by another flesh. As in the contemplation of blue sky, the *feeling* of incarnation is an escape from the body. The surge of presence passes through a flood of absence. The inner and the outer twist over and blend together.

There is nothing *to see*. "Painting for me is no longer associated with the eye,"[388] wrote Yves Klein. A work is no longer a *representation* of the world but becomes a *space of contact* with it.[389] And by perceiving it from the inside, Michael Blankfort lets it be and lets himself be along with it.

Restoring in the real world the *Eden of legend* is Yves Klein's declared ambition. *Ecstasy* has nothing to do with rapt stupor and entrancing visions, for Eden is not a homeland waiting for man after his death. It is achievable in real life. Not just promised, but right here. "The man of the future will live in a state of absolute harmony with a nature that is invisible and imperceptible to

195

Recovered!
What? Eternity.
The sea mingling with
The Sun

. . .

No more tomorrows,
Satin embers,
Your fervor
Is duty

Rimbaud

the senses, that is to say with life itself."[390] Here is a paradox which is actually hardly one at all.

The cession ritual conceived by Yves Klein is a disconcerting experience of life upside down. He had already attempted this experiment in 1961, when, alone with his tape recorder, he let words bubble out from his deepest thoughts. To establish an *immediate* contact with himself, "to try to dream and continue to dream while speaking . . . to try to capture this spirit of the mind,"[391] without the ego. The recording made of this *dialogue with oneself* opens with the *Monotone Symphony*, whose strength is precisely to draw out primordial music before all melody. "It is quite difficult to hear oneself dream, to dream while awake," murmurs Yves Klein. "It is quite difficult to pronounce thought . . . It's very curious, this state of things. I don't yet understand very well what's happening."[392] To become a stranger to oneself. To break away from oneself and then return to oneself . . . This is the see-saw movement Yves Klein wants to generate in all his work.[393]

"To see oneself turned completely inside out right under one's eyes"[394]: that is exactly what Michael Blankfort experienced on February 10, 1962. "The act of literally throwing away money did not match either my upbringing or my personality. Nevertheless, I felt a wave of exaltation and with it a kind of creativity, which I had only experienced a few times before while writing. It was a sensation of being outside my body, not completely myself; a paradoxical feeling of receiving more than I was giving." The gold offering is trumped by a greater gift: that of the world, inexhaustible donation in flesh.

"I must point out that I've never had my feelings so deeply engaged by any other artistic experience. It released in me a shock of self-recognition and an explosion of awareness of time and space," he confides.

"Poetry, future life within a reconditioned man" (Char) [395]

Immaterial initiation is a recreative experience. Yves Klein reconditions the world, like Pierre Ménard, invented by Jorge Luis Borges. This character is the author of an amazing book, a novel which is extraordinarily similar to Cervantes's *Don Quixote* in form, and yet totally different. Pierre Ménard didn't copy it: his novel is strictly personal and absolutely *original*. In this sense he is the author of *Don Quixote*,[396] just as Yves Klein dreams of an unmeasurable immaterial work[397] impregnated in the element of the world.

Yves Klein wants to use the immaterial to go beyond abstract and idealist metaphysics. His work is *incarnated* and we become its *demiurges*. One needs to have an enthusiastic frame of mind to create, and have vital energy. "Enthusiasm," writes Yves Klein, "is the sole direct link that we have with [spirit]. Enthusiasm is the sole direct and genuine means of investigation; enthusiasm always leads to the goal, which is creation: it lives and creates life;

YVES KLEIN PRÉSENTE :
LE DIMANCHE 27 NOVEMBRE
1960

NUMÉRO UNIQUE

FESTIVAL D'ART
D'AVANT-GARDE
NOVEMBRE - DÉCEMBRE 1960

La Révolution bleue continue

SEANCE DE 0 HEURE A 24 HEURES

Dimanche
27 NOVEMBRE

Le journal d'un seul jour

0,35 NF (35 fr.) — Algérie : 0,30 NF (30 fr.) - Tunisie : 27 mil.
Maroc : 32 f m. - Italie : 50 lires - Espagne : 3 pes. 5

THEATRE DU VIDE

LE théâtre se cherche depuis toujours : il se cherche depuis le début perdu.

Le grand théâtre, c'est l'Eden en fait ; l'important est d'établir une bonne fois nos positions statiques, chacun d'une manière individuelle et non plus personnelle dans l'univers. Depuis longtemps déjà j'annonce partout que je suis le peintre. Je m'en connais pas d'autre aujourd'hui ! Je tiens à dire aussi : « Je suis l'acteur, je suis le compositeur, l'architecte, le sculpteur ». Je tiens à dire : « Je suis ». L'on m'objectera sans doute que cela a déjà été hurlé de toutes sortes de manières variées ; c'est certainement juste. Par conséquent, je le répète peut-être cela, mais conscient, bien conscient d'avoir atteint le droit de le dire ; et voilà que, pour moi comme pour tous, il n'y a plus rien à faire ; le théâtre officiel, aujourd'hui, c'est « être » et je suis à bien effectivement tout ce que l'on veut bien que je « sois » et même tout ce que l'on ne veut pas que je « sois » ! J'attendrai même à ne plus « être » du tout un jour !... Mais, que l'on ne s'y trompe pas : il ne s'agit pas de moi quand je dis je, moi, mon, etc.

C'est parce que l'esprit dans lequel je vis est un esprit d'émerveillement, stabilisé et continu, un esprit classique, que je n'ai aucun caractère d'avant-garde, car elle, vieillit si vite, de génération en génération.

Mon art n'appartiendra pas à l'époque, pas plus que l'art de tous les grands classiques n'a appartenu aux époques où ils ont vécu, parce que je cherche avant tout, comme eux, à créer dans mes réalisations cette « transparence », ce « vide » incommensurable dans lequel vit l'esprit permanent et absolu délivré de toutes les dimensions !

Non, je ne me laisse pas prendre à mon propre jeu en parlant aujourd'hui d'un théâtre du vide avec un tel avant-propos orgueilleux, égocentrique et même vaniteux sans doute en apparence : mon théâtre prendra une valeur universelle dans la mesure même où mes compagnons connaîtront mieux ma pensée que moi-même je ne la connais, car s'ils sont des milliers, ils la refléteront des milliers de fois alors que moi je suis seul.

Je me rends très bien compte que je me présente, tout seul, en écrivant ces lignes avec ce qui semblerait une sorte de complexe du plus fort. Je signale à ceux qui seraient assez aveugles et maladroits pour me donner l'avantage d'attaquer mon exaspération du mot qu'il est bien facile de m'entraîner à la défaite mais à cette sorte de défaite qui sont les veilles des grandes victoires définitives pour ceux qui entrent dans le grand jeu et savent s'exposer.

J'ai lutté contre ma vocation de « peintre », en partant au Japon pour y vivre l'aventure Judo et Arts martiaux anciens de même j'ai lutté contre ma vocation « d'homme de théâtre » ; mais précisément, le Judo par la pratique physique et spirituelle des Katas, m'a constitué malgré moi, ma formation dans cette discipline de l'art qu'est le théâtre, d'une manière imprévisible, mais tout aussi profitable et profonde, sinon peut-être plus encore, que n'importe quelle autre. En présentant ce qui suit, j'obéis à une nécessité profonde, j'agis en réaliste plein de gros bon sens. J'aime Molière et Shakespeare parce que, dans leur œuvre, se trouve cette transparence du vide qui me fascine.

Pour moi « théâtre » n'est pas

● SUITE EN PAGE 2

L'ESPACE, LUI-MEME.

ACTUALITÉ

DANS le cadre des représentations théâtrales du Festival d'Art d'Avant-Garde de novembre-décembre 1960, j'ai décidé de présenter une ultime forme de théâtre collectif qu'est un dimanche pour tout le monde.

Je n'ai pas voulu me limiter à une matinée ou à une soirée :

En présentant le dimanche 27 novembre 1960, de 0 heure à 24 heures, je présente donc une journée de fête, un véritable spectacle du vide, au point culminant de mes théories. Cependant, n'importe quel autre jour de la semaine aurait pu être aussi utilisé.

Je souhaite qu'en ce jour la joie et le merveilleux règnent, que personne n'ait le trac et que tous, acteursspectateurs, conscients comme inconscients aussi de cette gigantesque manifestation, passent une bonne journée.

Que chacun aille dedans comme dehors, circule, bouge, remue ou reste tranquille.

Tout ce que je publie aujourd'hui dans ce journal est antérieur à la présentation de ce jour historique pour le théâtre.

Le théâtre doit être ou doit tout au moins tenter de devenir rapidement le plaisir d'être, de vivre, de passer de merveilleux moments, et de comprendre chaque jour mieux le bel aujourd'hui.

Tout ce que je publie dans ce journal ont été mes étapes jusqu'à ce jour glorieux de réalisme et de vérité : le théâtre des opérations de cette conception du théâtre que je propose n'est pas seulement la ville, Paris, mais aussi la campagne, le désert, la montagne, le ciel même, et tout l'univers même, pourquoi pas?

Je sais tout va fonctionner très bien inévitablement pour tous, spectateurs, acteurs, machinistes, directeurs et autres.

Je tiens à remercier ici M. Jacques Polieri, directeur du Festival d'Art d'Avant-Garde, pour son enthousiasme, en me proposant de présenter cette manifestation « le dimanche 27 novembre ».

— Yves KLEIN.

du tout synonyme de « Représentation » ou de « Spectacle ».

D'importants chercheurs qui, eux, ont été d'avant-garde, comme Tairoff, par exemple, voulaient théâtraliser le théâtre.

Evreinoff rêvait du monodrame, de la théâtralité dans la vie quotidienne, pensée — geste — parole.

★

Ce que je désire : Plus de rythme, surtout plus jamais de rythme !

Et puis mon œuvre n'est pas une « recherche », elle est mon sillage. Elle est là même de la vitesse statique vertigineuse, à laquelle je me propulse sur place dans l'immatériel ! Attention encore, je tiens à bien préciser que je ne dis pas, en parlant de mon œuvre y « C'est bien plus beau parce que c'est inutile ! Non, je dis : « C'est ainsi ce sera ainsi, et personne ne pourra jamais rien faire pour que ce ne soit pas ainsi ! » Pourquoi ? Parce que, précisément c'est « classique ! »

...Ainsi, très vite, on en arrive au théâtre sans acteur, sans décor, sans scène, sans spectateur... plus rien que le créateur seul qui n'est vu par personne, excepté la présence de personne et le théâtre-spectacle commence !

L'auteur vit sa création ; il

Stanislavsky, réaliste extrémiste, aurait souhaité la mort effective et définitive de l'acteur qui doit jouer sa mort en scène. Le précurseur Dada Vakhtangof enferma le public dans une salle de théâtre pendant deux heures dans le seul but cynique de les enfermer tout simplement. Cet événement faisait partie, d'ail-

leurs, de son « théâtre de la révolte » et s'intitulait « La Soirée insolite ».

Le Tchécoslovaque Burian créa un théâtre synthétique ; les personnages de sa pièce, « Roméo et Juliette », étaient des machines fantastiques et infernales qui évoluaient sur la scène pendant que les acteurs en coulisses disaient le texte. Amphithéâtroff montait des piècettes laconiques de dix minutes, coupées de discussions ; les discussions faisaient partie évidemment du programme. Ce qui l'amena à déclarer souvent à son public, qui lui commandait d'avance ses représentations, qu'il était prêt à supporter les tomates, les œufs pourris, mais en aucune manière, les pavés.

Les phonographes, dans « Les Mariés de la Tour Eiffel », de Jean Cocteau, sont aussi de très beaux phénomènes.

★

Il serait trop long de citer ici toutes les tentatives qui ont été faites pour sortir de la convention, de l'optique apprise, de l'académisme, dans le domaine du spectacle de la représentation théâtrale depuis le début du siècle. Je crois que presque tout a été fait, jusqu'à Jacques Polieri dans sa mise en scène de la pièce de Tardieu ces temps derniers, qui fait entendre des voix sur la scène où trois panneauxécrans sont là pour tout décor et toute présence ! (Son idée d'ailleurs est de faire vivre et parler les décors.)

Bravo ! — Quel bonheur que tout cela ait existé, mais attention ! J'avertis bien le lecteur, mon œuvre théâtrale n'a rien, absolument rien à voir avec l'une quelconque de ces directions ou recherches sauf, peutêtre, avec celles d'Antonin Artaud, qui sentait venir ce que je propose aujourd'hui ici. Cependant Artaud, comme bien d'autres « Grands » du vrai théâtre, se perdait dans cette fausse conception artificielle et intellectuelle du Verbe qui en a dérouté tant si longtemps. Pour ma part, je ne sais qu'une chose, c'est qu'au commencement était le Verbe, et le Verbe était Dieu ; deux fois « être » pour deux fois cinq points qui, si on les médite un peu, disent bien ce qu'ils veulent dire : le « Verbe » dans cette aforme n'est pas « Parole » articulée ni même désarticulée.

● SUITE EN PAGE 2

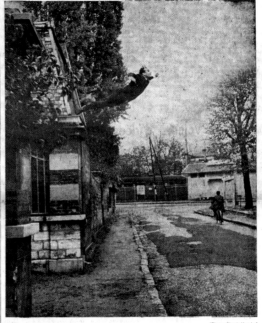

UN HOMME DANS L'ESPACE !

(Photo Shunk-Kender)

Le peintre de l'espace se jette dans le vide !

Le monochrome qui est aussi champion de judo, ceinture noire 4e dan, s'entraîne régulièrement à la lévitation dynamique ! (avec ou sans filet, au risque de sa vie).

Il prétend être en mesure d'aller rejoindre bientôt dans l'espace son œuvre préférée : une sculpture aérostatique composée de Mille et un Ballons bleus, qui, en 1957, s'enfuit de son exposition dans le ciel de Saint-Germain-des-Prés pour ne plus jamais revenir !

Libérer la sculpture du socle a été longtemps sa préoccupation. « Aujourd'hui le peintre de l'espace doit aller effectivement dans l'espace pour peindre, mais il doit y aller sans trucs, ni supercheries, ni non plus en avion, ni en parachute ou en fusée ; il doit y aller par lui-même, avec une force individuelle autonome, en un mot, il doit être capable de léviter. »

Yves :

« Je suis le peintre de l'espace. Je ne suis pas un peintre abstrait, mais au contraire un figuratif, et un réaliste. Soyons honnêtes, pour peindre l'espace, je me dois de me rendre sur place, dans cet espace même. »

Sensibilité pure

Une petite salle.

Les spectateurs, après avoir dûment payé chacun leur entrée, assez chère... pénètrent dans la salle et prennent place.

Le rideau est baissé. La salle illuminée.

Dès que la salle est pleine, un homme se présente sur la scène, devant le rideau toujours baissé et déclare :

« Mesdames, Messieurs en raison des circonstances, ce soir nous allons être contraints de vous enchaîner chacun à vos

sièges (et, de plus, vous bâillonner) pour la durée de la représentation.

» Cette mesure de sécurité est nécessaire, afin de vous protéger contre vous-même, en présence de ce spectacle particulièrement dangereux, d'un point de vue affectif pur !

» Nous exprimons d'avance nos regrets aux personnes qui ne pourraient supporter d'être enchaînées et bâillonnées avant le lever du rideau et nous les prions aimablement de bien

vouloir quitter la salle pour se faire rembourser à la sortie. Aucune personne non enchaînée ne sera tolérée dans la salle pendant le spectacle. Merci »

Aussitôt un groupe d'enchaineurs-bâillonneurs pénètrent dans la salle et, systématiquement, rang après rang, paralysent rapidement tous les spectateurs.

● SUITE EN PAGE 2

I want to be a poet, and I'm working to become
a Seer: you will not understand at all, and I can't
explain it to you. It's a matter of attaining the
unknown by disordering all the senses.
The suffering is enormous, but one has to be
strong, to be born a poet, and I find that I am
a poet.

. . .

I is another

Rimbaud

the rest perishes. Enthusiasm can only vibrate where there are no foundations or principles. It doesn't reflect, it doesn't calculate, it doesn't speak, and it doesn't give explanations; it acts."[398] Assured vitality. The light ardor of the instant, immortalized in the famous photograph of Yves Klein's leap into the void, in Fontenay-aux-Roses.

> "Recovered!
> What? Eternity.
> The sea mingling with
> The Sun
> . . .
> No more tomorrows,
> Satin embers,
> Your fervor
> Is duty." (Rimbaud) [399]

Man is the author of the world and its mystery. To be a seer is to discover the store of the visible.[400]

> "I want to be a poet, and I'm working to become a Seer: you will not understand at all, and I can't explain it to you. It's a matter of attaining the unknown by disordering all the senses. The suffering is enormous, but one has to be strong, to be born a poet, and I find that I am a poet.
> . . .
> I is another" (Rimbaud) [401]

Untitled blue monochrome (IKB 68), 1961

Pure Time, New Instant and Empty Duration

When the flame is burning the receipt, light time courses upwards and duration flies. The present instant rules, new and suspended between two nullities. *Ideal now.*[402] Pure time, delivering being from its clear ice.

> "The virgin, long-lived and beautiful day
> Will it tear us apart with a wing beat
> This hard, forgotten lake, haunted beneath the ice
> By the transparent glacier of flights not taken!" (Mallarmé)[403]

This moment drew itself out from stagnating, empty time. It is unique and impossible to repeat. And for this reason, it is timeless. This is when the "true me" awakes, as Proust writes in *Time Regained.*[404] It emerges, drawn out by its power and its dead soul. Gripped with joy, one discovers a time where the very idea of mortality is senseless. An instant with no beginning and no end, where in the end we have no origins and no destiny, freed from the past that explains us and from the future that frightens us. By keeping a fragment of his receipt, Dino Buzzati retains the chance of reviving this moment.[405] Man finds the supernatural is truly not beyond him.

For Yves Klein monochrome is one of these moments of immobilized time. He therefore exhibits eleven ultramarine paintings at the Apollinaire gallery in Milan, in January 1957, "all of them absolutely identical in tone, value, proportion, and size."[406] Each with a different *timbre*, like a colorful sound melody (*Klangfarbenmelodie*[407]). Each monochrome is a stabilized moment. Together, they form a duration.[408]

Monochrome. Space in which the center is everywhere and the circumference, nowhere. Experience of the deep color which communicates to us its space within. The IKB blue lasts. In principle, monochrome has no origin. Ideally, Yves Klein would like to dissolve the gesture which created him.

Monotone-Silence Symphony. Music whose beginning is always and whose end is never. The *monotone* note stretches through space, and when it stops it suddenly echoes in the silence. "An instant whose duration is incommensurable."[409] Ideally, the great symphony, a *naked* expanse,[410] should also be without origin.

Without cause, the mystery continues. The stroke- and line-less monochrome and the symphony with no melodic line have no history.

The *Blue Revolution.* On Sunday, November 27, 1960, Yves Klein decides to recondition a 24-hour sequence of human time. This precise day—which was meant to be swallowed up by the indifference of History—is uncoupled from time. Yves Klein distinguishes it, recreates it, and demands everyone's attention. Following a public announcement in the single issue of a

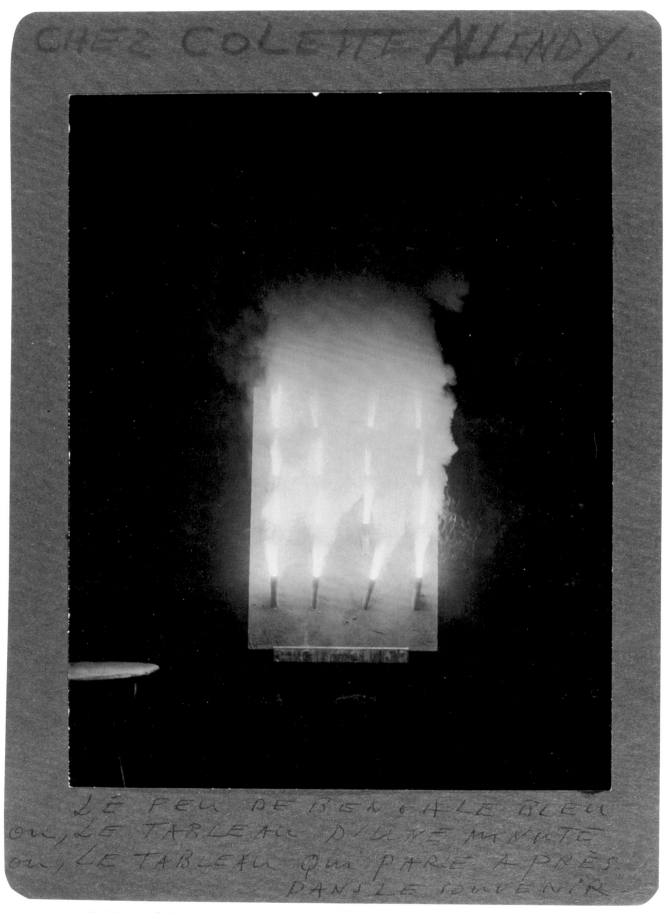

The *Tableau de feu bleu d'une minute* [*Blue Fire Painting of One Minute*] in the garden of Galerie Colette Allendy
during the *Propositions monochromes* exhibition. Paris. May 14. 1957

Newspaper for a Single Day, this day becomes an *event*. And everyone, *de facto*, is turned into an actor in a "collective theatre."[411] Klein replaces the anonymity of this Sunday, November 27 with the meaning of his own presence.[412] We dream of an extraordinary hour which would give everything.

Yves Klein had already created this intense time in May 1957 with his *Tableau de feu bleu d'une minute* (one-minute blue fire painting). "After the painting had been consumed by fire, [it swelled] in the memory."[413] The *visible duration* was followed by the inner duration.[414] One of the showrooms in the Colette Allendy gallery also displayed sculpted blue rain, as in a slow photographic exposure: the trajectory of the drops formed long stalks which the visitors would move among. Another duration crossed by the instant.

Having started out with an art that explored duration (monochromes, *Symphony*), Yves Klein evolved over the years towards an art concerned with the full instant, for which the immaterial cessions and the *Leap into the Void* are emblematic. Illumination of the world and clear impetus of the outpouring: two pure acts where the void is annihilated within a promise of novelty.

"The gospel of the artist"[415]

The enthusiasm that provides the impulse for Yves Klein's act is a particular ardor. The word originally meant a divine *transport*, stemming from an energy in the soul preparing it to experience mystery.[416] "Art is the inner secret" (Yves Klein). [417] It enables the immaterial to be touched bith the *eyes of the soul*.[418] The emotion he awakens becomes a shock for certain people, as Yves Klein realized when watching visitors come into contact with *Void* in the Iris Clert gallery in April–May 1958.[419]

And fearful infinity terrified your blue eye!
Rimbaud

Hollowing a place out, eliminating what there is inside, brings to mind what negative theology says about God. There is no other means to approach Him, who is unknowable, but to define Him by what He is not. In the presence of what is beyond understanding, the mind is in a state of suspension and accepts mystery. "My paintings affirm the idea of absolute unity in the context of perfect serenity."[420]

Working back to the inexpressible. The *Nada*—the nothing-creator—doubles back on itself, as in the verses of St. John of the Cross: "*Para venir a serlo*

203

Expression de l'univers de la couleur mine orange [*Expression of the Universe of the Color Lead Orange*] (M 60), May 1955

todo, / no quieras ser algo en nada" ("to become everything, / do not try to be something in nothing"). Yves Klein has the same instinct: "You understand, more dimension, more nothing, more infinite-ness, more nothingness, more divine-ness—except these apply to the inconceivable, what we, foolish as we are, refuse to see, contemplate, and use because it is too dazzling and burns reason."[421] Yves Klein considers, *impossibly*, distancing himself from his work so that it can achieve fulfillment without origin.

He is to be believed: "My monochrome works are landscapes of freedom." They support themselves.

Color is "full and pure sensibility."[422] It invents or revives in us—as we wish—a memory of unity.[423] Images and thoughts come to haunt us from we know not where, well up. Floating within us and virtual-like, they find their place in uniform color. "Through absolute art, that is to say through the living illumination that I become . . . by immersing myself in the limitless eternal sensibility of space, I return to Eden."[424] Pure color enables us to retrieve the inner vision that was lost. By devoting myself to it, "profligate, I can already sense my newly eternal eyes" (Char).[425]

I see that nature is only
a display of kindness.
Farewell chimeras, ideals
and errors
Rimbaud

In the Embrasure

Please lean in. The IKB monochrome is an *embrasure*.

If the word *embrasure* originally denoted an opening in a fortification where a cannon would be placed to *open* fire, today it is an undefined zone, a junction between inner and outer. To stand *in* an embrasure means to be in two spaces overlapping simultaneously. Not a frontier, but a contact zone. The monochrome is this *embrasure* between me and its deep blue.

Like me, it is a body lying against the visible locked away behind it. Like it, I am a collection of colors and surfaces capable of touching. The monochrome spiritualizes the senses and enables something beyond to be perceived.[426] "Spiritual sensuality," "the soul's joy,"[427] writes Yves Klein. Such a feeling of serene bliss is only possible because this world is within reach and not infinite.

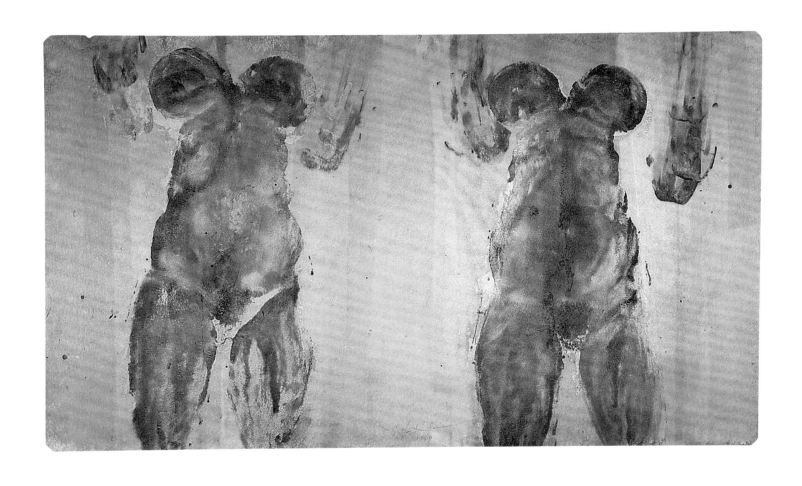

Untitled anthropometry (ANT 55), 1960

"And fearful infinity terrified your blue eye!" (Rimbaud) [428]

Yves Klein's work stimulates life. It holds neither nothingness nor ideal essence. It does not languish. It does not wither on the spot, imagining abstract truths to be attained. In its vitality, it keeps well away from chimeras and metaphysical mirrors, with their black water. "'The infinite,' source of despair,"[429] is instead what Yves Klein wrote in 1952. He was never to lose his horror of vertigo. His aim? The enchantment of renewal. The human condition is an artistic condition.

The world is inexhaustible when it encounters me in its flesh. The concept of the *infinite* reduces life to infirmity by urging us to refine ourselves and approach pure essences. Yves Klein speaks in terms of the depth of the world. Invisible and immaterial, of course, but perfectly real and quite responsive.[430] "Art is health," he declares on March 9, 1960 before visitors to the Arquian gallery. Art distracts from the *illness of death*, a form of abstraction.

"I see that nature is only a display of kindness.
Farewell chimeras, ideals and errors" (Rimbaud).[431]

"It is through the skin that metaphysics will be made to re-enter our minds" (Artaud)[432]

Through art, as in love, the body feels anchored to the life that envelops it and where it becomes intense.

Yves Klein designs his anthropometric sessions like a liturgy of the dormant mysteries of the body. He collaborates with the model to make the work *complete* itself and be *welcome* "at its birth."[433] The printing ritual has nothing to do with a spectacle.[434] And to avoid any misunderstandings regarding the nature of the operation, Yves Klein speaks of the "*temple* of the studio," whose "veil" he "strips away."[435] Exactly like Michael Blankfort, the model refashions herself by performing an act on her person.

The course is remembered. At first, Yves Klein wanted the model to be present in the flesh to create the monochromes. Then, bumping into a glass ceiling, he sprayed it, reincarnating the immaterial with a living brush.[436] At first, these were shapeless patches, and then this grace was fixed[437] in a print. Flesh has arrived.

Like cosmogony, anthropometry is an accumulative action[438] through which Yves Klein takes a sample of nature. To the classical image of the painter scrutinizing the private ramparts of the model posing for him, he adds another, astonishing, one. In his *Chelsea Hotel Manifesto*, Yves Klein does indeed describe cannibalism as "the most important and certainly the most secret phase of [his] art."[439] How should we interpret this?

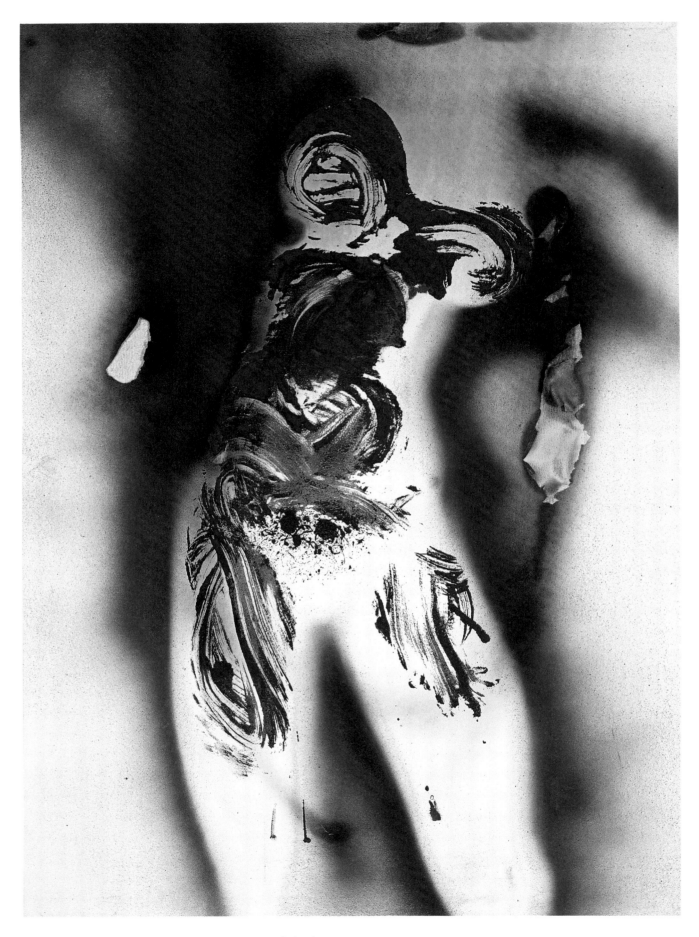

Untitled anthropometry (ANT 8), ca 1960

O splendor of flesh! O ideal splendor!
O renewal of love, triumphal dawn
Rimbaud

In 1960, he created a huge anthropometry on paper glued to a backing board, the *Grande anthropophagie bleue. Hommage à Tennessee Williams.* The work appears like the tangled swirls of the great battle the model joined on its surface. With the blue which covered over her body's prints? Some time before, Yves Klein had seen Joseph Mankiewicz's film, *Suddenly, Last Summer* (1959), based on the play of the same title by Tennessee Williams. He was struck by one scene in particular. It takes place under a burning sky in a Mediterranean village embracing a steep cliff facing the motionless sea. A crowd of children and teenagers, armed with jagged daggers made from tin cans, throw themselves like starving birds[440] on one of the characters, who disappears as his flesh is stripped, torn to bits, and hacked to pieces.[441] The scene fitted the ritual of the immaterialized body perfectly.

Yves Klein anticipated that one day models would be asked not just to be the living brush, but to be embodied in the work itself with their own blood.[442] The *Grande Anthropophagie* can be interpreted symbolically as a painting made with flesh and blood. In June 1959 Yves Klein quoted this line by Percy Bysshe Shelley: "The blood of sensibility runs blue."[443] This same fluid[444] covers and blurs the model's print. "The purest presence is spilled blood" (Bonnefoy).[445] The image of what the Christian Church calls transubstantiation: *true presence.*

**"O splendor of flesh! O ideal splendor!
O renewal of love, triumphal dawn."** (Rimbaud) [446]

So, is *Grande Anthropophagie* an image of glorious flesh?[447] No doubt. Yves Klein suggests this interpretation by linking his immaterial art to the belief in transfigured flesh.[448] After all, isn't the act of the cannibal part of the mystery of the Eucharist, where one subsumes Christ's body and blood, which are *really* transformed into bread and wine? "An anthropophagus era is drawing near," writes Yves Klein. "Fearful in appearance only, it will be the practical realization of a universal practice ever since these famous words: 'Whoever eats my flesh and drinks my blood remains in me, and I in him.'"[449]

Anthropometry, the *real*—and not symbolic—presence of the model in the flesh. This is her body. Can we doubt it? One need only approach one of her prints and, "nature and spirit,"[450] it awakens. Its origin takes shape once again, for the life lying there is permanent. We are *touched* by this flesh.

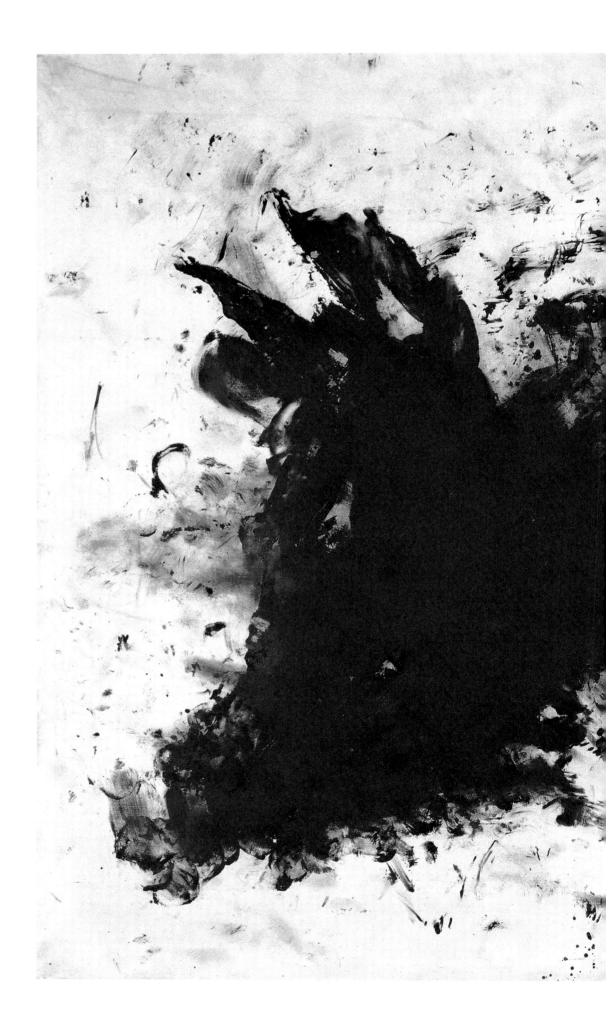

Grande Anthropophagie bleue.
Hommage à Tennessee Williams
[*Great Blue Anthropophagy.*
Homage to Tennessee Williams]
(ANT 76), 1960

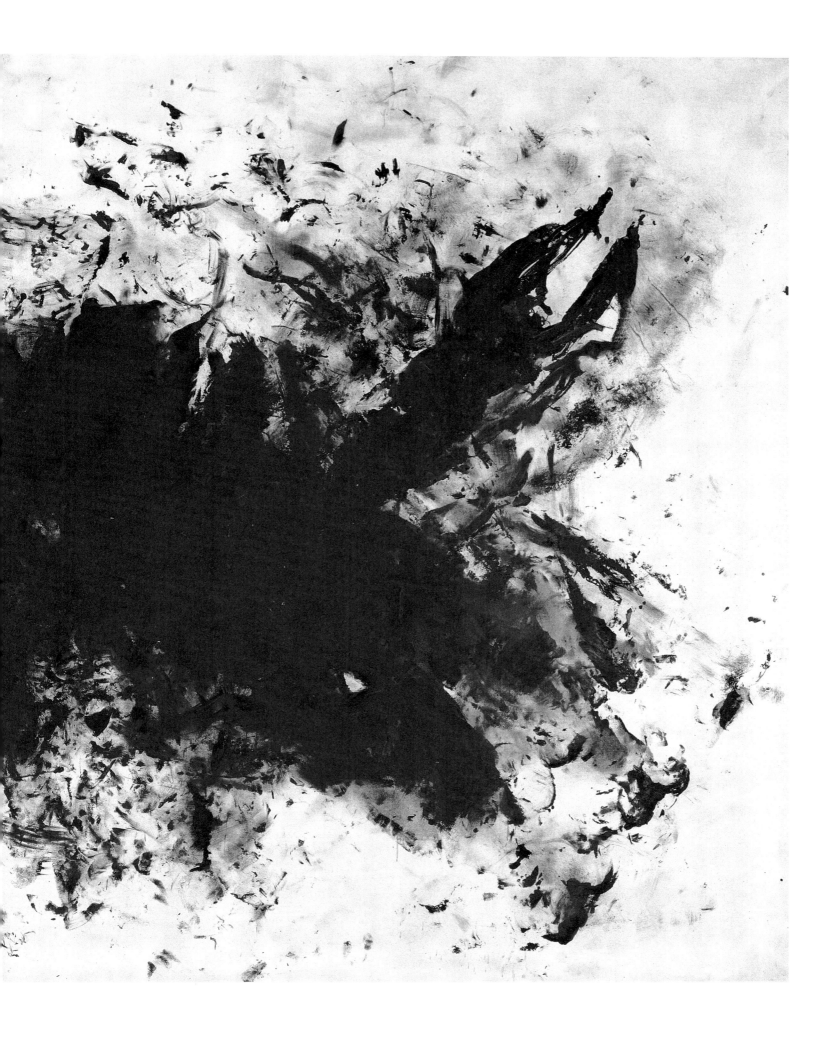

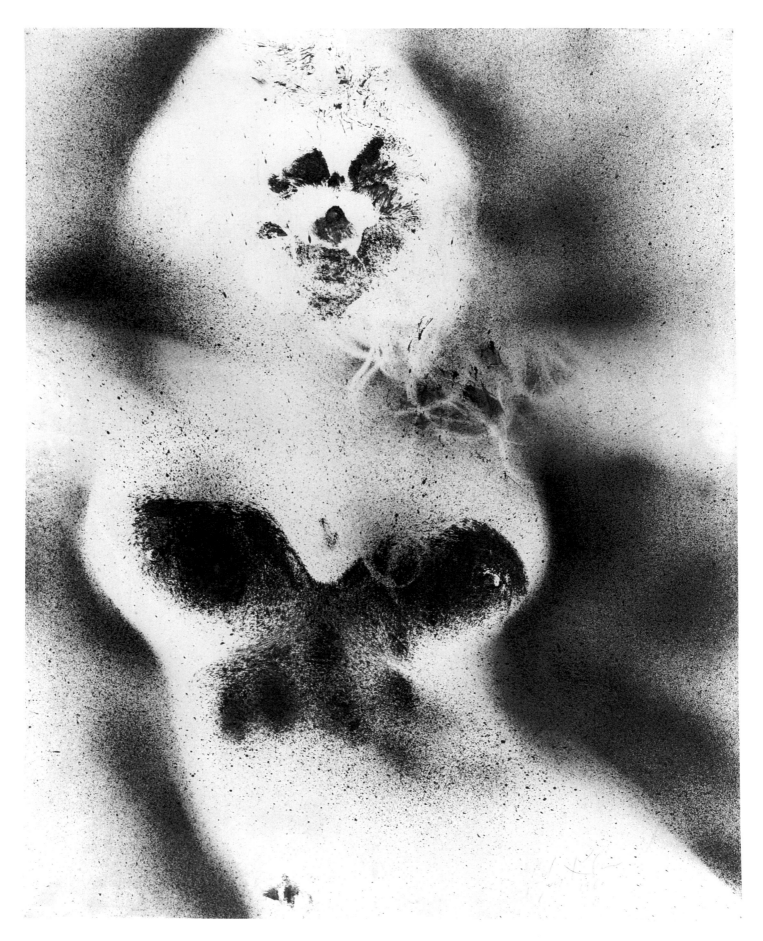

Untitled anthropometry (ANT 146), 1960

"O Living Flame of Love / . . . / Break the web of this sweet encounter! / . . . / O gentle touch, / Savoring of everlasting life / And paying the whole debt!" (St. John of the Cross) [451]

The model catches us just as fire did when breathing life into the cardboard landscapes. An image that escapes us and carries us beyond. In this flesh we always sense the visible locked up behind, in the *embrasure*, as if art were capable of conjuring up this mystery without explaining it.

The immaterial that Yves Klein pursues is already in the world, a latent Eden. The woman and the flame, denuded, acquire their flesh element and their sole splendor. The anthropometries *glorify* the model into a *glorious being*. Wonderful incarnation.

"Like Christ, the painter says Mass by painting and gives the body of his soul to others as nourishment. He repeats the miracle of the Last Supper on a small scale in each painting" (Yves Klein). [452] He "dismembers his own soul by tearing it out . . . in strips." [453] In Yves Klein, this gift enables transgressive joy—and a proud solitude—to show through, inspiring him to create the 1960 anthropometry entitled *L'Exilé d'Ischia*. [454] He prints himself as a dancing god [455] flanked by two blue fires, his arms flame in their glorious flesh.

Death has been overcome. On the gauze anthropometries called *shrouds*, the bodies live in the "immaterial permanence of flesh." [456] Better than a resurrection, art maintains life and embodies it *really*. And if death scowls beneath the face, it is does not cause unease by talking of an unknown world to follow it. Shining like a bluish electric fluid, it stares at us, without suggesting any fear that might make us quake. It is just there, *wrapped around life*.

And man "has warped his Olympian body,
Like an idol in the furnace, to serve coarse slaveries!
Yes, even after death, his pale skeletons
Wish to live on, affronting primordial beauty!"
Rimbaud

**"If only those times would come again,
the times that have passed"** (Rimbaud) [457]

In the *Mondo Cane Shroud*, two ages merge: the archaic and pagan combine with the Christian. Yves Klein takes after both of them. He would like to revive

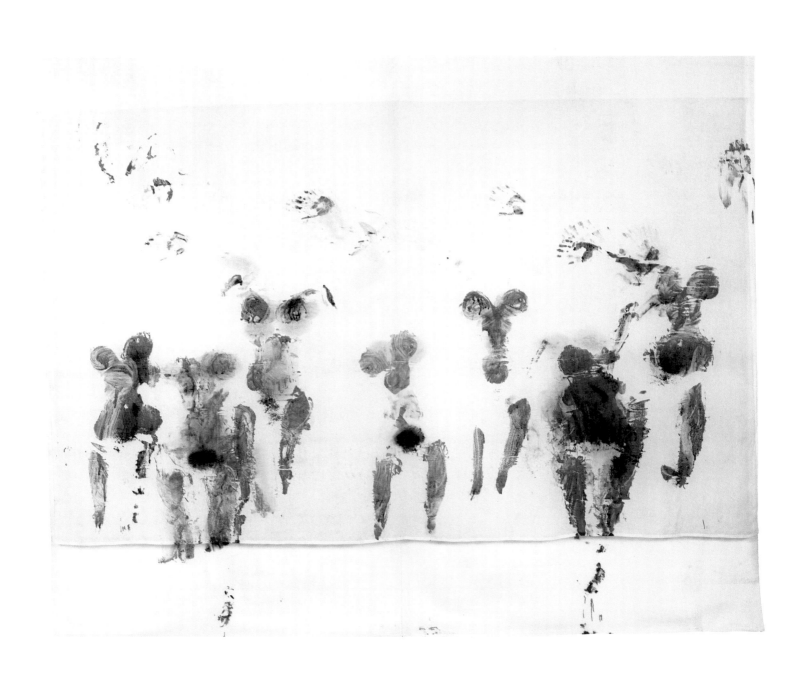

Suaire de Mondo Cane [*Mondo Cane Shroud*] (ANT SU 8 I), 1961

the Golden Age and the time of Eden. A mythology restored. Callipygian Venuses and swaying goddesses dance mysteriously in the whiteness of empty death on a *Shroud* that is by tradition[458] a promise of life resurrected.

"Do you regret the age when, in majestic grace, Fair haven amid the gods made earth her dwelling place?"[459] Yves Klein scribbled these verses by Musset in his manuscript *Analyse des temps*, where he puts down on paper the distress of a child of a "disinherited century," where the era of gods is over and where men wallow in materialism and empty pleasures. "Yesterday they were god-inspired creatures, inspired by the wonderful. Today, these creatures are empty, empty of all art and poetry . . . They are themselves gods!"[460]

A jolt, *untimely* being. "Let me tell you I'm a rebel against my time" (Yves Klein). [461] In order to revive the world, the myth will have to be revived: the Golden Age of the world in its infancy, where everything in living Nature was full of sparkle and color, and where "the streaming purity of boundless life" (Rimbaud) could be felt in the air. Everything there was young and immortal. It was the land of the god Pan, and of fauns and nymphs, as well as of early Christianity, "where the old universe and the newly young Lazarus / split the stone of the tomb."[462] A time of abundance. Since then, writes Yves Klein, the world has become sullied and hardened. It shines no more. And man "has warped his Olympian body, Like an idol in the furnace, to serve coarse slaveries! Yes, even after death, in pale skeletons he wishes to live on, affronting primordial beauty!" (Rimbaud).[463]

To these two happy eras—the mythological and the Christian—man will come to be revivified. Thus does the ritual cession of the immaterial before the river initiate the flesh of the world by the offering of gold under the shelter of Notre-Dame. The IKB monochrome, the image of the invisible blue depth, also resuscitates the mystical union within God, in the flesh-element of its color. Yves Klein thus also conceived a Way of the Cross where the twelve stations would be places of contemplation in the blue.[464] A furtive paganism, whose boldness is sensed by Yves Klein, also pulses in the glorious flesh anthropometries: "These pagans marks in my monochrome absolute religion, hypnotized me right away, and I worked on them *clandestinely on my own behalf*."[465]

"We should not seek happiness on earth, but happiness tout court" (Yves Klein).[466]

If only those times would come again,
the times that have passed
Rimbaud

215

Endnotes

AYK: Archives Yves Klein
(all quotations are our translation)

7 A. Rimbaud, "Le Bateau ivre," v. 88, p. 125.

8 A. Rimbaud, "Lettre du Voyant," letter to Paul Demeny, May 15, 1871, p. 93.

9 Y. Klein, "Des bases (fausses)," p. 20.

10 Y. Klein, "Création d'un centre de la sensibilité," *Le Dépassement de la problématique de l'art*, p. 114.

11 Cf. Y. Klein, "L'Habitation immatérielle," *L'Aventure monochrome*, p. 267: "this house must be built with the aid of a new material: 'air,' blown into walls, partitions, roofs, and furnishings."

12 Y. Klein, *L'Évolution*, p. 121.

13 Y. Klein, "Discours prononcé à l'occasion de l'exposition Tinguely à Düsseldorf," *Le Dépassement*, p. 103.

14 Y. Klein, *Le Dépassement*, p. 80. As an epigraph for "Le Vrai devient Réalité ou Pourquoi pas!" Klein quotes David Ben Gourion: "Qui ne croit pas aux miracles n'est pas un réaliste" ("Anyone who doesn't believe in miracles is not a realist") (*L'Aventure*, p. 224).

15 G. Bachelard, *L'Engagement rationaliste*. Paris: PUF, 1972. p. 11.

16 Y. Klein, "Des bases (fausses)," p. 20.

17 G. Bachelard, *L'Air et les songes. Essai sur l'imagination du mouvement*. Paris: Librairie générale Française (coll. "Le livre de poche"), 2010 (1943). p. 41.

18 Klein chose this epigraph for his work entitled *L'art* (Archives Yves Klein, Div. sno. 274). References to Yves Klein's archives will henceforth be abbreviated to AYK.

19 Y. Klein, *L'Évolution*, p. 127.

20 Albert Camus, "Préface," *L'Envers et l'endroit*. Paris: Gallimard, 1958 (1937). pp. 12–13.

21 Y. Klein, manuscript in AYK.

22 Y. Klein, "Le Vrai," *L'Aventure*, p. 239.

23 A. Rimbaud, "Lettre du Voyant," *op.cit*, p. 88.

24 *Ibid.*

25 G. Bachelard, *L'Air et les songes. Essai sur l'imagination du mouvement*, op. cit., p. 106.

26 Y. Klein, *L'Évolution*, p. 122.

27 Y. Klein, "Le Vrai," *L'Aventure*, p. 239.

28 A. Rimbaud, "L'Éclair," *Une saison en enfer*, op. cit., p. 201.

29 Y. Klein, "Religion, Sciences, arts" (ca. 1958) (AYK, Div. sno. 352).

30 *Moulin premier* (1935–1936), LVI, in *Le Marteau sans maître*, in *Œuvres complètes*. Paris: Gallimard ("Bibliothèque de la Pléiade"), p. 76.

31 Y. Klein, *Architecture de l'air*, p. 271.

32 Claude Parent, interview with Philippe Ungar (2006).

33 Y. Klein, *Manifeste de l'hôtel Chelsea*, p. 310.

34 Y. Klein, "Le Vrai," *L'Aventure*, p. 239.

35 Cf. "It's the old dream of men and of the imagination to play with nature's elements, to direct and control their phenomena and their manifestations" ("Exemple de collaboration réalisée," p. 107).

36 Y. Klein, *Journal*, Thursday, March 13, 1952, in AYK, Div. sno. 1085 b.

37 See chapter 3, "Au grand jour."

38 "L'amour," *Arsenal (1927–1929)*, in *Le Marteau sans maître*, op. cit., p. 12.

39 Y. Klein, "Discours à la Commission," p. 75.

40 Y. Klein, *L'Évolution*, p. 123.

41 Ludwig Mies van der Rohe quoted by David Watkin, *Morale et architecture aux xixᵉ et xxᵉ siècles*. Brussels: P. Mardaga. 1979. p. 41. See also Mies van der Rohe, "1950: Address to Illinois Institute of Technology," republished in Philip Johnson's *Mies van der Rohe*. New York: Museum of Modern Art. 1947. p. 204. The concept of *Zeitgeist* is a neoplatonic reading of time and culture.

42 Yves Klein sees the future as the continuing quest of classicism: "tomorrow's Classical city . . . will at last be flexible, spiritual, and immaterial" (*L'Évolution*, p. 152). The immaterial city thus aims to recover time immemorial. As Claude Parent puts it: "The notions Yves Klein and I were discussing had more to do with something ancestral and forgotten than the utopia of the moment. I don't think you can say that Yves Klein was utopian himself. I think he invented a different world, whose links to the past are as profound as those with what might be" (interviewed by Philippe Ungar).

43 From 1959 Klein ensured there was no misunderstanding about this by talking of a "general evolution of today's art towards Immaterialization (and not Dematerialization)" ("Exemple," *Le Dépassement*, p. 106).

44 Cf. *Ibid.*

45 Cf. "In the air, one builds with air—with immaterial materials. At ground level, with the ground—with material materials, denser and heavier than earth" (Y. Klein, "L'Habitation immatérielle," *L'Aventure*, pp. 267–268).

46 Cf. Umberto Eco, *The Open Work*. Cambridge. MA: Harvard University Press, 1989.

47 Y. Klein, *L'Évolution*, p. 123.

48 Y. Klein, "Le Réalisme authentique d'aujourd'hui," p. 154.

49 U. Eco, *The Open Work*, op. cit.

50 Y. Klein, "Discours prononcé à l'occasion de l'exposition Tinguely", *Le Dépassement*, p. 105.

51 Y. Klein, *L'Évolution*, p. 149.

52 Preparatory sketches show a "roofing mechanism to cover a square by means of air roofs with permanent air circulation," and "point-cities with individual air roofs," divided into residential, leisure, and business areas (cf. Y. Klein, "Exemple," *Le Dépassement*, pp. 108–110).

53 Y. Klein, "L'Habitation immatérielle," *L'Aventure*, p. 268.

54 A. Rimbaud, "Soleil et chair," v. 78, p. 68.

55 A. Rimbaud, "Adieu," *Une saison en enfer*, p. 203.

56 This act was to be likened to his "Specialization" in the Iris Clert gallery, in April–May 1958.

57 Cf. "This pictorial state, invisible within the gallery space, should in all respects provide the best general definition of painting to date, namely, radiance" (Y. Klein, *L'Évolution*, p. 131). In an interview with André Arnaud, on April 29,ᵗ 1958. Klein said: "I think my painting is invisible . . . It's a presence really, it dwells, it dwells in a place. And for me, for the time being, my painting inhabits this gallery, but I would like it to acquire almost immeasurable dimensions, to spread and to permeate the atmosphere, even of a whole city, or a country" (AYK, Div. sno. 332).

58 "Being beauteous," *Illuminations*, p. 214.

59 Y. Klein, "Discours à la Commission du theater," p. 75.

60 The team was made up of Max von Hausen and Ortwin Rave and under Werner Ruhnau had already been chosen by the city of Münster in 1954 to build the theatre, which was inaugurated in February 1956. Harald Deilmann was involved in the project but in the end withdrew from the Gelsenkirchen scheme.

61 The occasion was the private view of an exhibition of works by the sculptor Norbert Kricke, who was already part of the Gelsenkirchen team.

62 The contract with the town of Gelsenkirchen was signed on February 13, 1958.

63 Letter by Yves Klein (December 11, 1957), reproduced in *Wie das Gelsenkirchener Blau auf Yves Klein kam. Zur Geschichte der Zusammenarbeit zwischen Yves Klein und Werner Ruhnau*. Wiesbaden: Museum Wiesbaden, 2004, p. 45.

64 Cf. Klein, Letter to the chief executive of Küppersbusch (December 16, 1960) (AYK, Corr. 637a & b).

65 Y. Klein, *Le Dépassement*, p. 114.

66 He had already created a similar sculpture in 1955–1956 for the Münster theatre façade, a project run by Ruhnau.

67 Some city councilors and administrators were unsure about choosing blue exclusively, regarding it as dull and monotonous (cf. *Der Raum*, p. 41).

68 Two for the foyer's long wall, and two others for the cloakroom.

69 Cf. Letter from the Société Routtand to Yves Klein (January 12, 1959), typescript, Corr. 467.

70 A. Rimbaud, "Fairy," *Illuminations*, p. 234.

71 Y. Klein, *L'Évolution*, p. 140.

72 Y. Klein, "Le feu ou l'avenir sans oublier le passé," reproduced in *Yves Klein, la vie, la vie elle-même qui est l'art absolu*, exhibition catalogue. Nice: Musée d'art Moderne et d'Art Contemporain, 2000, p. 95.

73 Y. Klein, AYK, Div. sno. 1068.

74 Cf. *Forms of Water*, written in collaboration with British art critic John Anthony Thwaites.

75 Cf. Ruhnau, "Conférence de la Sorbonne" (June 3, 1959), typescript, private collection.

76 Norbert Kricke compares variations in the water streaming down the Plexiglas to "immaterial waves" (*Forms of Water*, Düsseldorf, November 1956, quoted by Marion Guibert in "Yves Klein en Allemagne 1957-1961," in *Yves Klein. Corps, couleur, immatériel*. Paris: Centre Pompidou, 2006, p. 184).

77 Yves Klein submitted his patent application in Soleau envelope n° 58973, dated April 14, 1959.

78 Cf. *Werner Ruhnau. Der Raum, das Spiel und die Künste*. Gelsenkirchen: Jovis Verlag, 2007, p. 56.

79 According to one of Yves Klein's letters to the chief executive of Küppersbusch (December 16, 1960), the company was to make the two scale models (AYK, Corr. 637a).

80 The same financial difficulties were to put an end to the shared Bad Hersfeld Abbey restoration project, in which a huge air roof, mentioned by Klein in the letter to the secretary of the Milan Triennale referred to above. Recognizing the problems associated with excessive noise, Klein made sure the machinery would be kept well away from the inhabitants in his immaterial city project (cf. "L'Habitation immatérielle," *L'Aventure*, p. 267).

81 Cf. Letter to the chief executive of Küppersbusch (AYK, Corr. 637a).

82 J. Caubère, *Déserts*. Paris: Éditions Debresse, 1955, p. 18.

83 Y. Klein quoted by Descargues, *Yves Klein*, p. 81.

84 Letter to art dealer George Marci (AYK, Coor. 674).

85 "Confronts," *Poèmes militants* (1932), in *Le Marteau sans maître*, op. cit., p. 39.

86 Y. Klein, *L'Évolution*, p. 140.

87 Y. Klein, "L'Eau et le feu," *L'Aventure*, p. 266.

88 Cf. Y. Klein, handwritten letter (AYK, Corr. 674).

89 Cf. A. Rimbaud, "Alchimie du verbe," *Une saison en enfer*, op. cit., p. 198.

90 Y. Klein, *L'Évolution*, p. 140.

91 Heraclitus, *Fragments*, 8.

92 Cf. Y. Klein, "Préparation et présentation de l'exposition du 28 avril 1958 chez Iris Clert," *Le Dépassement*, pp. 88–89.

93 Y. Klein, *L'Évolution*, p. 141.

94 *Art et utopie. Les derniers fragments (1799-1800).* Édition d'Olivier Schefer. Paris: Æsthetica, 2005. fg. 175. p. 62.

95 He was used to working with sculptors and similar artists. For instance, in 1955 he worked with Nicolas Schöffer and Yaacov Agam, two kinetic artists.

96 Novalis, op. cit., fg 101, p. 55.

97 Teresa de Avila, *Libro de la Vida.* Madrid: Algaba Ediciones, 2007, chap. XIX, p. 171.

98 G. Bachelard, *La Flamme d'une chandelle.* Paris: PUF, 1986 (1961), p. 29.

99 Letter reproduced in *Le Dépassement,* p. 356.

100 A. Rimbaud, "Bruxelles," *Derniers vers,* v. 3-4, p. 161.

101 Cf. "Dessin V" in Soleau envelope no. 58973, with stamp dated April 14, 1959 (cf. Didier Semin, *Le Peintre et son modèle déposé.* Geneva: Mamco, 2001, p. 79).

102 Y. Klein, *Architecture de l'air,* p. 271. See also *L'Évolution,* p. 121: "Air architecture . . . promises, in the near future I hope, to provide total physical comfort as regards the atmospheric phenomena and thermal conditions of nature on the surface of our planet."

103 Cf. R. Banham, *The Architecture of the Well-Tempered Environment* (1969).

104 Stéphane Mallarmé, *L'Après-midi d'un faune* (1876), v. 13, *Œuvres completes.* Paris: Gallimard, ("Bibliothèque de la Pléiade"), 1998, p. 163.

105 Y. Klein, "Le Vrai," *L'Aventure,* p. 229.

106 Cf. Fig. C bis and fig. E, in "Exemple," *Le Dépassement,* p. 108 and p. 110.

107 *Ibid.,* fig. D, p. 110.

108 Y. Klein, "Exemple," *Le Dépassement,* p. 107.

109 It is "sensibility becomes matter" (*Ma position dans le combat entre la ligne et la couleur,* p. 49). See also "Le Vrai," *L'Aventure,* p. 228: "[color] is spatial matter that is at once abstract and real."

110 Y. Klein, *L'Évolution,* p. 122.

111 Y. Klein, "L'Eau et le feu," *L'Aventure,* p. 266.

112 A. Rimbaud, "Est-elle almée ?...," *Derniers vers,* v. 3-4, p. 163.

113 Y. Klein and W. Ruhnau, "Projet pour une architecture de l'air," p. 269.

114 Cf. Johan Huizinga, *Homo ludens. Essai sur la fonction sociale du jeu.* Paris: Gallimard, 1988 (1938), p. 84.

115 Cf. Title of a monographic study by Mark Wigley (1998) on the *New Babylon,* a city imagined by painter and artist Constant Nieuwenhuys.

116 Claude Parent, interview with Philippe Ungar.

117 Cf. *Dimanche,* p. 174 sqq., and "La Grande force de ce mouvement ," p. 396.

118 A. Rimbaud, "Tu en es encore à la tentation d'Antoine ," *Illuminations, op. cit.,* p. 237.

119 "In my opinion the 'air-conditioning of large inhabited geographical areas' . . . will happen not so much thanks to technical wonders but above all by the human mind putting itself in tune with the universe" (Y. Klein, manuscript, AYK, div. sno. 3149).

120 Y. Klein, "Le Réalisme authentique," p. 154. In 1950, Yves Klein became interested in Lettrisme. Some of its disaffected figures, among whom Guy Debord, left to found the *Internationale Lettriste* two years later, followed by the *Internationale situationniste* in 1957. Debord's terminology survives in the neologism "viveur" (liver), taken from *Rapport sur la construction des situations* (1957) (in *Œuvres.* Paris: Gallimard, 2006, p. 325).

121 Cf. "Théorie de la dérive," *Les Lèvres nues,* no. 9, December 1956.

122 Y. Klein, *Architecture de l'air,* p. 271.

123 Y. Klein, "Climatisation," pp. 403-404.

124 G. Bachelard, *L'Air et les songes. Essai sur l'imagination du mouvement.* op. cit., p. 39.

125 "I am not sure this truly immaterial concept can be tackled using air. What I'm interested in is the principle of achieving true immateriality in architecture" (Klein, note on a loose sheet of paper, quoted in *Le Dépassement,* p. 403).

126 Y. Klein and W. Ruhnau, "Projet pour une architecture de l'air," p. 269.

127 Y. Klein, *Prière à sainte Rita,* p. 276.

128 Cf. the Jesuit priest Philippe Le Moyne, in *Les Peintures morales* (1640), claims that architecture has no reason to exist in the earthly Paradise: "If this blessed state should continue, architecture would be of no use."

129 Cf. J. Rykwert, *La Maison d'Adam au paradis.* Paris: Éditions du Seuil, 1976 (1972).

130 Y. Klein, "Climatisation," p. 403.

131 B. Goetz, *La Dislocation. Architecture et philosophie.* Paris: Éditions de la passion, 2001, p. 26-27.

132 The exact title of this installation-performance is *La spécialisation de la sensibilité à l'état matière première en sensibilité.*

133 Y. Klein, "La Guerre. Petite mythologie personnelle de la monochromie," *Dimanche,* p. 200.

134 Y. Klein, "Comment et pourquoi en 1957...," p. 392.

135 Y. Klein, "La Guerre," p. 201.

136 *Ibid.,* p. 202. "We are making the same error as ADAM and EVE, who lived, enlightened and sensitive, in nature's great sensibility, and who ate the fruit of the Tree of Knowledge. Suddenly they felt ashamed, 'they saw they were naked and covered themselves with fig leaves.' Beginning of man's psychological era" (Y.Klein, "Comment et pourquoi en 1957...," p. 392).

137 The two miss truth: one in its pseudo-mimetic representation of the real, and the other in its non-figurative interpretation (cf. Y. Klein, "La Guerre," *Dimanche,* p. 200: "Realism and abstraction combine in a horrible Machiavellian mixture which is what human life on earth becomes and is living death . . . Color is subordinated to line, which becomes writing . . .").

138 Y. Klein, *L'Évolution,* p. 150.

139 Y. Klein, "Du vertige au prestige" (conversation on January 17, 1959). p. 402. See also "Le Propre de l'homme," *L'Aventure,* pp. 263–264.

140 Cf. ". . . Inner research should not be done intellectually, but emotionally, by the only and all-powerful sensibility; it's the voice of *life,* picking the fruit from the Tree of Life, which was also in Eden" (Y. Klein, "Comment et pourquoi en 1957...," p. 392).

141 *Ibid.,* p. 385.

142 Y. Klein, typed manuscript of the lecture at the Sorbonne, *L'Évolution* (AYK. Div. sno. 366).

143 A. Rimbaud, "Solde," *Illuminations, op. cit.,* p. 234.

144 See next chapter, "The silence of these infinite spaces creates me."

145 Cf. Y. Klein, "Du vertige au prestige" (conversation on January 17, 1959). p. 402. "So, since Man's Fall the return to Eden is proceeding well . . . Evolution proceeds at present by passing from dematerialization to immaterialization, and happiness leads us towards an authentic and dynamically cosmic well-being" (Y. Klein, *L'Évolution.* p. 142).

146 A. Rimbaud, "L'Époux infernal," *Une saison en enfer, op. cit.,* p. 189.

147 Cf. Y. Klein, "Le Propre," *L'Aventure,* p. 264.

148 "A une sérénité crispée" (1952). *Recherche de la base et du sommet* (1955). p. 759.

149 R. Char, "Flux de l'aimant" (1963) *Alliés substantiels,* in *Recherche de la base et du sommet,* p. 693.

150 R. Char, "Les Premiers Instants," *La Fontaine narrative* (1947), in *Fureur et mystère,* p. 275.

151 *Aeneid,* Book VI, v. 725.

152 "To see, with my own eyes to SEE, what was visible in the absolute," says Yves Klein (*Le Dépassement,* p. 80). "To see is always to see more than what one sees" (M. Merleau-Ponty, *Le Visible et l'invisible.* Paris: Gallimard [coll. Tel], 2010 [1964], p. 295).

153 Y. Klein, *Le Dépassement.,* p. 80.

154 Y. Klein, *Manifeste de l'hôtel Chelsea,* p. 305.

155 Y. Klein, "Le Vrai," *L'Aventure,* p. 230.

156 Rough draft for *Une saison en enfer,* in *Œuvres completes.* Paris: Édition d'Aurélia Cervoni, Gallimard (coll. Poésie), 2009, p. 283.

157 The expression is Freud's, in a warning to Carl Jung.

158 "Le Vrai," *L'Aventure,* pp. 252–253. He also wrote: "I reject occultism and secret societies. Although I know something about them, I sense their lamentable limitations" (AYK, Div sno. 24).

159 Yves Klein's answer to the questionnaire sent by Victor Musgrave, the owner of Gallery One (London), in the flier for the exhibition held from June 24 to July 13. 1957 (AYK).

160 "Barbare," *Illuminations,* p. 233.

161 "Le Vrai," *L'Aventure,* pp. 246–247.

162 *Ibid.,* p. 248.

163 Y. Klein, *L'Évolution,* p. 151.

164 Y. Klein, *Le Dépassement,* p. 82.

165 The imaginary casting of being into pure action, as if detached from any intention or premeditation, is what Yves Klein claims to have felt when embarking on the "monochrome adventure": "Having reached that point . . . I no longer made myself function; I simply functioned. I was no longer myself; I, without the 'I,' became one with life itself. All my gestures, movements, activities, and creations were this original, essential life itself" (*Yves le monochrome.* p. 280).

166 Cf. G. Bachelard, *L'Air et les songes. Essai sur l'imagination du mouvement, op. cit.,* p. 15.

167 Y. Klein, "Le Vrai," *L'Aventure,* p. 237.

168 Klein mentions the male / female binary opposites arranging themselves (cf. *L'Évolution,* p. 142).

169 J. Joubert, *Pensées, essais, maximes et correspondances.* Paris: Imprimerie Le Normand, 1850 (1838), vol. I, p. 332.

170 Heraclitus, *Fragments,* 51, in A. Jeannière, *La Pensée d'Héraclite d'Éphèse,* p. 106. Simone Weil speaks of the "the simultaneous existence of opposite virtues in the soul" (*La Pesanteur et la grâce,* p. 119).

171 Y. Klein, *Yves le monochrome,* p. 287. This was borrowed from Bachelard (*La Psychanalyse du feu.* Paris : Folio, 2009 [1949], pp. 23–24), an echo of which also appears in *L'Évolution de l'art vers l'immatériel* (p. 141) and *Manifeste de l'hôtel Chelsea* (p. 305).

172 "Mauvais sang," *Une saison en enfer, op. cit.,* p. 180.

173 Cf. "I managed to paint with fire, using especially powerful and desiccating [sic] gas flames, some three to four meters high" (Y. Klein, *Manifeste,* p. 304).

174 Cf. Interview with Pierre Restany in Peter Noever and François Perrin, *Yves Klein. Air Architecture.* Los Angeles: MAK Center for Art and Architecture and Hatje Cantz, 2004, p. 109.

175 The first *Fire Paintings* at the Centre d'Essai de Gaz de France were probably created in March: on February 28, Yves Klein was actually in Krefeld,

handing Paul Wember, Director of the Haus Lange Museum, the receipt for a "Zone of Immaterial Pictorial Sensibility," two days after his retrospective there had closed.

176 The other project of the *Fontaines de Varsovie*, at the foot of the Palais de Chaillot, involved connecting *torchères* to a number of gas pipes, each with an output of 700 m³/hour of gas compressed to 0.5 kg (cf. Letter from the Director of the Société pour le Développement de l'Industrie du Gaz en France, December 18, 1961, AYK, Coor. 633).

177 Heraclitus, *Fragments*, 30, in A. Jeannière, *op. cit.*, p. 104.

178 M. Merleau-Ponty, "Notes de travail," "Nov. 1960," *Le Visible et l'invisible*, op. cit., p. 315 ; see also R. Barbaras, *Le Tournant de l'expérience*. Paris: Vrin, 1998, p. 220.

179 "L'Éternité," v. 5-6, p. 156.

180 Y. Klein, *L'Évolution*, p. 140.

181 Cf. *Ibid.*, p. 141.

182 Bachelard, *La Psychanalyse*, p. 30.

183 Cf. "My goal is . . . to register the trace of what precisely generated this very civilization, namely fire" (Y. Klein, *Manifeste*, p. 305).

184 *Ibid.*, p. 305.

185 For Nietzsche, art is the moment when aesthetics overcomes metaphysics: "Art is the highest task and the proper metaphysical activity of this life" ("Dédicace à Richard Wagner," *La Naissance de la tragédie*, *Œuvres philosophiques complètes*. Paris : Gallimard, vol. I, p. 40).

186 S. Weil, *La Pesanteur*, p. 171.

187 "Soir historique," *Illuminations*, p. 239.

188 Yves Klein dates his first perforated monochromes to 1955.

189 "Génie," *Illuminations*, p. 244.

190 Cf. A. Jouffroy, *Manifeste pour Yves Klein*. Besançon: Éditions Virgile, 2006, p. 39. Yves Klein himself uses the image of submersion in order to describe the effect the work has on the audience: "The curtain rises accompanied by a continuous fizzing sound, similar to that made by freshly opened carbonated water, but hugely amplified. It is an acoustic, monotonous inundation, impregnating space in a volumetric way, perceptible to the sensitive hearing of each spectator" ("Sensibilité pure," *Dimanche*, p. 183).

191 Klein mentions a first production of the symphony in 1949—presumably in his mind—following the discovery of the monochrome principle in 1947 (cf. "Le Vrai," *L'Aventure*, p. 241). He added the date 1947 on some of the symphony's scores (such as IMMA 43c).

192 The same "conscious *monochrome* vision" binds the two expressions (Y. Klein, *Ibid.*, p. 241). Paul Klee defended "polyphonic painting," as the best way of conveying simultaneity and "the temporal as spatiality" (*Tagebüscher (1898-1918)*. Stuttgart-Teufen: G. Hatje - A. Niggli, 1988, 1081). Can the term monophonic painting, expressing time and space to their full extent by choosing a single plane, be used for Yves Klein?

193 Eliane Radigue was born in 1932 and in 1953 married the Nice artist Arman, childhood friend of Yves Klein and the poet Claude Pascal. Yves Klein first contacts her to have the *Monotone-Silence Symphony* transcribed.

194 Louis Saguer (1907–1991) worked with Arthur Honegger and Paul Hindemith, before becoming choir master, assistant stage manager at the Berlin State Opera, and then conductor at the Piscator Theatre. At the end of the 1940s he began introducing the music of composers such as Pierre Boulez, Henri Dutilleux, Olivier Messiaen to radio audiences. In all likelihood, Louis Saguer wrote the score of the *Monotone Symphony* in 1959–1960. In

1961 he signed the one annotated by Klein himself. He was given an anthropometry in thanks (ANT 170), dated 1960, and dedicated as follows: "To Louis Saguer / your friend / Yves the Monochrome."

195 Cf. Eliane Radigue, interview with Philippe Ungar (AYK). The conductor Arrii-Blachette identifies two options: either the chord *D - F* sharp - *A*, spread over several octaves, stressing the basses; or the *D* note, by itself, over several octaves, which Yves Klein prescribed in 1961.

196 "I suggest many violins, cellos, violas, and double basses so as to give depth and thus obtain an even sound with no gaps: the strings must not vibrate excessively and should try to produce a sound that is as linear as possible. If we hire singers, there must also be many of them and they must not breathe at the same time, once again in order to avoid gaps in the sound" (Letter from P. Arrii-Blachette [January 15, 1998], reproduced in the anthology of the writings of Y. Klein, *Le Dépassement de la problématique de l'art*, p. 347).

197 Cf. F. Albera, "Yves Klein au cinema," *1895*, 49, 2006, pp. 92–127.

198 R. Rolland, "Lettre du 7 janvier 1912," *Deux hommes se rencontrent. Correspondance entre Jean-Richard Bloch et Romain Rolland (1910-1918)*. Paris: Albin Michel, 1964, p. 96.

199 Georges Mathieu had pressed Pierre Henry several times, especially at the Comte d'Arquian's Galerie Internationale, as well as on April 2, 1959, in Vienna, for a "Tribute to the Bourbon Commander, responsible for the sack of Rome." Pierre Henry composed *Sound Sequences*, inspired by the artist's 18 *Voids*, for the private view of the Jean Degottex exhibition, held in the same venue on November 25, 1959. His partnerships with Maurice Béjart, Arman, and Nicolas Schöffer should also not be forgotten.

200 Cf. "Pierre Henry: une ouverture," *Yves Klein*, exhibition catalogue, March 3 –May 23, 1983. Musée National d'Art moderne. Paris: Centre Georges Pompidou, 1983, p. 265). In 1959 Yves Klein appointed Pierre Henry to one of the two Chairs of Music in his School of Sensibility. The other was given to Sylvano Bussotti, who had visited the Gelsenkirchen construction site.

201 Schaeffer also rejected it, preferring the expression "experimental music."

202 P. Henry, interview given to French newspaper *Le Figaro* in 1955.

203 "From this point of view, music didn't go as far as poetry or painting. It hasn't yet dared to destroy itself in order to survive. To live more vibrantly, the way every truly living thing does" (P. Henry, "Pour penser à une nouvelle musique," *Journal de mes sons, suivi de Préfaces et manifestes*. Arles: Acte Sud, 2004, p. 100).

204 Y. Klein, manuscript (AYK, Div. sno. 406). See also P. Henry, "Pour penser à une nouvelle musique," *op. cit.*, p. 101.

205 *Ibid.*

206 There is no certainty regarding the date of the first electronic performance of the *Monotone-Silence Symphony*. According to Pierre Henry, the sound material was ready by 1958 (cf. *Yves Klein*, 1983, p. 266). Some accounts mention a public broadcast on May 10, 1957, the same day as the vernissage of Yves Klein's exhibition *Propositions monochromes* at the Iris Clert gallery (cf. D. Riout, *Manifester l'immatériel*. Paris: Gallimard, 2004, p. 46).

207 Pierre Henry composed several, including the ones Yves Klein wanted to play on June 3, 1959, in the Turgot Hall of the Sorbonne, where he was giving his lecture entitled "The Evolution of Art towards the Immaterial." A problem with the tape recorder prevented him. He had a second version that day which was also electronic, although the author is unknown (cf. Y. Klein, *L'Évolution*, p. 143).

208 Cf. *Ibid.*, p. 144. He regards the spectral envelope of electroacoustic music as being too cold. See also an untitled manuscript by Klein (AYK, Div. sno. 397).

209 Since "the bow should not be heard striking the strings" (cf. note by Yves Klein in the top left-hand corner of the IMMA 43a score), the music creates the effect of a uniform and homogeneous soundtrack. It's the tone of the voices and instruments (strings, woodwinds, brass) that provide the color.

210 P. Henry, conversation, *Yves Klein*, p. 266.

211 "Guerre," *Illuminations*, p. 235.

212 Such as the work of Giacinto Scelsi, who finished his *Quattro pezzi su una nota sola* for chamber orchestra in 1959, after ten years of research. Each of these four pieces develops a single note, where only the pitch, the vibrato, the tone, and the octave vary. The intention is to reach the innermost life of sound. The listener is invited to plunge into its subtle matter, its concentrated existence, which seems homogeneous but is full of details. A music situated *on this side*, where a new consciousness is born. Another figure was La Monte Young, a pioneer of minimal music and the creator, in 1957 and 1958, of two pieces (*For Brass* and *Trio for Strings*) composed around several notes held for an indeterminate length of time. His intention was to exploit all the formal and psycho-acoustic resources of sound. He invented the *Dream House*, a sound and visual installation creating a feeling of immersion in a concrete and imaginary environment. Acoustic technology enables notes to be stretched ad infinitum.

213 "Délires II," *Une saison en enfer, op. cit.*, p. 192.

214 Y. Klein, "Le Vrai," *L'Aventure*, p. 241.

215 As in Scelsi's *Quattro pezzi su una nota sola*. According to P. Henry, "Yves and I wanted a 'sound value' which wouldn't be a transcription, but some sort of sound evolution, both static and moving, like a long musical snake" (entretien, *Yves Klein*, p. 266).

216 Y. Klein, *L'Évolution*, p. 123.

217 *Le Bateau ivre*, v. 83, p. 125.

218 Y. Klein, *Le Dépassement*, p. 105. He also speaks of "static velocity" ("Compte-rendu de l'exposition en collaboration avec Jean Tinguely," p. 63).

219 H. Bergson, *L'Évolution créatrice*. Paris: PUF (coll. "Quadrige"), 1989 (1941), pp. 164, 166.

220 H. Bergson, *La Pensée et le mouvant*. Paris: PUF (coll. "Quadrige"), 1998 (1934), p. 166.

221 Cf. Y. Klein, "Le Vrai," *L'Aventure*, pp. 232–233.

222 G. Bachelard, *L'Air et les songes. Essai sur l'imagination du mouvement, op. cit.*, p. 218.

223 Cf. Y. Klein's letter to T. Ferraris (October 2, 1959), in *Le Dépassement*, p. 355.

224 Contrary to the tradition of arranging music around the harmonic structure (cf. J-Y. Bosseur, *John Cage*. Paris: Minerve, 1993, p. 14).

225 P. Verlaine, "Art poétique," v. 1, *Jadis*, in *Œuvres poétiques complètes*. Paris: Gallimard ("Bibliothèque de la Pléiade"), 1962, p. 326.

226 Y. Klein, manuscript (AYK, Div. sno. 488).

227 Y. Klein, *Le Dépassement*, p. 82. "So, this symphony doesn't exist even if it's there, emerging from the phenomenology of time, because it was neither born, nor will it die, however after existing in the world of our conscious possibilities of perception" (*Ibid.*).

228 P. Schaeffer, *Traité des objets musicaux*. Paris: Éditions du Seuil, 1977 (1966), p. 219.

229 *Ibid.*, p. 222.

230 P. Schaeffer, "Premier journal de la musique concrète 1948-1949," *A la recherche d'une musique concrète*. Paris: Éditions du Seuil, 1952, p. 15.

231 "À une raison," *Illuminations*, p. 217.

232 Acousticians in fact describe the trajectory of the sound divided into *Attack - Resonance - Decay*. There is also another pattern called ADSR: *Attack - Decay - Sustain - Release*.

233 Cf. Y. Klein, "Le Vrai," *L'Aventure*, p. 241: the sound "emerged from space even while remaining in it, penetrated it anew, then returned to silence . . ."

234 Cf. "This continuous *sound* was deprived of its initial attack and its ending by an electronic process" (Y. Klein, "Le Vrai," *L'Aventure*, p. 241).

235 *Yves le monochrome*, p. 285. "Sound builds *silence*" (Y. Klein, AYK, Div. sno. 407a).

236 Any instrumentalist can be the performer.

237 *Lettre du Voyant*, to Paul Demeny, May 15, 1871, p. 93.

238 Cf. P. Schaeffer, *Traité des objets musicaux, op. cit.*, p. 198.

239 Heraclitus, *Fragments*, 54, in A. Jeannière, *op. cit.*, p. 107.

240 *Un cœur sous une soutane*, p. 29.

241 *Deuxième journal de la musique concrète*, in *À la recherche d'une musique concrète*. Paris: Éditions du Seuil, 1952, pp. 114–115.

242 *Traité des objets musicaux, op. cit.*, p. 23.

243 Just as Yves Klein wants to correct the "conditioned way of seeing" ("Discours à la commission du théâtre de Gelsenkirchen," p. 72), so Pierre Schaeffer "un-conditions" the listening, and "empties our consciousness from its usual contents" (*Traité des objets musicaux*, respectively, p. 478 and p. 271).

244 *Le Réalisme authentique d'aujourd'hui*, p. 154.

245 Cf. "I am the painter of space. I am not an abstract painter, but on the contrary a figurative and Realist one" (manuscript, AYK, Div. sno. 483).

246 *Traité des objets musicaux, op. cit.*, p. 23.

247 Cf. P. Szendy, "Abstraite musique concrète ou 'tout l'art d'entendre.' (Le rêve de Pierre Schaeffer)," in M. Gagnebin and C. Savinel (eds.), *Le Commentaire et l'art abstrait*. Paris: Presses de la Sorbonne Nouvelle, 1999, p. 94.

248 Yves Klein wrote: "My painting strives to be a representation of freedom in the state of raw material" ("Discours à la commission du théâtre de Gelsenkirchen," p. 75). The immaterial "will lead us to rediscover a true love of matter" (Y. Klein, *L'Évolution*, p. 131).

249 Yves Klein did see himself in this way on several occasions: ". . . it will not be with rockets, sputniks, or missiles that mankind will *conquer* space, for he will then always remain just a tourist in space. Rather, it will be achieved by inhabiting its sensibility . . ." (*L'Évolution*, p. 123); "Obscurantism is not my aim, on the contrary, it's the *re-conquest* of pure sensibility, contact with space" (manuscript, AYK, reproduced in *Le Dépassement*, 2003, p. 392).

250 Cf. M. Merleau-Ponty, *Le Visible et l'invisible, op. cit.*, p. 182.

251 Y. Klein, *Manifeste*, p. 306. See also *Yves le monochrome*, p. 286.

252 *Ibid.*, p. 285.

253 Cf. Y. Klein, *Manifeste*, p. 305.

254 M. Foucault, *Les Mots et les choses*. Paris: Gallimard (coll. Tel). 1990 (1966), p. 41.

255 Y. Klein, *Yves the monochrome*, p. 188: "I leap outside and there I am on the riverbank amidst the bulrushes and the reeds. I spray color over everything and the wind, which bends the delicate stems, comes and precisely and delicately adds others to my canvas that I thus present to *quivering* nature: I obtain a vegetal mark."

256 Y. Klein, "Le Vrai," *L'Aventure*, p. 246.

257 "Jeunesse," *Illuminations*, p. 236.

258 Yves Klein was keen to distinguish his anthropometric works from the action painting of Jackson Pollock and its "ultra" version: the Japanese *Gutaï* (concrete) avant-garde movement, founded in Osaka in 1954 by Jiro Yoshihara, whose manifesto was published in 1956. One its leading figures, Kazuo Shiraga (1924–2008), used his body as a tool for material or pictorial expression. In 1955 he rolled around in mud, and in 1956 he created an artwork using his feet as brushes.

Yves Klein's *living brush* is of a completely different nature (cf. *Manifeste*, p. 307).

259 This was P. Cervi, a native of Corsica. The young girl posed for the Académie Julian in the Rue du Dragon studio. When she appeared in front of the guests, Tibetan voices were heard, according to the account of Mrs. Gianna Sistu, present that evening. Robert Godet had traveled to the Himalayan foothills a few years earlier. Maybe he brought back a recording from one of the monasteries where he stayed.

260 In *Dimanche*, Yves Klein describes a similar process: "I threw a large white canvas on the ground. I poured some twenty kilos of blue paint in the middle of it and the model literally jumped into it. She painted the painting by rolling her body over the surface of the canvas in every direction" ("Viens avec moi dans le vide," p. 192).

261 Jigorō Kanō, the founder of this dojo (1882), is also the founder of Judo.

262 "Judo gave me a lot. I began it almost at the same time as my painting. They have both lived with me as I live with my physical body!" (Y. Klein, "Réflexions sur le Judo").

263 "Réflexions sur le Judo, le Kiai, la Victoire constante" (AYK, Div. sno. 567).

264 Inverting the terms *Ki*, "mind, will, inner force" and *Ai*, "unite."

265 G. and R. Habersetzer, "Kiai," *Encyclopédie des arts martiaux de l'Extrême Orient*. Paris: Amphora, 2004, p. 360.

266 "Réflexions sur le Judo," *op. cit.*

267 *L'Évolution*, p. 132.

268 "I then put together a kind of ballet with girls covered in paint on a large canvas that looked like a white Judo mat" (Klein, interview with Pierre Descargues, *La Tribune de Lausanne*. October 30, 1960).

269 Including Picasso, Braque, and Dali, in 1943, 1945, and 1951, respectively. He also published poets such as Henri Michaux (1943) and Robert Desnos (1943 and 1944).

270 R. Godet, *Le Judo de l'Esprit*. Paris, published privately, 1964, 4th sheet, quoted by M. Brousse, *Les Racines du judo français: histoire d'une culture sportive*. Bordeaux: Presses Universitaires de Bordeaux, 2005, p. 235. The pamphlet is illustrated by Georges Mathieu, who spoke to Klein at the time of his anthropometric performance on March 9, 1960.

271 I. Abé, preface for Yves Klein's book, *Les Fondements du judo* (1954). Paris: Éditions Dilecta, 2006, p. 15. Ichiro Abé was 6th dan, official envoy of the Tokyo Kōdōkan.

272 Y. Klein, interview with Descargues, *La Tribune de Lausanne*, op. cit. It is likely that Yves Klein was his own model for the first anthropometries.

273 The anthropometry *Héléna* (ANT 50) dates from January.

274 It is worth mentioning Elena Palumbo-Mosca, Jacqueline Morlock, and a young woman we now only know by her first name, Michèle. Rotraut Uecker, who married Yves Klein in January 1962, also made a print. During the spring of 1961, she acted as the brush in Larry Rivers's studio in New York for the ANT 156 anthropometry, which was given to Marcel Duchamp as a tribute for his *Nu descendant un escalier*.

275 In the following month, on March 8, 1960 to be precise, he held the first monochrome painting theme exhibition in Leverkusen, *Monochrome Malerei*, where Yves Klein exhibited, heralding the "triumph" of a style of painting that had become a "genre" (D. Riout, *La Peinture monochrome. Histoire et archéologie d'un genre*. Nîmes: Éditions Jacqueline Chambon, 1996, p. 95).

276 P. Restany, *Yves Klein le monochrome*, p. 95, quoted by D. Riout, *Manifester l'immatériel, op. cit.*, p. 129.

277 A. Artaud, "Le Théâtre de la cruauté. Premier manifeste" (1932), *Le Théâtre et son double*, in *Œuvres complètes*. Paris : Gallimard, 1978, p. 88.

278 Y. Klein, *Manifeste*, p. 309.

279 "What led me towards anthropometry? The answer can be found in my work between 1956 and 1957, when I was involved in the great adventure of creating the immaterial pictorial sensibility" (Y. Klein, *Ibid.*, pp. 307–308). Yves Klein sometimes deliberately asked for a model's *collaboration* when making some of his monochromes (cf. Y. Klein, "Viens avec moi dans le vide," *Dimanche*, p. 191).

280 A. Rimbaud, "Mystique," *Illuminations*, p. 228.

281 Y. Klein, *Manifeste*, p. 309.

282 The identification with flesh is such that Klein speaks of "perfect scientific telekinesis" between him and his models (*Yves le monochrome*, p. 284).

283 Y. Klein, "Viens avec moi dans le vide," *Dimanche*, p. 192.

284 Y. Klein, *Manifeste*, pp. 308–309.

285 Cf. Y. Klein, "Viens avec moi dans le vide," *Dimanche*, p. 192. It's the body's sensuality which acts. Yves Klein designed a live show where "beautiful young girls" and "extremely handsome young men," entirely naked or scantily dressed, would wander about among the spectators-livers, with the job of "cheering up" the audience (cf. "Sensibilité pure," *Dimanche*, p. 183). The purpose of nudity is to decondition man from his acquired reflexes and his existential inhibitions. Klein also suggested the audience fondle the nude male and female models he called "hypersensitive tactile sculptures" ("Projet pour un institut national théâtral," *Dimanche*, p. 189). A friend of his, and one of his models, Elena Palumbo-Mosca, remembers the unfinished project of a collaboration between Yves Klein and Alain Bernardin, who founded the *Crazy Horse* cabaret in 1951: the nude dancers were dressed only in light, like Yves's models.

286 *Yves le monochrome*, p. 281. "The head, the arms, the hands are intellectual articulations around the flesh, which is the body!"

287 *Ibid.*, p. 282.

288 Y. Klein, *Yves le monochrome*, p. 282.

289 *Ibid.* In his *Manifeste*, he also writes: "all phenomena manifest *themselves*" (p. 305).

290 Eugène Delacroix, quoted by Klein, "My position," p. 51.

291 Y. Klein, "Viens avec moi dans le vide," *Dimanche*, pp. 192–193.

292 Interview in Brussels on December 3, 2010.

293 A. Rimbaud, *Lettre dite du Voyant*, to Paul Demeny, pp. 88–89.

294 M. Blanchot, *Le Livre à venir*. Paris: Gallimard (coll. Folio Essais), 2008 (1959), pp. 9–10.

295 It was created on March 9, 1960 at d'Arquian's. The title is a tribute to Elena Palumbo-Mosca, a friend and model of Yves Klein.

296 A. Breton, *Manifeste du surréalisme* (1924). Paris: Gallimard: (coll. "Bibliothèque de la Pléiade"), 1988, p. 332.

297 P. Valéry, *L'Idée fixe*, in *Œuvres*. Paris: Gallimard (coll. "Bibliothèque de la Pléiade"), 1960, vol. II, p. 215.

298 Y. Klein, manuscript (AYK, Div. sno. 34).

299 Y. Klein, *Yves le monochrome*, p. 280.

300 "Discours à la Commission du théâtre de Gelsenkirchen," p. 75.

301 Cf. *L'Air et les songes. Essai sur l'imagination du mouvement, op. cit.*, p. 214 and p. 218, respectively.

302 A. Rimbaud, "Les Poètes de sept ans," v. 59–60, p. 102.

303 Cf. Y. Klein, "Discours prononcé à l'occasion de l'exposition Tinguely," p. 103.

304 Y. Klein, "Comment et pourquoi, en 1957," *L'Aventure*, p. 388.

305 Y. Klein, "Le Vrai," *L'Aventure*, pp. 236–237.

306 Cf. Y. Klein, "Creation of a Centre of Sensibility," *Le Dépassement*, p. 114: "At present, this is a question of recognizing the decayed state of the problematics of art, religion, and science . . . The goal here is the nonproblematic existence of man in this world."

307 Y. Klein, *L'Évolution*, p. 127.

308 H. de Balzac, *Gambara* (1837), *Études philosophiques*. Paris: Gallimard, 1979, vol. X, p. 516.

309 Y. Klein, "Le Vrai," *L'Aventure*, p. 228. On the absolute value of color and its "pictorial presence," see B. Aubertin, "Esquisse de la situation picturale du rouge dans un concept spatial," *Zéro*, 3.

310 Y. Klein, ca.1958 (AYK, Div. sno. 705).

311 G. d'Annunzio, *Contemplazione della morte* (1912).

312 Y. Klein, manuscript, 1959 (AYK, Div. sno. 477a).

313 Cf. Y. Klein, typescript on paper, ca.1960 (AYK, Div. sno. 238): "color bathes in the whole in the same way as all that bathes." The Stoic theory of bodiless entities describes this same wrapping of the world within *a whole* (cf. A. Cauquelin, *Fréquenter les incorporels*, p. 16 sqq.) The relationship between "visible" and "invisible" is quite similar to "void" and "place" (cf. "Incorporels, le lieu et le vide sont une même chose, qui est nommée 'vide' quand aucun corps ne l'occupe, et 'lieu' lorsqu'elle est occupée par quelque corps," p. 22).

314 G. Bachelard, *La Flamme d'une chandelle*, op. cit., p. 2.

315 G. Deleuze and F. Guattari, *Qu'est-ce que la philosophie?*. Paris: Éditions de Minuit, 1991, p. 41.

316 "For me it is no longer a question of brushing canvases but rather of establishing . . . between myself and this nature, which in fact are one, neo-figurative painting as at once the most *real* and the most *immaterial* there is" (Y. Klein, *Le Réalisme authentique aujourd'hui*, p. 154).

317 S. Mallarmé, *L'Après-midi d'un faune*, v. 77–78, *Poésies*, op. cit., p. 38.

318 "The most interesting thing . . . is the mark of Fire: it is immaterial, yet tangible and visible flesh" (Y. Klein, typescript on paper, ca 1962, AYK, Div. sno. 299).

319 Rimbaud, "Soleil et chair," v. 40–41, "Les Cahiers de Douai", p. 67.

320 Y. Klein, *L'Évolution*, p. 132. Klein and Merleau-Ponty are in close agreement: "the body interposed is not itself a thing, interstitial matter, connective tissue, but *sensitive towards itself*; what does this . . . paradox mean [?]: a set of colors and surfaces inhabited by touch and vision, hence a *sensitive exemplar*, which offers him who inhabits and senses it the wherewithal to feel everything that resembles himself on the outside" (M. Merleau-Ponty, *Le Visible et l'invisible*, op. cit., p. 176).

321 Y. Klein, "La Guerre," *Dimanche*, p. 206. Klein also speaks of "sensibility in the state of raw material."

322 Y. Klein, typescript on paper, 1960 ca. (AYK, Div. sno. 202).

323 Cf. E. de Saint-Aubert, *Du lien des êtres aux éléments de l'être*. Paris: Vrin, 2004, p. 49: "Perception is the preferred place for the manifestation of the union of the soul and the body because it is also the preferred place for its *realization*."

324 G. Bachelard, *L'Eau*, p. 146.

325 H. de Balzac, *Histoire intellectuelle de Louis Lambert*. Paris: Charles Gosselin Libraires, 1832, p. 23.

326 Y. Klein, *L'Évolution*, p. 124.

327 C. Baudelaire, "Exposition universelle – 1855," *Curiosités esthétiques*. Paris: Michel Lévy Frères, 1868, p. 215. Yves Klein proclaims the superiority of the eye's serious naivety over the naive seriousness of inspecting intelligence (cf. "Des bases (fausses)," p. 21; ". . . to be naïve is to live"; "Comment et pourquoi en 1957," p. 389: "In this sense abstract painting is an unforgivable naïvety"; see also Saint-Aubert, *Du lien des êtres aux éléments de l'être*, op. cit., p. 60).

328 R. Char, "Faire du chemin avec...," in *Fenêtres dormantes et porte sur le toit* (1973–1979), p. 581.

329 A. Rimbaud, "Comédie la soif," v. 72–73, p. 152.

330 "Permanent invisible," *Dans la pluie giboyeuse*, in *Le Nu perdu* (1964–1970), v. 2, p. 459.

331 Dino Buzzati, "Sortilegio a Notre-Dame," *Corriere della Sera*, February 4, 1962.

332 Yves Klein aims for the "exasperation of the Ego" so that, once the critical point is obtained, he frees himself and reaches the deep dimension of the world, where his own flesh will merge, through "a kind of absolute purifying sublimation" (*Dimanche*, "Du vertige au prestige," pp. 190–191).

333 Interview given to Marjorie D., May 28, 1957, for ORTF, transcribed in Yves Klein's private journal, "7 September, 1957," p. 46.

334 [*Proses en marge de l'Évangile*]. p. 174.

335 Two immaterializations follow one another thus: the one in the painting in a blinding light and this burnt one echoing in the mind.

336 The film can be viewed at www.yveskleinarchives.org

337 "Le Vrai," *L'Aventure*, p. 235. Klein speaks of "impalpable freedom matter in a non-concentrated state."

338 Y. Klein, *L'Évolution*, p. 131.

339 Yves Klein probably gave it to him as a gift.

340 Strolling along with the painter Louis Benisti in Lourmarin in the early 1960s, Francine Camus said to him: "My God, Louis, do you know what happened to me? I found a piece of blue cardboard among Albert's documents. I thought it was some folder to store loose sheets in. Well, can you imagine, it was nothing of the kind! It was a painting, a blue monochrome by Klein. I realized when I saw the signature on the cardboard" (M. Mahasela, "Albert Camus, réflexions sur la peinture, de Picasso à Giotto," *Bulletin de la Société des Etudes camusiennes*, 88, September 2009).

341 A. Camus, *La Chute*. Paris: Gallimard, 1956, pp. 9, 150.

342 Y. Klein, "Le Vrai," *L'Aventure*, pp. 237, 238, respectively.

343 *Fragments posthumes (début 1888 – début janvier 1889)*. Paris: Gallimard, 1977, vol. XIV, fg. 17 (3), p. 269.

344 Yves Klein was sorry about a misunderstanding concerning this topic (cf. Manuscript, AYK, Div. sno. 3066).

345 Unlike the previous ones, the exact weight of fine gold was not specified. This flexibility enabled transactions of considerable value to take place.

346 *Règles rituelles de la cession des zones de sensibilité picturale immatérielle*, p. 278.

347 "Anyone acquiring a Zone of Immaterial Pictorial Sensibility is hereby informed that the mere fact of accepting a receipt for the price paid completely cancels the authentic immaterial value of the work, even though he possesses it" (*Ritual*, p. 182).

348 Klein says of the monochrome painting that it expresses "the artist's state of communion and enlightenment in the presence of everything," in "Le Vrai," *L'Aventure*, p. 246). However, this wandering from hand to hand only postpones its inevitable fate: to disappear in flames.

349 Every new owner has to sign it on the back so that the various stages of the transfer are recorded.

350 The series 0 receipts do not bear this statement.

351 Six of series 1; one of series 4; and two of series 0.

352 When the cession was completed in September, Yves Klein had not arranged the ritual yet, nor organized an official receipt. This is why the Zone was sold for 20,000 Lire in cash rather than gold (cf. Iris Clert's letter, November 18, 1959).

353 In arranging for the formalities concerning the cession of the *zones of sensibility* to be conducted in the fall of 1959, Palazzoli extends to Yves Klein the credit of an art dealer. Shrewd businessman as he was, a few months later he founded Galleria Blu, where he exhibited the works of Lucio Fontana, Alberto Burri, Emilio Vedova, and Ennio Morlotti.

354 In 1970, he opened a gallery at 279 Rue Saint-Honoré, Paris. He was also famous for his important collection of drawings and paintings created by traveling artists in Brazil between 1820 and 1870.

355 Just like Palazzoli, whom he certainly knew, he would have seen the IKB immaterial at the Apollinaire gallery.

356 He was responsible six years earlier for publicizing in Italy the IKB monochromes shown in Milan ("Blu blu blu," *Corriere d'informazione*, Januray 9. 1957).

357 Among the works in his catalogue were: *Okinawa* (1950), *The Juggler* (1953), *The Caine Mutiny* (1954)—for additional dialogue—and *Untamed* (1955).

358 He had met Yves Klein at Virginia Dwan's gallery a few months earlier, in spring 1961.

359 "Délires I," *Une saison en enfer*, op. cit., p. 191.

360 Cf. P. Verlaine, "Mon rêve familier," v. 1–4, *Poèmes saturniens*. Paris: Le Livre de poche classique, 1961, p. 43.

361 Cf. M. Mauss, *Essai sur le don*. Paris: PUF, Quadrige, 2007 (1925), p. 81.

362 He admits having given way to a "mean, bourgeois spirit" ("Sortilegio").

363 Cf. *Règles*, p. 278.

364 G. Bataille, *La Part maudite*. Paris: Ed. de Minuit, 2011 (1949), p. 89.

365 Y. Klein, *Règles*, p. 279. These seem to have involved two "immaterial paintings," executed during the *Void* exhibition at Iris Clert gallery, in April–May 1958 (cf. Y. Klein, "Préparation," *Le Dépassement*, p. 94). In a letter dated September 20, 1959, Iris Clert congratulated Palazzoli on his new acquisition, stressing it was the first work of its kind (cf. D. Riout, *Manifester l'immatériel*, op. cit., p. 165, note 5). So, unless Yves Klein carried out secret cessions behind his gallery owner's back, it can be concluded that no immaterial was sold prior to fall 1959. This is corroborated by one further detail: Yves Klein donates the gold to be turned into ex-votos for St. Rita as the yield from the first *four* cessions of immaterial, from September to December 1959.

366 The true circumstances of how the three December 1959 cessions took place are unknown. In her autobiography, Iris Clert writes that she closed the deal during a cocktail party held at her flat on Avenue Paul Doumer (*Iris-Time. L'Artventure*. Paris: Denoël, 2003 (1978), p. 206).

367 Yves Klein had obtained its financial backing for the distribution in Paris of the *Journal d'un seul jour*, on Sunday, November 27. In July 1961, the Galerie Rive Droite also hosted the group exhibition *Le Nouveau Réalisme à Paris et à New York*.

368 M. Blankfort, in Maurice Tuchman (ed.), *The Michael and Dorothy Blankfort Collection*. exhibition catalogue (April 1 –June 13, 1982). Los Angeles: County Museum of Art, 1982, p. 14. All the quotations that follow come from his account.

369 This counter-donation has distinct similarities with what Mauss describes in the Maori *taonga* and *hau* rituals (cf. op. cit., p. 15).

370 "Vagabonds," *Illuminations*, p. 226.

371 Y. Klein, typescript, ca.1962 (AYK, Div. sno. 854c).

372 Interview with André Arnaud, April 29, 1958 (AYK, Div. sno. 332).

373 At the last moment the Paris police headquarters cancelled the project; it wasn't carried out until 1983.

374 *Règles*, p. 278.

375 It is almost certain that gold wasn't the medium of exchange for the December 1959 cessions. In February 1961, Yves Klein went to Cascia Monastery for the third time, where he dedicated an ex-voto to St. Rita containing three gold ingots presented as the yield of the first four immaterial cessions. It is quite reasonable to suppose Klein had changed cash into gold. Indeed, in a letter dated November 18, 1959 Iris

Clert asks Palazzoli to settle the 10,000 Francs outstanding for the purchase of the complete zone 1 series 1, amounting to 20,000 Francs in total. She writes that she sold each of the three December 1959 transfers for 10,000 Francs.

376 Neither he nor Claude Pascal seems to have bought the gold leaves: Yves Klein gave them as a gift, together with the *Zone of Immaterial Sensibility*. In his article, Buzzati hints that the appointment had been made on the previous day: he therefore couldn't possibly have found time to obtain the gold.

377 Cf. D. Buzzati, "Sortilegio," *op. cit.*

378 During his stay in Japan in 1952, Yves Klein heard that the artist Ôgata Kôrin (1658–1716) had scattered gold leaves covered with poems on the surface of a river on a feast day. Cf. M. Tiampo, "Empreintes de l'immatériel: Yves Klein au Japon," in *Yves Klein*. Paris: 2006, p. 196.

379 Mathey is said to have given the ingots to two tramps who happened to be there, thinking that his generosity fitted in with the notion of the offering to the river (cf. Descargues, *Yves Klein, comme s'il n'était pas mort*. Paris: Galerie 1900-2000, 1995).

380 Cf. "In order for the fundamental immaterial value of the zone to belong to him and *become a part of him*, [the buyer] must solemnly burn his receipt" (*Règles*, p. 278).

381 D. Buzzati, "Sortilegio," *op. cit.*

382 Yves Klein distinguishes two procedures: if the receipt stays intact, the buyer will only receive "[his] monochrome freed thought." If it is completely burnt up, it "takes away [his] Void" which then becomes "his" (typescript, ca.1959, AYK, Div. sno. 3066).

383 "The gold remitted to Yves Klein by the buyer for the acquisition of a *Zone of Immaterial Pictorial Sensibility* can also be burnt (blue flames)" (Y. Klein, "Press Book," AYK, IMMA 15). Klein also declared: ". . . blue, gold, and pink are of the same nature. Barter between these three states is honest" (*L'Évolution*, p. 122).

384 *Ibid.*

385 Cf. Bachelard, *op. cit.*, p. 30.

386 The pictures only show Yves Klein throwing the gold into the Seine.

387 "L'Éternité," v. 9–12, p. 156.

388 Y. Klein, *Yves le monochrome*, p. 280.

389 This is why Yves Klein aspires to create a work embracing the world. He wants to "paint a monochrome in (his) new manner, 'the specialization of sensibility,' the size of the WHOLE OF France . . . using as pigment "the people and tangible nature, like the intangible which is dynamic, explosive, and pneumatic in the highest degree" ("Comment et pourquoi en 1957 ," AYK, Div. sno. 152).

390 *Ibid.*

391 Y. Klein, *Dialogue avec moi-même*, p. 314.

392 *Ibid.*, p. 313.

393 He was to attempt this experiment on himself first: "Having arrived in that place, in the monochrome adventure, I no longer worked; I simply functioned. I was no longer myself; I, without the 'I,' became one with life itself. All my gestures, movements, activities, and creations were this original, essential life itself" (*Yves le monochrome*, p. 280); "such an ideal viewer of my colored surfaces would then become extradimensional,' only with regard to sensibility of course, 'to such an extent that he would be 'all in all'—immersed in the sensibility of the universe" ("Le Vrai," *L'Aventure*, p. 246).

394 M. Merleau-Ponty, *Le Visible et l'invisible*, *op. cit.*, p. 186.

395 "A la santé du serpent," XXVI. *Le Poème pulvérisé* (1945–1947), p. 267.

396 Cf. J.L. Borges, "Pierre Ménard, autor del *Quijote*." D. Riout is the first to propose this analogy (*Manifester l'immatériel*, *op. cit.*, p. 17).

397 Cf. *Manifeste*, p. 303.

398 "Utopie de l'enthousiasme," ca. 1960, typescript on paper, AYK, Div. sno. 588.

399 "Délires II," *Une saison en enfer*, *op. cit.*, pp. 196–197.

400 Cf. "This freedom is no more than an interval, a frontier. I am now entering another country, another kingdom, which is still totally unknown to me but certainly exists" (Y. Klein, "Les scènes de la vie de Jésus ," 1 ca. 960, Ballpoint pen on paper, AYK, Div. sno. 362).

401 "À Georges Izambard," *Lettres dites du voyant*, p. 84.

402 The expression is Husserl's (*Lectures on Phenomenology of internal time-consciousness*, §16).

403 "Sonnet," *Poésies*, p. 57.

404 Cf. *Time Regained*, or *Le Temps retrouvé*. Paris : Gallimard, 1927, ch. III, p. 20: "Immediately the permanent and usually concealed essence of things is freed and our true self, which had sometimes seemed dead for years but was not, is awakened and reanimated as it receives the heavenly nourishment brought for it. A minute freed from the order of time has been recreated in us so we can feel like a man freed from the order of time. And one can understand that this man should feel confident in his joy."

405 "But one day, if I'm sad and tired, I'll take this piece of paper out from my wallet and I will burn it. Then I'll feel comforted in some way, maybe" ("Sortilegio," *op. cit.*).

406 Y. Klein, *Ma position dans le combat entre la ligne et la couleur*, p. 50.

407 The sounds follow one another at the same frequency, but in different tones.

408 Cf. "They understand that behind the varying personal styles of artists there are moments to be found, each of a specific and different nature" (*Quelques extraits de mon journal (1957)*, "Samedi 7 septembre," p. 45). See also "Le Vrai," *L'Aventure*, p. 230, where Yves Klein takes up the Proustian idea of eternal moments: "My paintings represent poetic events or rather motionless, silent, and stationery witnesses of the very essence of movement and of free life, which is the flame of poetry during the pictorial moment!"

409 Y. Klein, *Yves le monochrome*, p. 285.

410 Y. Klein, "Avant le Vide ," ca. 1960, typescript on paper, AYK, Div. sno. 488.

411 "Actualité," *Dimanche*, p. 174.

412 The ideal is a fervent and burning presence in the world: "If I managed . . . / Only one day / To Love / every instant / of my life / with enthusiasm / I can certainly believe / That at the end of the day / I would no longer be / just a small pile / of ashes" (Y. Klein, *Journal de 1952*, "lundi 17 mars," AYK. Div. sno. 1085f).

413 Y. Klein, *Remarques sur quelques œuvres exposées chez Colette Allendy*, p. 53. To be compared with a passage in *Manifeste de l'hôtel Chelsea* regarding monochromes (p. 303).

414 Cf. Y. Klein, "Tableaux et sculptures de feu," AYK.

415 F. Nietzsche, *Fragments posthumes (début 1888 – début janvier 1889)*, frag. 17 [3], p. 270.

416 Cf. Cicero, *De Divinatione*, Book I, XXXI.

417 "Le Vrai," *L'Aventure*, p. 252.

418 Teresa of Avila, *Vida de Santa Teresa*. Madrid: Aguilar, 1970, p. 75.

419 Y. Klein, "Préparation et présentation de l'exposition du 28 avril 1958," p. 94: "some stay inside for hours without saying a word, others tremble or start to cry"; see also *L'Évolution*, p. 133.

420 Y. Klein, *Text for the exhibition "Yves Peintures,"* p. 40.

421 "Des bases (fausses)," p. 23.

422 Y. Klein, "Le Vrai," *L'Aventure*, pp. 231–232.

423 Cf. Y. Klein, "Aujourd'hui 1957," *L'Aventure*, p. 254: "Ma position vis-à-vis de l'art contemporain " (My

position regarding contemporary art), ballpoint pen on paper, ca. 1960, AYK, Div. sno. 252.

424 "Le Propre," *L'Aventure*, p. 264.

425 *Moulin premier* (1935–1936), LXX, p. 79.

426 Cf. Y. Klein, *L'Évolution*, p. 124.

427 Respectively, "Avant le Vide ," (ca. 1960, typescript on paper, AYK, Div. sno. 488) and *Journal de Paris* (1955, manuscript, AYK, Div. sno. 1090). Like certain mystics, Klein spiritualizes touch, in his desire to fondle even the immaterial: "Such a way . . . of exploring one's way of being, one's behavior, going right back to one's origins, up to the creator himself, and to explore him, too, as far as his very deepest nooks and crannies, through the simple joy of being . . . with some sort of heightened *attention*, with this hazy look of pure intensity" ("La fouille affective," manuscript, ca. 1960, AYK, Div. sno. 275).

428 "Ophélie," v. 32, p. 57.

429 "Des bases (fausses)," p. 19.

430 Klein wrote: "Blue is the invisible becoming visible" (variant of the Gelsenkirchen "speech," quoted by N. Charlet, *Yves Klein*. Paris: Biro, 2000, p. 101).

431 "Mauvais sang," *Une saison en enfer*, *op. cit.*, p. 183.

432 A. Artaud, "Le Théâtre de la cruauté (Premier manifeste)," in *Le Théâtre et son double*, *op. cit.*, p. 95.

433 Cf. Y. Klein, *Yves le monochrome*, p. 283. The dinner jacket and white gloves are his official outfit.

434 Cf. Y. Klein, "Le Vrai," *L'Aventure*, p. 226.

435 *Ibid.*, p. 284.

436 Cf. Y. Klein, *Manifeste*, p. 282.

437 H. Bergson, *La Pensée et le mouvant*. Paris: PUF, 1969 (1934). IX, p. 280.

438 Cf. Y. Klein, manuscript, AYK: "I will go picking prints in the countryside, in the mountains, in the climates, the winds, the rain, the lakes . . . Everything will take part in and witness the resurrection of the flesh."

439 *Manifeste*, p. 306.

440 Cf. T. Williams, *Suddenly, Last Summer*: "Sebastian had disappeared in the flock of featherless little black sparrows . . . they had torn bits of him away and stuffed them into those gobbling fierce little empty black mouths of theirs. There wasn't a sound any more, there was nothing to see but Sebastian, what was left of him, that looked like a big white-paper-wrapped bunch of red roses had been torn, thrown, crushed!—against that blazing white wall."

441 In the play, the character is murdered by children and teenagers sexually abused by him; he himself had witnessed similar bloodshed in the Galapagos: recently born tortoises devoured by birds swooping down on them.

442 Cf. Y. Klein, *Yves le monochrome*, p. 286.

443 *L'Évolution*, p. 122. This verse appears in his writings in 1958 ("Préparation," *Le Dépassement*, p. 85).

444 In 1958, Yves Klein distinguished the "material and physical blue, waste and coagulated blood" from the immaterial blue that would cover the Obelisk of the Concorde with its luminous flesh ("Préparation," p. 89).

445 "La lumière profonde a besoin pour paraître ," *Derniers gestes*, in *Poèmes*. Paris: Gallimard, 1982, p. 74.

446 "Soleil et chair," v. 81–82, p. 68.

447 Yves Klein never claimed to be involved in applied theology, inverts canonical terms: while the Church speaks of the transfiguration of the *flesh* in the *glorious body*, he describes the transfiguration of a *body* in its *immaterial flesh*.

448 "As I went ahead painting monochromes, I almost automatically attained the immaterial, which made me realize I was a real Westerner, a right-thinking Christian who justifiably believes in the "resurrection of the body, the resurrection of the flesh" (*Yves le monochrome*, p. 282); see also "Viens avec moi dans le vide," *Dimanche*, p. 192.

449 *Ibid.*, p. 287. He speaks of "biological synthesis" (p. 290).

450 Y. Klein, "Le Vrai," *L'Aventure*, p. 252.

451 St. John of the Cross, *La Vive Flamme d'amour*. Paris: Éditions du Cerf, 2002, p. 23.

452 Y. Klein, "La Guerre," *Dimanche*, p. 213. Followed by a verse from St. John's Gospel (6: 53): "Truly, truly, I say to you, unless you eat the flesh of the Son of Man and drink his blood, you have no life in you."

453 *Ibid.*, p. 212. In a handwritten note, Klein also writes: "Painting is a colored surface which becomes living skin . . . and which consequently becomes a presence . . . a being tout court. This is the wonderful mystery-miracle; it's sensibility-matter, made from bits of sensibility the painter has torn from space during each expedition, as well as pieces of his own sensibility . . ." (ca. 1958, ballpoint pen on paper, AYK, Div. sno. 723).

454 This anthropometric self-portrait can be compared to another (ANT 170) which Klein gave to the composer Louis Saguer.

455 Cf. "I [cf. Zarathustra] can only believe in a god who can dance" (Nietzsche, *Ainsi parlait Zarathoustra*. Paris : Garnier-Flammarion, 2006, Première partie. "Lire et écrire", p. 79). The figure of the *exile* can conceal either the divinity Typhon (Typhoeus) or the Titan Epimetheus, both insubordinate in their relations with the god of gods. The former, son of Gaia and Tartarus, rebelled against Zeus and the Olympians. Struck by lightning, he was buried under rocks on the island of Ischia, in the Gulf of Naples (or on Mt. Etna). The latter, son of Iapetus and brother of Prometheus, was the first to make a terracotta statue of a human being. Zeus therefore turned him into a monkey and exiled him to the island of Ischia (cf. Boccaccio, *Genealogia Deorum*, Book IV, 42).

456 Y. Klein, *Yves le monochrome*, p. 284.

457 "Soleil et chair," v. 64, p. 68.

458 St. Veronica's veil, on which was impressed the image of the holy face during the climb to Golgotha, or the Turin Shroud, said to bear the imprint of Christ's body, certainly inspired Yves Klein.

459 A. de Musset, *Rolla*, in *Œuvres complètes*. Paris: Louis Conard, 1923, v. 1–2, p. 1.

460 "Analyse des Temps," ink on paper, AYK, Div. sno. 106. This phrase bears a striking resemblance to Rimbaud's: "Misfortune! Now he says: I understand things, / And goes about with eyes shut and ears closed. / – And again, no more gods! no more gods! Man is King, / Man is God!" ("Soleil et chair," v. 33–36, p. 67).

461 *Ibid.*

462 A. de Musset, *Rolla, op. cit.*, v. 28–29, p. 2.

463 "Soleil et chair," v. 52–55, p. 67.

464 The design was for the chapel of Saint-Martin de France school in Pontoise. Father Tourde, the school's head, passed the design on to a colleague who was an architect, with the result that it was turned down (cf. Iris Clert, *Iris.time*, p. 180).

465 *Yves le monochrome*, pp. 283–284. Italics ours.

466 "Comment et pourquoi en 1957," *L'Aventure*, p. 390.

THE FIFTH ELEMENT

The Fifth Element

1

When I close my eyes and think of Yves Klein, I see the edges of an immaculate shirt, rolled sleeves, his stick dipping into blue and blotting out the dimensions of white. I see a Rorschach canvas with no determinants. I hear a music that cannot be scored. I see Klein, cool and as passionately indifferent as a trumpet player, opening his shirt and revealing a buzzing imprint. On his pale skin, as though executed by the hand of an irreverent archangel, the word AETHER drips in International Klein Blue. It bleeds into his shirttail. He motions for another shirt. I approach the closet, envisioning stacks of them on makeshift shelves, the white shirts of Yves Klein. But I, incapable valet, cannot open the door. I scan his apartment, getting a sense of size, imagining his process. The radiators, so iconic in photographs, seem heartbreakingly small. Klein walks right through me. He showers, shaves, and goes to the closet. The door is suddenly transparent. Each shirt is identical and folded with the dedication of a foreign maid. He carefully chooses and adds a bowtie. He is ready for the tribunal.

His blue stick lies in state—a humble yet magnificent piece of evidence. He has dipped into a forbidden realm, penetrating ethereal space like the ancient crew who built the tower of Babel. Angels had implored him not to expose their secrets. Own them, they cry, and come with us. Be the embodiment of our enigmas. A beautiful thought, to be King of the Aether. Yet as an artist, he prefers to choose who he is or is not.

2

And who is he? He is the one who expressed the density of silence and called it music. He drew from the intangible element above the air and begat a symphonic diptych: Monotone and Monotone Silence. He birthed it in the night, releasing a mute howl and producing a cunning shift in altitude. Want to hear, not hear, and then float? And where shall we float? Klein leads on. We enter a massive tube that spirits us into another atmosphere no less intriguing than the apartment at number 14; our soundtrack one chord as interminable as a prime number series.

3

We navigate white sky, blue clouds, and abruptly land in a bright green field. I tramp the blades of grass barefoot. My feet are badly cut, leaving a blue trail that Klein pauses to examine. I get there first. Where is there? Nowhere but a clearing adorned by a pedestal of ice crowned by his Nike of Samothrace. She is at first glance a garish yet appealing souvenir. Her saturated form (dry IKB pigment on plaster-cast) dominates the field. I notice an index card with the IKB formula scribbled in Klein's hand, jutting from the ice. I chip away and pocket it. It's a poem I say, somewhat sheepishly. He just shrugs and topples the statue. Voices from the celestial arena gasp.

He scoops into chaos and draws a shimmering egg that he deftly cracks. Within the substance are the proteins of art. It begins to thunder. Nike turns in the wind, pitted by rain. A flash ignites the blue of her heart, spattering her gown with the blood of synthetic resin.

Klein drops to his knees and regards her quizzically. A hairline crack races the length of her wing. Extracting a sliver of graphite from her widening wound he scrawls ciphers in the air. Rumors erupt of a secondary formula stuffed in the bowels of a statue carved in IKB pastry foam. It is enough to make you wince with delight—seeing Klein look for one thing and find something else, like the alchemist Bottger investigating the Arcanum and stumbling upon a recipe for porcelain.

4

The first time I saw his canvases I did not know of the photographic edge of his white shirt, nor did I read his manifesto, nor was privy to the installations, the happenings, and the nude collaborations. I saw the expanding void, the sonic Klein being, the alchemy of love transmuted. I was too young to experience the gestation of the era he ushered in. Yet I was old enough to venture to Paris and search him out in the spring of 1969. I sat on a curb across from his apartment on Rue Campagne Premiere, hoping he would enter or exit, not caring that he was dead. I think I did not believe he was dead. He was too young, too vibrant, and still too present. His aura burned, filtrating the atmosphere like residue from Sputnik II. His work was the French contribution to the outer space program. He gave art to science, as the architect gives a cathedral to religion.

In 1977 I had a bad accident and could not leave my bed. Paul Simonon, the bass player for The Clash, sent me a postcard from London—the image of two figures in space not touching but infinitely connected. There was no message. The image was the message. A telepathy so distilled that it begat form. What was the form? The body entered by the energy of another body from a region infinitely elastic.

5

When I close my eyes I see an immaculate white shirt. When I open my eyes it is night in Tokyo. A bowl of sake covered in 24-karat gold leaf—pure enough to ingest—is set before me. I sit and do not drink. Gold is the matter that veined the banks that lined the River Havila that flowed out of Eden. I think of gold leaf canvases, considering what it would be like to peel the leaf and partake of it. Klein produced Immaterial Zones (thus rendering them material) in exchange for pure gold. Half of it was tossed into the River Seine as an offering to restore natural order, and half was allotted towards the execution of future work. His offering of half of his acquired gold did not appease the Tribunal. His unspeakable crimes included: manipulating silence, manufacturing a new kind of blue, and revealing the fifth element within his body of work on earth. The tribunal, an altogether heavenly body, sentenced him to create art eternally in heaven. And thus at thirty-four years old, the King of Aether was united with the petulant angels within the realm he had conquered.

Patti Smith
July 2012

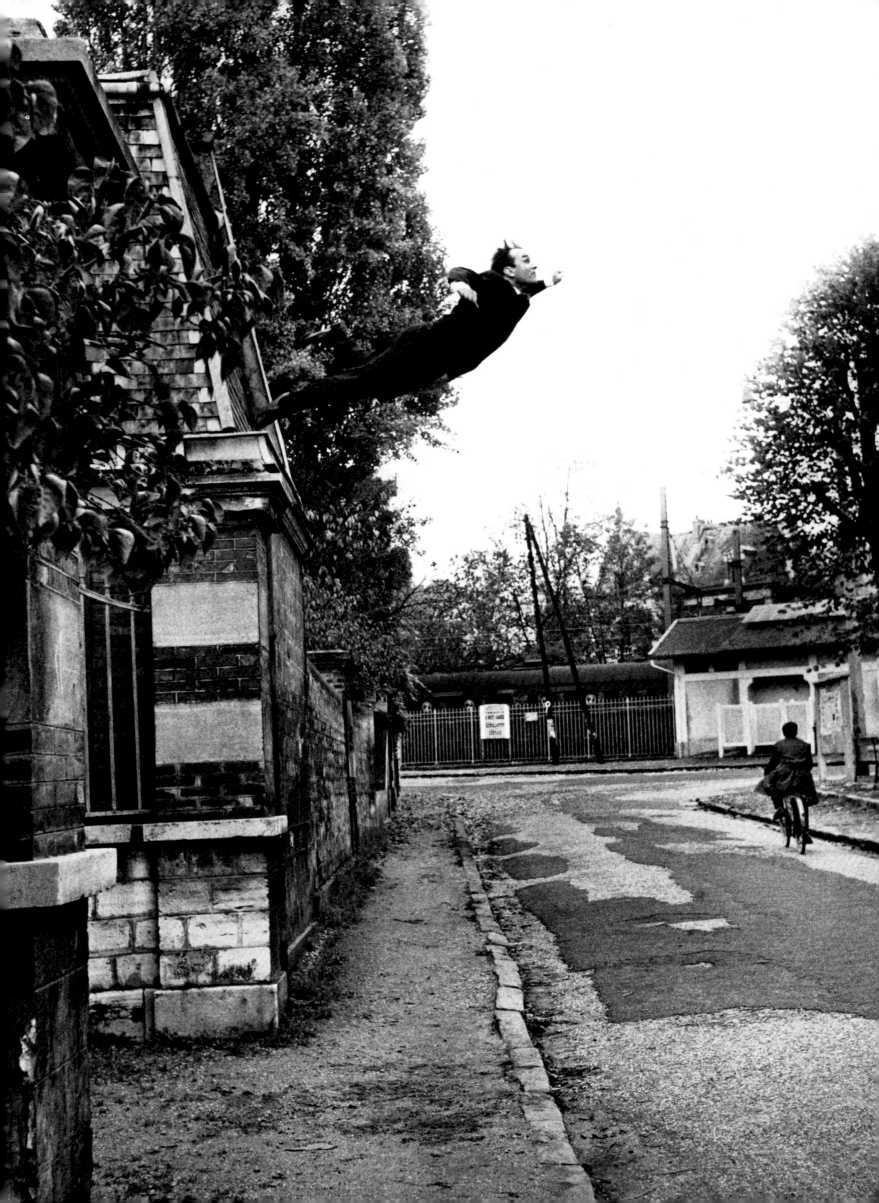

Work Index

Previous page

Le Saut dans le vide, October 1960.
5, rue Gentil-Bernard, Fontenay-aux-Roses.
(According to Yves Klein's journal, *Dimanche 27 novembre 1960*, the title of this work is: "Un homme dans l'espace! Le peintre de l'espace se jette dans le vide!," 1960).
Artistic action by Yves Klein.
© Photo Harry Shunk-John Kender

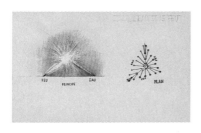

18
L'Eau et le Feu (Fontaine de feu)
[*Water and Fire* (Fountain of Fire)], ca 1960
Ink and pencil on paper
19.8 x 30.4 cm | 7.7 x 11.9 in.

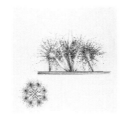

19
Jets d'eau et de feu [*Jets of Water and Fire*], ca 1959
Ink on paper
33 x 31 cm | 12.9 x 12.2 in.
Yves Klein assisted by Claude Parent

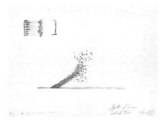

20
Jets d'eau et de feu [*Jets of Water and Fire*], 1959
Watercolor, gouache, and pen on tracing paper
23.7 x 30.7 cm | 9.3 x 12 in.

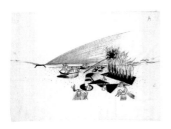

21
Cité climatisée (toit d'air, murs de feu, lit d'air)
[*Climatized City* (Air Roof, Walls of Fire, Bed of Air)], 1961
Ink and pencil on tracing paper
50 x 68 cm | 19.6 x 26.7 in.
Yves Klein assisted by Claude Parent

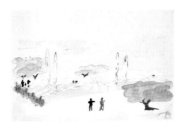

22
Fontaines d'eau et de feu
[*Fountains of Water and Fire*], ca 1960
Watercolor, gouache, and ink on paper glued on canvas
52.5 x 75 cm | 20.6 x 29.5 in.

23
Cité climatisée – Accès à l'éden technique
[*Climatized City – Access to Technical Eden*], 1961
Pencil and ballpoint on paper
26 x 36 cm | 10.2 x 14.1 in.
Yves Klein assisted by Claude Parent and Sargologo

26
Place publique : murs d'eau et de feu
[*Public Square: Walls of Water and Fire*], ca 1960
Oil pastels on paper
25 x 46 cm | 9.8 x 18.1 in.

28
Detail of one of the two blue monochromes
at the Gelsenkirchen opera house, Germany, 1959

30
Mur de feu [*Wall of Fire*], ca 1959
Crayons on paper
54 x 37 cm | 21.2 x 14.5 in..

32
Detail of one of the two great sponge-reliefs
at the Gelsenkirchen opera house, Germany, 1959

34
Sous-sol d'une cité climatisée (*Climatisation de l'espace*)
[*The Underground Climatized City* (*Climatization of Space*)],
ca 1959
Ink and pencil on tracing paper
73 x 48 cm | 28.7 x 18.8 in.
Yves Klein assisted by Claude Parent

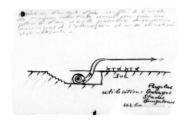

35
Création d'un toit d'air soufflé
[*Creation of a Roof of Forced Air*], 1959
Ink and pencil on tracing paper
13.5 x 20.4 cm | 5.3 x 8 in.

36
...projections d'air... [*. . . Air Projections . . .*], 1955
Ballpoint on paper
28 x 21 cm | 11 x 8.2 in.

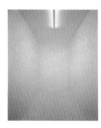

38
Interior view of the "empty" room devoted
to the immaterial pictorial sensibility, 1961,
Museum Haus Lange, Krefeld, Germany

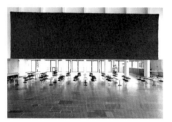

40
Monochrome bleu [*Blue Monochrome*],
Gelsenkirchen opera house, Germany, 1959
7 x 10 m
© David Bordes

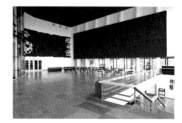

40
Monochrome bleu [*Blue Monochrome*] (7 x 10 m)
and *Relief éponge bleu* [*Blue Sponge Relief*] (5 x 10 m)
in the foyer of the Gelsenkirchen opera house,
Germany, 1959 (photo 1999)
© David Bordes

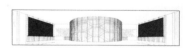

42
Perspective drawing for the Gelsenkirchen opera house,
Germany, 1958
Ink and gouache on paper
31 x 119 cm | 12.2 x 46.8 in.

48–49
Monochrome und Feuer exhibition,
Fontaine de feu [*Fountain of Fire*] in the garden
of Museum Haus Lange, Krefeld, January 14, 1961
© Bernward Wember

50
Mur de feu [Wall of Fire], 1961
190 x 170 x 25 cm
Edition of 3, 1961–1994
Courtesy Galerie Gmurzynska

52 (top)
Mur d'eau traversé de flammes
[Wall of Water Traversed by Flammes], ca 1959
Crayons on paper
37 x 54 cm | 14.5 x 21.2 in.

52 (bottom)
Mur d'eau traversé de flammes sur une pièce d'eau
[Wall of Water Traversed by Flames on a Sheet of Water]
ca 1959
Crayons on paper
37 x 54 cm | 14.5 x 21.2 in.

54
Murs d'eau et de feu (Fontaine d'eau et de feu),
[Walls of Fire and Water (Fountains of Water and Fire)]
ca 1960
Oil pastels on paper
33 x 48 cm | 12.9 x 18.8 in.

56
Fontaine d'eau et de feu [Fountain of Water and Fire],
ca 1959
Ink on paper
23.7 x 31.2 cm | 9.3 x 12.2 in.

57 (top)
L'Eau et le feu... [Fire and Water . . .], ca 1959
Pencil, ink, and watercolor on paper
15 x 36 cm | 5.9 x 14.1 in.

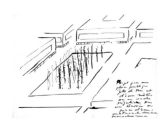

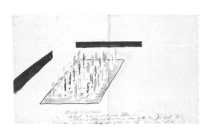

57 (bottom)
Le Feu [The Fire], ca 1959
Pencil, ink, and watercolor on paper
15 x 36 cm | 5.9 x 14.1 in.

58
Projet pour une place publique...
[Project for a Public Place . . .], ca 1959
Ink on tracing paper glued on canvas
23 x 31 cm | 9 x 12.2 in.

59
Place carrée, Reliefs monochromes bleus
[Square, Blue Monochrome Reliefs],
Watercolor and ink on paper glued on canvas
32.5 x 52.5 cm | 12.7 x 20.6 in.

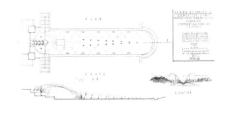

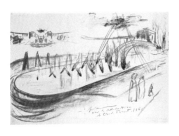

60 (top)
Drawing for *Fontaines de Varsovie [Warsaw Fountains]*, 1961
Ink and pencil on tracing paper
Yves Klein assisted by Claude Parent

60 (bottom)
Projet for *Fontaines de Varsovie [Warsaw Fountains]*, 1961
Oil pastels on paper
75 x 108 cm | 29.5 x 42.5 in.
Yves Klein assisted by Claude Parent

62
Architecture de l'air [Air Architecture] (ANT 102), 1961
Pure pigment and synthetic resin
on paper glued on canvas
261 x 213 cm | 102.7 x 83.8 in.
Tokyo Metropolitan Museum, Tokyo, Japan

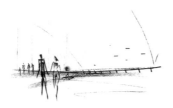

64
Projet d'une ville...[Project for a City . . .], ca 1960

66
Untitled anthropometry (ANT 4), ca 1961
Pure pigment and synthetic resin on paper
121 x 81 cm | 47.6 x 31.8 in.

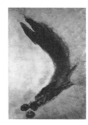

68
Untitled anthropometry (ANT 127), 1960
Pure pigment and synthetic resin
on paper glued on canvas
225 x 145 cm | 88.5 x 57 in.

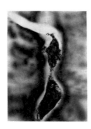

69
Hiroshima (ANT 72), 1960
Pure pigment and synthetic resin
on paper glued on panel
108.5 x 75.5 cm | 42.7 x 29.7 in.

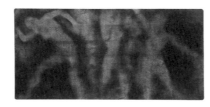

70–71
Hiroshima (ANT 79), ca 1961
Pure pigment and synthetic resin
on paper glued on panel
139.5 x 280.5 cm | 54.9 x 110.4 in.
Menil Collection, Houston, USA

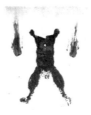

72
Untitled anthropometry (ANT 170), 1960
Pure pigment and synthetic resin
on paper glued on panel
167 x 123 cm | 65.7 x 48.4 in.

76
Untitled fire painting (F 80), ca 1961
Burnt cardboard on panel
175 x 90 cm | 68.8 x 35.4 in.

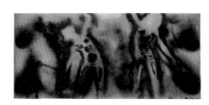

78–79 and cover
Untitled colored fire painting (FC 1), 1962
Blue and pink pigments and burnt synthetic resins
on cardboard mounted on panel
141 x 299.5 x 3 cm | 55.5 x 117.9 x 1.1 in.

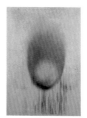

84
Untitled fire painting (F 2), 1962
Burnt cardboard
147 x 97.5 cm | 57.8 x 38.3 in.

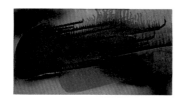

91
Feu de l'enfer [*The Fire of Hell*] (FC 30), 1962
Pure pigment and synthetic resin on burnt cardboard
attached to panel
50 x 89 cm | 19.6 x 35 in.

93
Untitled colored fire painting (FC 19), 1962
Pure pigment and synthetic resin on burnt cardboard
attached to panel
117.5 x 90.5 cm | 46.2 x 35.6 in.

94
Untitled fire painting (F 27 I), ca 1961
Burnt cardboard mounted on panel
250 x 130 cm | 98.4 x 51.1 in.

96
Untitled colored fire painting (F 26), ca 1961
Burnt cardboard
73 x 54 cm | 28.7 x 21.2 in.

98–99
Untitled fire painting (F 71), 1962
Burnt cardboard on panel
130 x 97 cm | 51.1 x 38.1 in.

100
Le Feu de l'esprit et l'empreinte de l'amitié
[*The Fire of the Spirit and the Mark of Friendship*] (F 94),
1961
Burnt cardboard on panel
100 x 65 cm | 39.3 x 25.5 in.

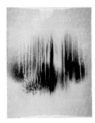

102
Untitled fire painting (F 67), 1962
Burnt cardboard on panel
50 x 38 cm | 19.6 x 14.9 in.

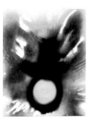

103
Untitled fire painting (F 67), 1962
Burnt cardboard on panel
50 x 38 cm | 19.6 x 14.9 in.

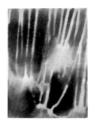

105
Carte de Mars par l'eau et le feu
[*Map of Mars by Water and Fire*] (F 83), 1961
Burnt cardboard
69 x 49 cm | 27.1 x 19.2 in.

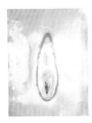

106
Untitled colored fire painting (FC 13), 1962
Burnt cardboard and gold
32 x 23.4 cm | 12.5 x 9.2 in.

109–110
Blue Monochrome holed by fire (IKB 25), ca 1959
Pure pigment and synthetic resin on paper
18 x 19.3 cm | 7 x 7.5 in.

114
Héléna (ANT 111), 1960
Pure pigment and synthetic resin
on paper glued on canvas
218 x 151 cm | 85.8 x 59.4 in.

116
Musée de Krefeld (Ruhr)... [Krefeld Museum (Ruhr) . . .].
1960
Photograph cutting and ink
Kaiser Wilhelm Museum, Krefeld, Germany

118
Score for *Symphonie monoton-Silence*
[*Monotone-Silence Symphony*], 1947-1961
Print and pen on paper
41.7 x 29.5 cm | 16.4 x 11.6 in.

124
Untitled monogold (MG 29), 1961
Burnt goldleaf on cardboard
39.8 x 28.6 x 1.4 cm/15.6 x 11.2 x 0.5 in.

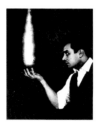

125–126
Le Rêve du feu [*The Dream of Fire*], ca 1960
Photograph Shunk-Kender
© Roy Lichtenstein Foundation

128
Embouchure du Loup . . . [*Mouth of the Loup*] (COS 4),
March 23, 1960
Pure pigment and synthetic resin
on paper glued on canvas
49 x 64 cm | 19.2 x 25.1 in.

130
Cosmogonie de la pluie [*Cosmogony of the Rain*]
(COS 29), 1961
Pure pigment and synthetic resin on cardboard
16 x 10.5 cm | 6.2 x 4.1 in.

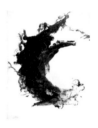

132
Barbara (ANT 113), ca 1960
Pure pigment and synthetic resin
on paper glued on canvas
200 x 145 cm | 78.7 x 57 in.

140
California (IKB 69), 1961
Pure pigment and synthetic resin
on gauze mounted on panel
194.5 x 140 x 3 cm | 76.5 x 55.1 x 1.1 in.

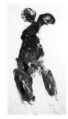

141
Untitled anthropometry (ANT 174), 1960
Pure pigment and synthetic resin
on paper glued on canvas
98.5 x 52.5 cm | 38.7 x 20.6 in.

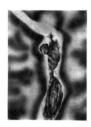

142
Untitled anthropometry (ANT 134), ca 1960
Pure pigment and synthetic resin
on paper glued on canvas
109 x 76 cm | 42.9 x 29.9 in.

144
Untitled anthropometry (ANT 177), 1960
Pure pigment and synthetic resin
on paper glued on canvas
65 x 50 cm | 25.5 x 19.6 in.

148
Untitled blue monochrome (IKB 67), 1959
Pure pigment and synthetic resin
on gauze mounted on panel
92 x 73 cm | 36.2 x 28.7 in.

150
Untitled fire painting (F 115), March 1961
Burnt cardboard on panel
80 x 120 cm | 31.4 x 47.2 in.

152–153
Untitled fire painting (F 81), ca 1961
Burnt cardboard on panel
130 x 250 cm | 51.1 x 98.4 in.
Menil Collection, Houston, USA

154–155
Untitled fire painting (F 119), 1962
Burnt cardboard mounted on panel
51 x 60 cm | 20 x 23.6 in.

156
Untitled colored fire painting (FC 17), 1962
Pure pigment and synthetic resin on burnt cardboard
106 x 94 cm | 41.7 x 37 in.
Louisiana Museum, Humlebæk, Denmark

158
Untitled anthropometry (ANT 6, verso), 1961
Pure pigment and synthetic resin
101 x 70 cm | 39.7 x 27.5 in.

159
Untitled anthropometry (ANT 6), 1961
Pure pigment and synthetic resin
101 x 70 cm | 39.7 x 27.5 in.

160
Untitled monogold (MG 3), 1960
Burnt goldleaf on cardboard
14 x 12 cm | 5.5 x 4.7 in.

162
Résonance [*Resonance*] (MG 16), 1960
Gold leaf on panel
199 x 153 x 1.5 cm | 78.3 x 60.2 x 0.5 in.
Stedelijk Museum, Amsterdam, Holland

164
Untitled monogold (MG 5), 1961
Goldleaf on hardboard panel
41 x 32.5 cm | 16.1 x 12.7 in.

166 (top)
Model for a counterfoil book (Series A Certificate no. 2), 1959
Ink and gold paint on paper glued onto gouached paper
15.5 x 37 cm | 6.1 x 14.5 in.
Centre Pompidou - Musée National d'Art Moderne, Paris,
France

166 (bottom)
Receipt book for *Zones of Immaterial Pictorial Sensibility*
Series 5, no. 01
Printed paper, 320 grams of gold
8.7 x 29.8 cm | 3.4 x 11.7 in.

168
Paravent [*Folding Screen*] (IKB 62), 1957
Pure pigment and synthetic resin on wooden panels
150 x 350 x 2.2 cm | 59 x 137.7 x 0.8 in.

171
Tableau de feu bleu d'une minute
[*Blue Fire Painting of One Minute*] (M 41), 1957
Pure pigment and synthetic resin, flare burns, on panel
110 x 74.8 x 2.1 cm | 43.3 x 29.4 x 0.8 in.

172–173
Klein presenting a "Pictorial intention" in the room
reserved for *Surfaces et blocs de sensibilité picturale*
[*Surfaces and blocks of pictorial sensibility*], May 1957
Still from film entitled *Propositions Monochromes*, 1957
© Unknown

174
Albert Camus, *Avec le vide, les pleins pouvoirs*
[*With the Void, Full Powers*], 1958
Ink on paper
13.5 x 21 cm | 5.3 x 8.2 in.

175 (top and bottom)
*La Sensibilité picturale à l'état matière première,
spécialisée en sensibilité picturale stabilisée*
[*Pictorial Sensibility in Raw Material State. Specialized
as Stabilized Pictorial Sensibility*], April 28–May 12, 1958
© Unknown

176
Receipt given to Peppino Palazzoli | Series 1, Zone no. 01,
Paris, November 18, 1959
Ink on paper
8.7 x 19.3 cm | 3.4 x 7.5 in.
Museum Insel-Hombroich, Neuss, Germany

178
Untitled anthropometry (ANT 47), 1960
Pure pigment and synthetic resin
on paper glued on canvas
134 x 78.5 cm | 52.7 x 30.9 in.

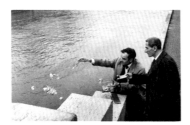

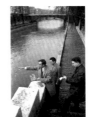

180 (top and bottom)
Yves Klein's cession to Dino Buzzati of *Zone de sensibilité
picturale immatérielle* [*Zone of Immaterial Pictorial
Sensibility*], series 1, zone 5, January 26, 1962
Photograph Shunk-Kender © Roy Lichtenstein Foundation

182–183
Yves Klein's cession to Michael Blankfort of *Zone de
sensibilité picturale immatérielle* [*Zone of Immaterial
Pictorial Sensibility*], series 4, zone 1, February 10, 1962
Photograph Gian Carlo Botti © Archives Yves Klein

184
Yves Klein's cession to Claude Pascal of *Zone de sensibilité
picturale immatérielle* [*Zone of Immaterial Pictorial
Sensibility*], series 1, zone 6, February 4, 1962
Photograph Gian Carlo Botti © Archives Yves Klein

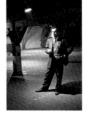

186
Taking down pictures exhibited in the Salon Violet
of Musée d'Art Moderne de la Ville de Paris,
January 26, 1962
Jacques Villeglé, François Dufrêne, and Yves Klein
Photograph Shunk-Kender © Roy Lichtenstein Foundation

188–189
Excerpts from *Comparaisons* catalogue of 1962
Musée d'Art Moderne de la Ville de Paris,
with photograph showing Yves Klein's action
Photograph Shunk-Kender © Roy Lichtenstein Foundation

190
Vision in Motion-Motion in Vision exhibition
at Hessenhuis, Antwerp, March 21–May 3, 1959

194
Pluie bleue [*Blue Rain*] (S 36), 1961
Pure pigment and synthetic resin on twelve wooden rods
208.9 cm | 82.2 in.

198
Dimanche 27 novembre 1960. Le journal d'un seul jour
[*Sunday November 27 1960. The Newspaper
of a Single Day*], November 27, 1960
Black recto-verso letterpress, double page
55.5 x 38 cm | 21.8 x 14.9 in.

200
Untitled blue monochrome (IKB 68), 1961
Pure pigment and synthetic resin, gravel, on gauze
mounted on panel
194 x 140 x 3 cm | 76.3 x 55.1 x 1.1 in.

202
The *Tableau de feu bleu d'une minute*
[*Blue Fire Painting of One Minute*] in the garden
of Gallerie Colette Allendy during the *Propositions
monochromes* exhibition, Paris, May 14, 1957

204
Expression de l'univers de la couleur mine orange
[*Expression of the Universe of the Color Lead Orange*]
(M 60), May 1955
Pure pigment and synthetic resin
on cardboard mounted on panel
95 x 226 x 5 cm | 37.4 x 88.9 x 1.9 in.

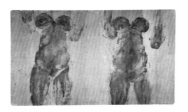

206
Untitled anthropometry (ANT 55), 1960
Pure pigment and synthetic resin
on paper glued on canvas
89.5 x 146.5 cm | 35.2 x 57.6 in.

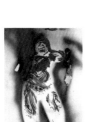

208
Untitled anthropometry (ANT 8), ca 1960
Pure pigment and synthetic resin on burnt paper
102 x 73 cm | 40.1 x 28.7 in.

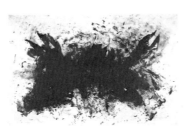

210–211
*Grande Anthropophagie bleue. Hommage
à Tennessee Williams* [*Great Blue Anthropophagy.
Homage to Tennessee Williams*] (ANT 76), 1960
Pure pigment and synthetic resin
on paper glued on canvas
275 x 407 cm | 108.2 x 160.2 in.
Musée National d'Art Moderne, Paris, France

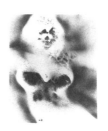

212
Untitled anthropometry (ANT 146), 1960
Pure pigment and synthetic resin on paper
65.5 x 50.5 cm | 25.7 x 19.8 in.

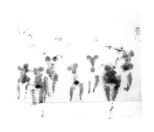

214
Suaire de Mondo Cane [*Mondo Cane Shroud*]
(ANT SU 8 I), 1961
Pure pigment and synthetic resin on gauze
234 x 297 cm | 92.1 x 116.9 in.
Walker Art Center, Minneapolis, USA

Photograph Index

Name Index

Acknowledgements

As this book draws to a close, I would like to thank Daniel Moquay, the director of Archives Yves Klein, who was the driving force behind this project centered on the element of fire. His advice, energy, and confidence have accompanied me throughout the long period spent at my desk writing. I take this opportunity to extend my heartfelt gratitude to him. Thanks to our conversations, Yves's widow, Rotraut Klein-Moquay, led me to an understanding of her husband's spirit, the world of his imagination and his vitality. Philippe Siauve was an essential guide in my research through Yves Klein's personal papers, which he knows so well. Thanks to Elena Palumbo-Mosca, the painter's friend and model, I was granted access to the intimate moments when the works were being created. Her friendship and our numerous discussions have inspired several pages of this book. Patti Smith invited me into her home in New York just before she was due to leave for her European tour. The memory of our conversation about Yves Klein, this book, and Robert Mapplethorpe has been branded powerfully and wonderfully on my mind, as has the text she has written. I also thank Gilbert Auzias and Isabelle Caplet with all my heart for their thoughtful and intelligent readings. I dedicate the book to my parents and my friends.

Frédéric Prot

This book is accompanied by a DVD (duration: 12 min.).
including the sequence dedicated to the *Mur de feu*
[*Wall of Fire*] and the *Fontaine de feu* [*Fountain of Fire*]
in the exhibition *Yves Klein Monochrome und Feuer*, Krefeld,
Germany, 1961 (filmed by: Yvan Butler) as well as a sequence
by Yves Klein of *Peintures de feu* [*Fire Paintings*] at the Centre
d'Essai de Gaz de France, France, 1962 (filmed by: Albert Weill).
© 2013 Yves Klein, Paris
Music: Daniel Humair
© 2013 Daniel Humair, Paris

Editorial Coordination
Laura Maggioni

Translation
Julian Comoy

Editing
Emily Ligniti

Production Manager
Enzo Porcino

Design and layout
Alain Julliard, Genève
www.alain-julliard.com

Colour Separation
Pixel Studio, Milan

ISBN: 978-88-7439-625-2

5 Continents Editions
Piazza Caiazzo, 1
20124 Milan, Italy
www.fivecontinentseditions.com

Distributed in the United States
and Canada by Harry N. Abrams, Inc., New York

Distributed outside the United States
and Canada, excluding France and Italy,
by Abrams & Chronicle Books Ltd UK, London

Printed in Italy by
Grafiche Flaminia, Foligno (PG)
for 5 Continents Editions, Milan